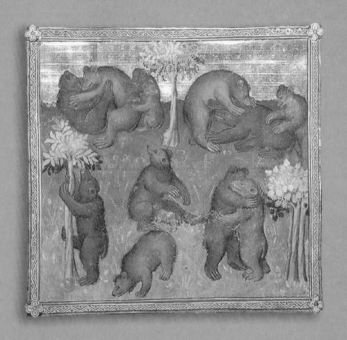

I envy the beasts two things—
their ignorance of evil to come,
and their ignorance of what is
said about them.

VOLTAIRE

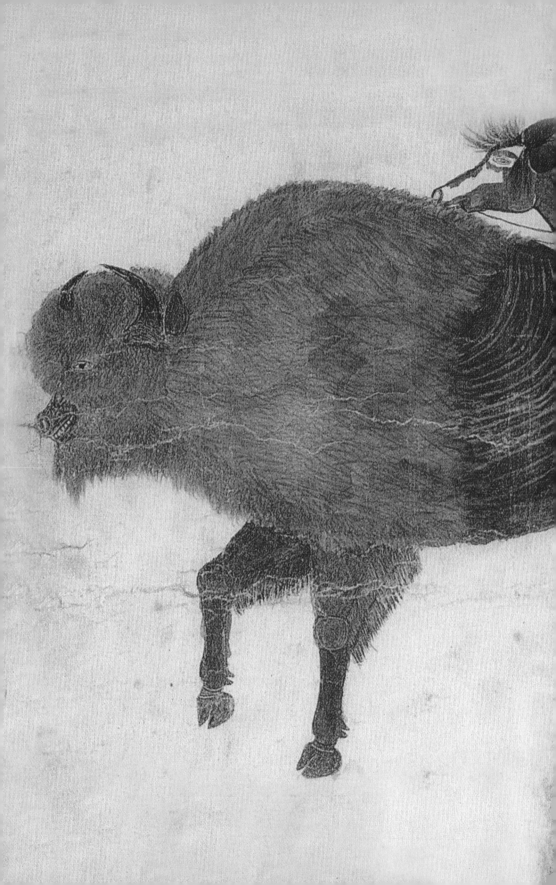

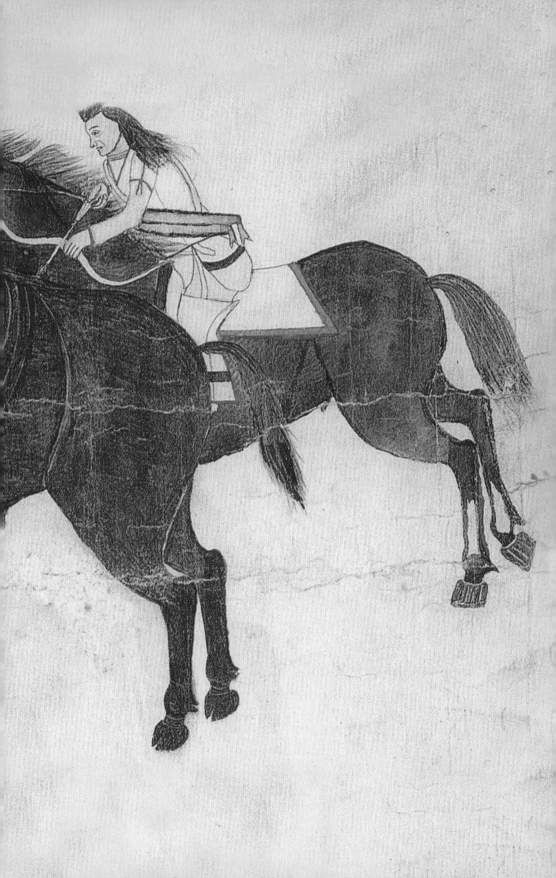

The
BEDSIDE BOOK
of **BEASTS**

A Wildlife Miscellany

GRAEME GIBSON

Book design by CS Richardson

Nan A. Talese · Doubleday
New York · London · Toronto · Sydney · Auckland

To M.E.A.

INTRODUCTIONS COPYRIGHT © 2009 BY MYSTERIOUS STARLING, INC.

All rights reserved. Published in the United States by Nan A. Talese / Doubleday, a division of Random House, Inc., New York.

www.nanatalese.com

Doubleday is a registered trademark of Random House, Inc. Nan A. Talese and the colophon are trademarks of Random House, Inc.

Originally published in Canada by Doubleday Canada, a division of Random House of Canada Limited, Toronto.

Pages 348–362 constitute a continuation of the copyright page.

LIBRARY OF CONGRESS CATALOGING-IN-PUBLICATION DATA
Gibson, Graeme, 1934–
The bedside book of beasts : a wildlife miscellany/ Graeme Gibson,
book design by CS Richardson.
p. cm.
Includes bibliographical references and index.
ISBN 978-0-385-52459-9 (alk. paper)
1. Predatory animals. 2. Animals in art. 3. Animals in literature.
I. Richardson, CS II. Title.
QL758.G53 2009
591.5'3—dc22 2009012965

Printed and bound in Canada

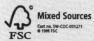

Mixed Sources
Cert no. SW-COC-001271
© 1996 FSC
FSC

10 9 8 7 6 5 4 3 2 1

First United States Edition

ENDPAPERS: *The Bunyip*, J. Ford (1860–1940), England
PAGE I: *Bears and cubs wrestling, climbing tree, grazing and suckling*, Gaston Phébus (1331–1391), France
PAGES II–III: *Native Sketch of Bison Hunting*, perhaps Blackfoot (c.1890–1910), United States
TITLE PAGES: *Male Leopard*, Jean-Baptiste Oudry (1686–1755), France

I said in mine heart concerning the estate of the sons of men, that God might manifest them, and that they might see that they themselves are beasts.

For that which befalleth the sons of men befalleth beasts; even one thing befalleth them: as the one dieth, so dieth the other; yea, they have all one breath; so that a man hath no preeminence above a beast: for all is vanity.

All go unto one place; all are of the dust, and all turn to dust again.

Who knoweth the spirit of man that goeth upward, and the spirit of the beast that goeth downward to the earth?

ECCLESIASTES III, 18–21

CONTENTS

Una and the Lion (detail), William Bell Scott (1811– 1890), Scotland

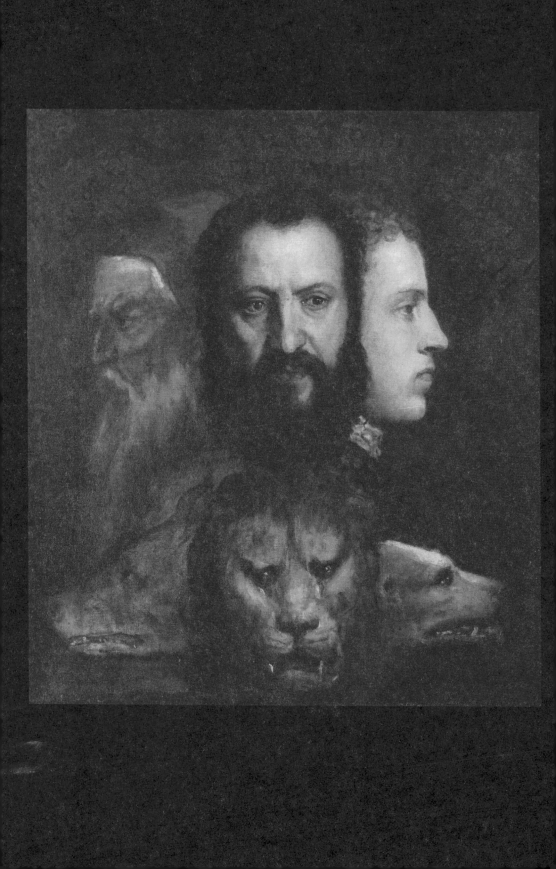

INTRODUCTION

The natural world is still imbedded in our genes and cannot be eradicated . . .
E.O. WILSON

THE BEDSIDE BOOK OF BEASTS follows on the heels of my *Bedside Book of Birds*, and is intended to complement it. Whereas birds are associated with creativity, longing and imagination—with spiritual matters rather than earthly ones—beasts are overwhelmingly physical. They and we—our animal side—are the body itself, with all its physical hungers, its strength and joyfulness, its vulnerability, grace, inventiveness and courage—and, beyond that, its mortality.

 This miscellany is devoted to alpha predators and their prey. They are central to us, and to our understanding of our place in nature, because the primal fact of hunting and/or being hunted, and the inescapable demands of hunger, have largely defined animal life on earth, and are undoubtedly among the key engines driving evolution. We are what we are largely because we must

Allegory of Prudence, Titian (1485–1576), Italy

eat—and have lived in danger of being eaten. Dean William R. Inge, the "Gloomy Dean," isn't far wrong when he says, "The whole of nature, as has been said, is a conjugation of the verb *to eat*, in the active and passive."

Those of us who have had the good fortune to walk in a landscape harbouring carnivores bigger and more powerful than ourselves know that such an experience can evoke a profound sense of the relationship that we—we human animals—have always had with true wilderness, for wilderness almost invariably contains an alpha predator. Indeed, there is good reason to believe that without an alpha predator there is no true wilderness. But more of that elsewhere.

I RECENTLY RETURNED, for the first time in sixty-two years, to a lake where I'd spent three summers at a boys camp during the War. Punctuated now with cottages along the shore, the low tight forest had nevertheless overgrown the place where the camp had been. Preparing for bed that evening in the old log house of friends, I listened to the distant thumping bass of a boombox somewhere back along the road, and what sounded like the strangled chatter of an amplified discjockey.

At camp, it was the freedom of canoe trips I fed on. We slept in blanket-rolls wrapped in groundsheets, with our heads under overturned canoes if it rained. Lying beneath the stars and spiky conifers, I imagined feeling the curve of the turning earth beneath me. I already knew the cries of loons and had heard owls calling at night from a wet cedar bush, but I was utterly unprepared for the explosive rising call of a wolf that jolted me from sleep one night. It was a sound that Aldo Leopold describes as "an outburst of wild defiant sorrow, and of contempt for all the adversities of the world." The wolf's family quickly joined in with a hair-raising

chorus of harmonic howls over a cacophony of underlying yips and barks. Then, just as suddenly as the chorus began, it stopped. It was an enchanting gift for an eleven-year-old boy from the city, and I had to wait fifty years before receiving it again. I was transfixed on that occasion, too, as if those voices had once again touched something ancient in me that I almost remembered.

We harbour a primordial animal memory in our being. Although largely inaccessible, its shadows dwell in our instincts, just as they stir in our dreams and fears. Sometimes they can be sensed in the beating of our hearts, or in an unexpected encounter with wild creatures—the sudden howling of wolves, or the appearance of a stag that stares intently before vanishing over the edge of a hill.

Not surprisingly, there is growing evidence that spending time in the natural world restores and even heals us in remarkable ways. Not only can it reduce stress, lower blood pressure and strengthen the immune system, it has been shown to bolster the attention span of children and shorten the healing process for post-operative adults.

ONE OF THE DELIGHTS in compiling miscellanies such as this is that you start out with a regimen of relatively simple-minded and obvious reading—about bears, say, or animism, or animal gods and how lions hunt or how the prey escapes—but very soon the material takes charge, and you find yourself encountering what you hadn't expected. For example, I now believe that the natural world worked in perfect balance until we developed weapons that allowed us to kill from a distance. I suspect it was our knowledge of spears and bows that expelled us from the Garden.

Humankind's extraordinary, and some might say compulsive ability to make things—from chipped stone arrowheads to the space

shuttle *Challenger*—has largely estranged us from nature. What characterizes our species now is an overwhelming dependence on the technologies it has fashioned. Henri Bergson has suggested that "... intelligence, considered in what seems to be its original feature, is the faculty of manufacturing artificial objects, especially to make tools, and of indefinitely urging the manufacture."

> The term 'beasts' belongs properly to lions, leopards and tigers, wolves and foxes, dogs and monkeys, and all others (except snakes) which rage by mouth or with claws. They are called 'beasts' from the force with which they rage; and they are termed 'wild' because they are by nature used to freedom and they are motivated by their own will. They do indeed have freedom of will and they wander here and there, going as their spirit leads them.
>
> *Peterborough Bestiary*

Because they are "used to freedom," wild horses are of no practical use to us until we "break" and then perhaps "school" them. Once we have done so, once they are domesticated, we can manage them as "beasts of burden," as creatures of the chase or as working companions, because they are no longer free. They can no longer *"wander here and there, going as their spirit leads them."*

We humans share that fate. What we call "civilization" is a form of domestication, albeit an astonishingly rich and complex one, at its best. It has provided us with many exceptional achievers, from Beethoven to Einstein. Nevertheless, we too have been tamed and are utterly dependent on our societal and intellectual milieus. Few of us would last long without the varied technologies and infrastructures that support us.

THIS BOOK EXPLORES THESE IDEAS, while also striving to celebrate the deeply moving truth of creatures that are truly wild. Although tragically diminished, the natural world that made us is out there still. With effort and some passing luck, we might find our own ways of reconnecting, and in doing so learn to honour our ancient and long-standing debt to life on earth.

GRAEME GIBSON

Tiger, artist unknown (c.19th century), India

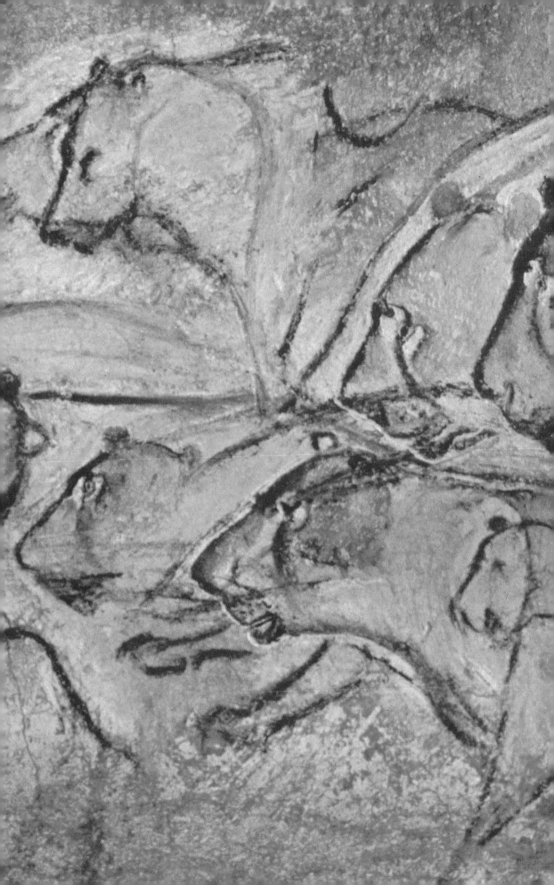

In the heart of a city I have heard the wild geese crying
on the pathways that lie over a vanished forest.

Loren Eiseley

We have learned nothing . . .

Pablo Picasso, on exiting the cave

This is a law: where Nature flowers,
so does the brain.

José Marti

I —

Echoes of a
Working Eden

Language without Words

Cave lions, Chauvet, France

A typical four square mile patch of rainforest will contain
the following species (not individuals)—1,500 flowering plants,
750 trees, 125 mammals, 400 birds, 100 reptiles, 60 amphibians,
150 butterflies and probably over 50,000 of insects.
CLIVE PONTING

A BIG CAT RUNS DOWN an antelope in what has become television nature-programming's equivalent of a car chase: with atavistic emotions we watch the beast charge past apparently luckier members of the herd, who trot skittishly about until their companion is killed in a convulsion of dust. Whereupon they resume grazing. Why didn't the cat turn on one of these others, who were closer than the victim and hadn't yet broken into full flight? And why did the survivors seem so unconcerned?

True predators have at best an uncertain time of it. Because even top carnivores only make a kill in about one of ten attempts, they cannot afford to be injured, for a weakened hunter is at a critical disadvantage. Most predators, therefore, try to find prey that is old or young, sick or injured. In short, they look for animals that are afraid. In return, prey that is vulnerable knows it is a likely target. Understandably this makes the weakened individual more nervous than its fellows when a predator appears. Nervous behaviour identifies the suitable prey. *Here I am*, it says. *Over here . . .*

In *The Hunting Animal* Franklin Russell describes a cheetah's strategy: it begins with the cat resting on a slight rise, contemplating a herd of hartebeest. She scarcely moves, except perhaps for a lazy twitching at the end of her tail. Although the hartebeest bunch together, with the large males in front, they don't seem to pay much attention until the cat takes a loping run around the herd and returns to stare at them more intently from her vantage point. This manoeuvre unsettles some, but most continue to graze until she does it again. Perhaps, after another of these leisurely runs, there's a stirring among the hartebeest, and one of them loses its nerve. Because it is old or young, injured or ill, it knows the cheetah's performance has been intended to flush it out—and has succeeded.

The hard logic of such encounters emerged during what George Santayana called the long "even flow and luscious monotony of organic life." As a result, all players in the drama know the script and their roles. It isn't just the weakened animal or the predator that understands; the healthy ones do as well, and rest in the faith that one of their number will offer itself as scapegoat.

The biological implication of these encounters highlights one of the key elements in animal evolution. By taking the least vital and effective individual, predators relentlessly strengthen the prey's genetic pool. Faster, smarter prey, in their turn, cause the failure and ultimate death of weakened predators. As George Schaller says in *The Marvels of Animal Behavior*, "There is a continual evolutionary race between predator and prey, a race with no winner. Constant predation, weeding out the stolid and the slow, produces alert and fleet prey."

In contrast, from the time we humans learned to kill from a distance—with relative imputiny—we have almost invariably focused on the most impressive individuals. Instead of weeding out

"the stolid and slow," we choose the healthiest animals, those with the greatest amount of fat or biggest antlers. In doing so we are routinely selecting out the most genetically valuable members of the group, thus compromising a whole population's vitality.

Sometimes, of course, the prey fights back. There's a remarkable video on the Internet of a buffalo herd challenging a pride of lions that has seized one of its calves in Kruger National Park. Soon after one of the lions is hurled high in the air by a big male buffalo, the others are driven off by the rest of the herd.

In an ornithological park in the Camargue in south-western France I saw a more modest but equally stirring example of group defence. A Black kite (*Milvus migrans*), which is a medium-sized bird of prey, drifted low over a wet sand islet where Black-winged stilts, Mediterranean gulls, Avocets and Common terns were feeding and resting. Led by the terns, and then the stilts, they rose up in an explosion of noisy avian adrenalin and collectively mobbed the intruder. Most pursuers only buzzed the retreating raptor, but some of the stilts appeared to hit its wings and back with considerable force, and they didn't cease in their pestering until the kite had been driven off.

DESPITE SOCIAL DARWINIST assumptions about "survival of the fittest" and "nature red in tooth and claw," it seems clear that evolution is not driven by competition; nor are wild animals intentionally cruel. Instead, as John A. Livingston—along with a good many others—insists, the factor (in nature) "that appears to . . . be more important than any other is *compliance*. I can very comfortably interpret ecologic interdependence as co-operation."[1]

For most social animals the "will to comply" stabilizes a group

Cernunnos, Gundestrup Cauldron (detail), Celtic (c.1st century BC), Denmark

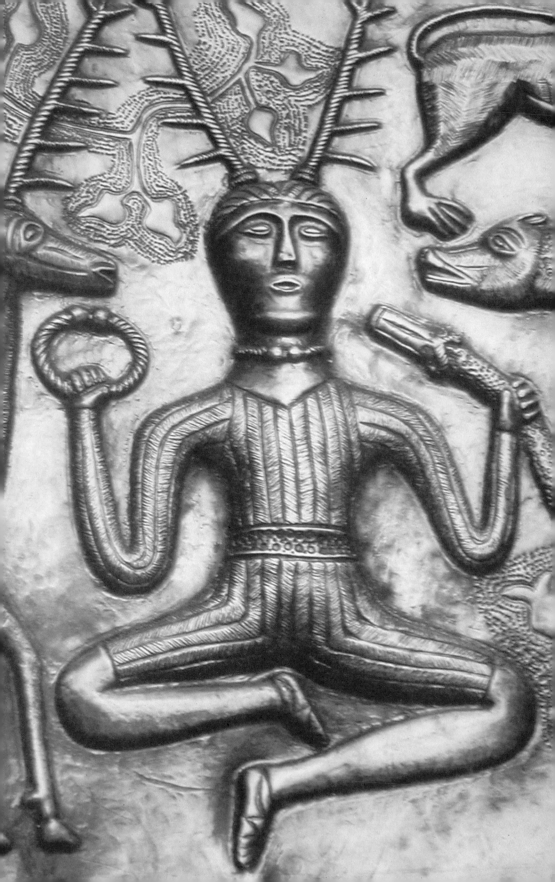

and prevents its internal disintegration. An excellent and well-studied example can be found amongst wolves. If a young wolf precipitously challenges the alpha male and discovers he isn't up to the challenge, that he's going to lose, he ritually capitulates by offering the most vulnerable part of his throat—or else sprawls on his back like a puppy. And that's an end to it. Obviously compliance must go both ways: the young pretender abjectly submits, and the alpha wolf must spare him.

Had the will to comply not governed this exchange, one or both of the pack's strongest males would have been seriously injured and the group's authority deeply compromised.

Compliance also seems to inform relations between species. Working among the people of the Kalahari in the 1950s, Elizabeth Marshall Thomas discovered that an ancient truce existed between lions and the Bushmen; each basically left the other alone. After some puzzlement, she arrived at the following explanation:

> . . . the people, who were not combative with each other, were also not combative with animals. People hunted, of course, but hunting isn't a form of combat—or at least it wasn't to the hunter-gatherers. Hunting was merely a method of obtaining food and clothing. Most animals, as a rule, avoid conflict when they can because conflicts cause injuries, and injuries impair survival. For most of our time on earth, our kind, too, had to abide by the practical considerations that govern other animals. And the Bushmen in the 1950s lived in the old way, by the old rules.

In their *Spirit of the Wild Dog*, Lesley J. Rogers and Gisela Kaplan describe a startling partnership that involves coyotes and badgers hunting co-operatively. The coyote's acute sense of smell

detects a rabbit, and the badger digs with its formidable claws into the unfortunate creature's burrow: when the panicked rodent finally emerges, it is killed by the waiting coyote, whereupon the two hunters share the meal.

IN COMMON WITH ALL LIVING THINGS, we humans emerged within the leisurely passage of evolutionary time. But then bipedalism freed our hands, and our opposable thumbs encouraged sophisticated tool-making. This, coupled with the remarkable complexity of our growing language skills, led to the development of our remarkable brains, which—unfortunately, given the reality of our animal origins—live inside us like alien beings. Astonishingly, it has almost persuaded us that we have no debt to nature, that we owe it neither allegiance nor respect, let alone reverence.

The artificiality of our civilization is causing great damage not only to the earth, but to us as well. As George Grant says in *Technology and Empire*, "When one contemplates the conquest of nature by technology one must remember that that conquest had to include our own bodies. Calvinism provided the determined and organized men and women who could rule the mastered world. The punishment they inflicted on nonhuman nature they had first inflicted on themselves."

Thomas Mann's protagonist in *Confessions of Felix Krull, Confidence Man*, believes that "He who really loves the world shapes himself to please it . . ." Although the operative word here is *love*, the key principle of adaptation is also present. Living forms that have survived and prospered have done so because they adapted; in other words, they shaped themselves to nature—and in doing so perhaps even pleased it.

However, in *The Failure of Technology*—which he wrote during Hitler's rise to power—Friedrich Georg Jünger warns that our

"intellect is a tool for the exploitation of nature." If so, if our vaunted reason is one of our technologies, then it will surely undermine any attempt to "please nature."

The resultant conflict between Krull's love and Jünger's intellect—or heart and brain—explains why virtually all nature-based religions—Shinto, for example—tend to avoid dogma, and have various emotional and/or spiritual strategies for subduing the intellect.

"The heart has its reasons," wrote Pascal, "that reason cannot know." While Reason may help us develop strategies for mending the earth and ourselves, it will not open us to the process and possibilities that will help us reconnect with the animal inside us, which is to say with our biological reality. Until we do that, the mind will continue to spin its wheels.

G.G.

Swift Fox, J.J. Audubon (1785–1851), Haiti/United States

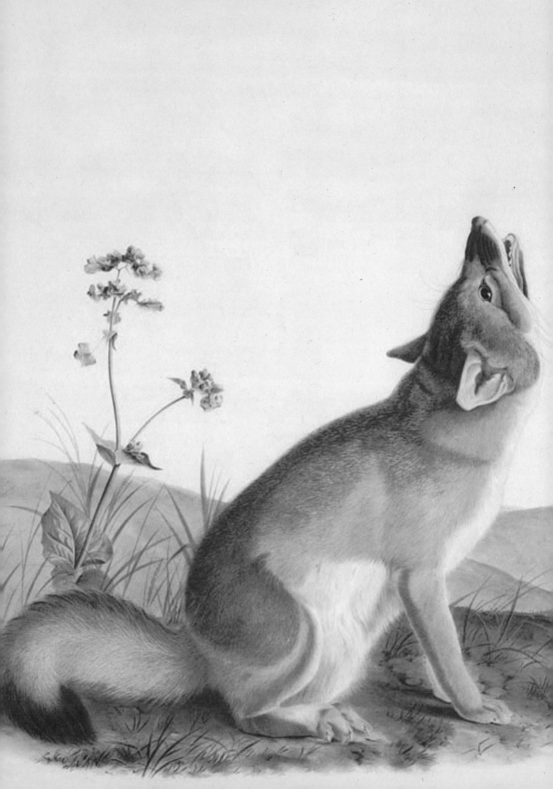

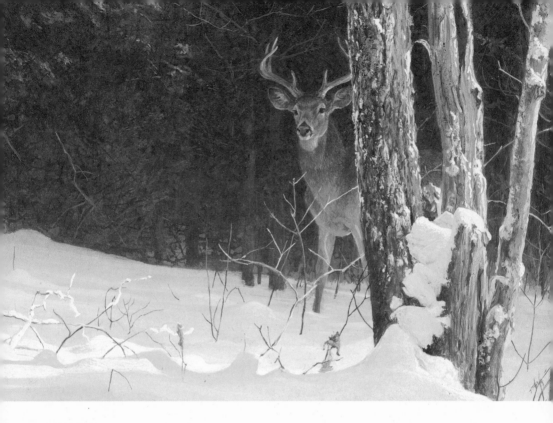

FROM MARCH 1979

Sick of those who come with words, words but no language,
I make my way to the snow-covered island.

Wilderness has no words. The unwritten pages
Stretch out in all directions.

I come across this line of deer-slots in the snow: a language,
Language without words.

TOMAS TRANSTRÖMER (1931–), Sweden

Whitetail, Robert Bateman (1930–), Canada

Thinking Like a Mountain

A DEEP CHESTY BAWL, echoes from rimrock to rimrock, rolls down the mountain, and fades into the far blackness of the night. It is an outburst of wild defiant sorrow, and of contempt for all the adversities of the world.

Every living thing (and perhaps many a dead one as well) pays heed to that call. To the deer it is a reminder of the way of all flesh, to the pine a forecast of midnight scuffles and of blood upon the snow, to the coyote a promise of gleanings to come, to the cowman a threat of red ink at the bank, to the hunter a challenge of fang against bullet. Yet behind these obvious and immediate hopes and fears there lies a deeper meaning, known only to the mountain itself. Only the mountain has lived long enough to listen objectively to the howl of a wolf. Those unable to decipher the hidden meaning know nevertheless that it is there, for it is felt in all wolf country, and distinguishes that country from all other land. It tingles in the spine of all who hear wolves by night, or who scan their tracks by day. Even without sight or sound of wolf, it is implicit in a hundred small events: the midnight whinny of a pack horse, the rattle of rolling rocks, the bound of a fleeing deer, the way shadows lie under the spruces. Only the ineducable tyro can fail to sense the presence or absence of wolves,

or the fact that mountains have a secret opinion about them.

My own conviction on this score dates from the day I saw a wolf die. We were eating lunch on a high rimrock, at the foot of which a turbulent river elbowed its way. We saw what we thought was a doe fording the torrent, her breast awash in white water. When she climbed the bank toward us and shook out her tail, we realized our error: it was a wolf. A half-dozen others, evidently grown pups, sprang from the willows and all joined in a welcoming mêlée of wagging tails and playful maulings. What was literally a pile of wolves writhed and tumbled in the center of an open flat at the foot of our rimrock.

In those days we had never heard of passing up a chance to kill a wolf. In a second we were pumping lead into the pack, but with more excitement than accuracy: how to aim a steep downhill shot is always confusing. When our rifles were empty, the old wolf was down, and a pup was dragging a leg into impassable slide-rocks. We reached the old wolf in time to watch a fierce green fire dying in her eyes. I realized then, and have known ever since, that there was something new to me in those eyes—something known only to her and to the mountain. I was young then, and full of trigger-itch; I thought that because fewer wolves meant more deer, that no wolves would mean hunters' paradise. But after seeing the green fire die, I sensed that neither the wolf nor the mountain agreed with such a view.

Since then I have lived to see state after state extirpate its wolves. I have watched the face of many a newly wolfless mountain, and seen the south-facing slopes wrinkle with a maze of new deer trails. I have seen every edible bush and seedling browsed, first to anaemic desuetude, and then to death. I have seen every edible tree defoliated to the height of

a saddlehorn. Such a mountain looks as if someone had given God a new pruning shears, and forbidden Him all other exercise. In the end the starved bones of the hoped-for deer herd, dead of its own too-much, bleach with the bones of the dead sage, or molder under the high-lined junipers.

I now suspect that just as a deer herd lives in mortal fear of its wolves, so does a mountain live in mortal fear of its deer. And perhaps with better cause, for while a buck pulled down by wolves can be replaced in two or three years, a range pulled down by too many deer may fail of replacement in as many decades. So also with cows. The cowman who cleans his range of wolves does not realize that he is taking over the wolf's job of trimming the herd to fit the range. He has not learned to think like a mountain. Hence we have dustbowls, and rivers washing the future into the sea.

We all strive for safety, prosperity, comfort, long life, and dullness. The deer strives with his supple legs, the cowman with trap and poison, the statesman with pen, the most of us with machines, votes, and dollars, but it all comes to the same thing: peace in our time. A measure of success in this is all well enough, and perhaps is a requisite to objective thinking, but too much safety seems to yield only danger in the long run. Perhaps this is behind Thoreau's dictum: In wildness is the salvation of the world. Perhaps this is the hidden meaning in the howl of the wolf, long known among mountains, but seldom perceived among men.

ALDO LEOPOLD (1887–1948), United States

Tlingit wolf mask, artist unknown (before 1867 AD), Alaska

The Famous Black Panther

... THE DOCTOR AND I STOPPED to look at the famous black panther, which died the following winter of lung-disease—just as though it had been a young girl.

All around us was the usual public of the zoological gardens, soldiers and nurse-maids, who love to stroll round the cages and throw nutshells and orange-peel at the sleepy animals. The panther, before whose cage we had arrived, was of that particular species which comes from the island of Java, the country where nature is most luxuriant, and seems itself like some great tigress untameable by man. In Java the flowers have more brilliancy and perfume, the fruits more taste, the animals more beauty and strength, than in any other country in the world.

Lying gracefully with its paws stretched out in front, its head up, and its emerald eyes motionless, the panther was a splendid specimen of the savage products of the country. Not a touch of yellow sullies its black velvet skin—of a blackness so deep and dull that the sunlight was absorbed by it as water is absorbed by a sponge. When you turned from this ideal form of supple beauty—of terrific force in repose—of silent and royal disdain—to the human creatures who were timidly gazing at it, open-eyed and open-mouthed, it was not the human beings who had the superiority over the animal. The latter was so much the superior that the comparison was humiliating.

BARBEY D'AUREVILLY (1808–1889), France

Black Puma, William Home Lizars (1788–1859), England

PREDATORS CONTROL . . .

THE WILD PREDATOR controls the population of his prey and thus automatically safeguards himself. If a hunter develops new techniques its prey soon adopts new methods of defence. Hunters and hunted are adapted to one another in the long evolutionary process. Predators even exercise family planning, killing or neglecting their offspring if litters become too large. No prey species has ever become extinct as a result of predation, whereas instances are on record where the destruction of a natural predator has upset the balance of nature and created conditions difficult even for human life.

Let us take as an example a small area of the Bharatpur Sanctuary. There used to be a few leopards that kept the wood poachers away, at least at night, and owing to their presence the village dogs did not dare enter the Sanctuary. The cattle population was kept under control by the leopards thinning out their calves. Then in 1962 the last leopard was shot by the Maharaja, who enjoyed exclusive rights even though it was a Sanctuary. The result is that large areas of forest have been lost; the chital population has deteriorated as a result of hunting by dogs, and feral cattle have become a problem not only in the Sanctuary but in the neighbouring agricultural fields.

Tiger, Edward Topsell (c.1572–1625), England

16

The tiger is at the apex of nature's pyramid and controls the whole ecosystem. By thinning out his prey he prevents over-use of vegetation and saves the land from destruction. He acts as a sentinel to protect the forests, some of which have been saved solely because wood poachers lacked the courage to enter them at night when the forest guard is asleep.

KAILASH SANKHALA (1925–1994), India

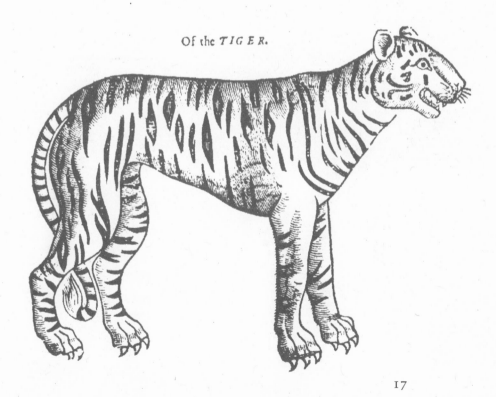

Of the *TIGER.*

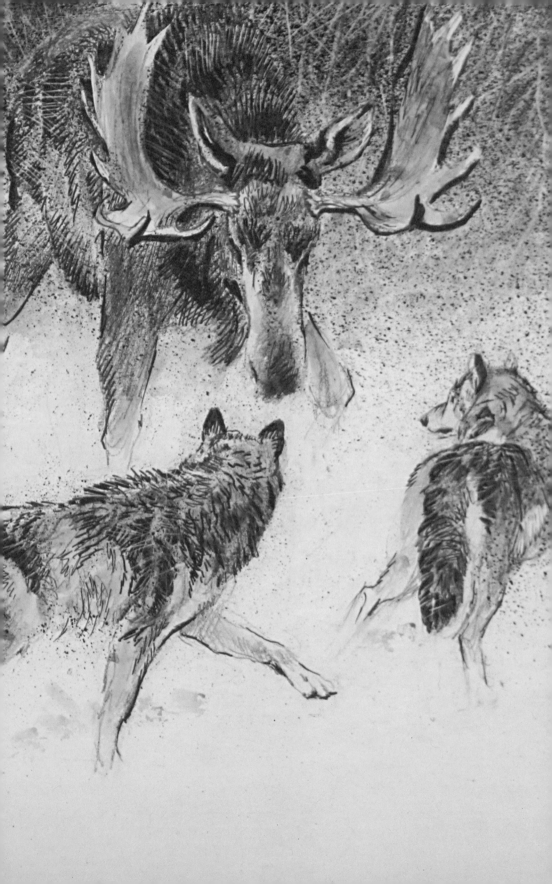

The Conversation of Death

IN THE PRECEDING SECTION on hunting I merely touched on that moment of eye contact between wolf and prey, a moment which seemed to be visibly decisive. Here are hunting wolves doing many inexplicable things (to the human eye). They start to chase an animal and then turn and walk away. They glance at a set of moose tracks only a minute old, sniff, and go on, ignoring them. They walk on the perimeter of caribou herds seemingly giving warning of their intent to kill. And the prey signals back. The moose trots toward them and the wolves leave. The pronghorn throws up his white rump as a sign to follow. A wounded cow stands up to be seen. And the prey behave strangely. Caribou rarely use their antlers against the wolf. An ailing moose, who, as far as we know, could send wolves on their way simply by standing his ground, does what is most likely to draw an attack, what he is least capable of carrying off: he runs.

I called this exchange in which the animals appear to lock eyes and make a decision the conversation of death. It is a ceremonial exchange, the flesh of the hunted in exchange for respect for its spirit. In this way both animals, not the predator alone, choose for the encounter to end in death. There is, at least, a sacred order in this. There is nobility. And it is something that happens only between the wolf and his major prey species. It produces, for the wolf, sacred meat.

Imagine a cow in the place of the moose or white-tailed deer. The conversation of death falters noticeably with domestic stock. They have had the conversation of death bred

Wolf Pack and Bull Moose (detail), Robert Bateman (1930–), Canada

19

out of them; they do not know how to encounter wolves. A horse, for example—a large animal as capable as a moose of cracking a wolf's ribs or splitting its head open with a kick—will usually panic and run.

What happens when a wolf wanders into a flock of sheep and kills twenty or thirty of them in apparent compulsion is perhaps not so much slaughter as a failure on the part of the sheep to communicate anything at all—resistance, mutual respect, appropriateness—to the wolf. The wolf has initiated a sacred ritual and met with ignorance.

This brings us to a second point. We are dealing with a different kind of death from the one men know. When the wolf "asks" for the life of another animal he is responding to something in that animal that says, "My life is strong. It is worth asking for." A moose may be biologically constrained to die because he is old or injured, but the choice is there. The death is not tragic. It has dignity.

. . . To illustrate, begin with a classic case that took place in Wood Buffalo National Park, Alberta, Canada, in 1951. Two buffalo bulls and two cows are lying in the grass ruminating. Three of them are in good health; one cow is lame. Wolves approach and withdraw a number of times, apparently put off by a human observer. At each approach, though, the lame cow becomes agitated and begins looking all around. Her three companions ignore the wolves. When one wolf comes within twenty-five feet, the lame cow gets up on shaking legs to face it alone. It seems clear that prey selection is something both animals play a role in.

BARRY LOPEZ (1945–), United States

20

Neither Cruelty nor Compassion

Whether, as Robert Ardrey argues, we are descended from carnivorous apes, or whether our proto-human ancestors were peaceful and we only later acquired, along with erect posture, a taste for red meat, does not matter here. What matters is that it was in response to predatory urges, our own or others, that we developed our nimble minds, our weapons-making skills, our agile and fertile brains. Our imperatives were no different from those of any other species: to eat, to procreate, and to avoid being eaten. It was only our method of coping with these imperatives that was unique, at least in degree: the enormous development of our cerebral functions, which in time led to language, and to the arts, and to a vision of God. I recognize out uniqueness, but I reject our alleged separateness. It is lonely up there atop the pyramid of life; a cold wind blows in from the intergalactic void, and I gladly step down to a lower, less-exposed level and cuddle up to the warmth of my brother animals. When I speak of my cousin the toad or my brother the coyote, I mean just that. And I am ever saddened and dismayed to hear so many of my fellow-humans denying this commonality. Their hubris, I fear, may be our undoing in the end.

François Leydet (1927–1997), United States

The Old Bear Died

I was roaming the big woods, one day in springtime, when I found my first bear's den. It was between two rocks that leaned to each other, forming a low entrance, which the bear had filled with leaves and evergreen boughs that he had collected for the purpose of shutting out the snow. For years I had vainly searched for such a den; and once, when some woodcutters had driven a bear from his winter sleep, I had followed him for the better part of three days, camping on his trail, in order to find out how he prepared his hibernaculum. In all that time I never saw him or came near him. He was the better traveller; he seemed to know that he was followed, and he led me a heartbreaking chase hither and yon over the ruggedest country until a storm came, when he probably went straight to a good place he had in mind, trusting the falling snow to cover his tracks. Here at last was the long-sought den, and my first glance told me that the bear was at home: his doorway was still closed—with the litter that he had pulled in after him. I was moving cautiously, being unarmed, and was wondering how best to awaken the sleeper, when the thought came that every other bear in the country had been roving the woods for two or three weeks past. Then I opened his door,

letting in the sunshine; and there lay Mooween, very still, very peaceful, but with no answering light in his open eyes. He had curled himself up, just as he had always done when winter threatened, to sleep and doze and dream through all the storms, until the chickadees sounded their sweet mating call through the woods, Spring coming! Spring coming! telling him that he could soon go forth and find his first food of tender grass sprouting by every spring and brookside. As this old bear died, so, I think, do most birds and animals meet their end in a place of their own selection, as serenely as the old man fell asleep in his accustomed chair. One strange thing is noticeable in the wood folk at such a time, when they are answering the last call—namely, that they show no trace of pain or care, and that they have lost all fear, even the fear of man. I have found several animals and many birds beside whom death, the "dark mother," had plainly halted, and without exception they were gentle, fearless, confident. The animals allowed me to sit beside them and to stroke their fur without resistance; the birds would settle down on the finger that I slid beneath their feet, and would rest there contentedly, opening their eyes wide to look at me with a gleam of interest, until I placed them back on their own twig once more.

WILLIAM J. LONG (1857–1952), United States

Grizzly bear paw print (hind leg), shown actual size

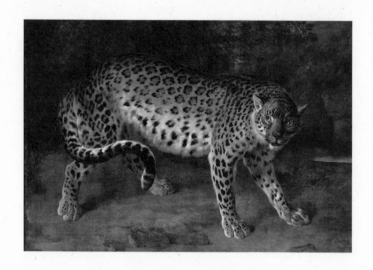

DISCOVERY

As I REFLECTED on a variety and abundance of meat eaters, I was struck by the fact that here in Africa, for the first time in my experience, I was seeing something that approached the "balance of Nature." We had tallied thousands of antelopes that day, at the end of the most difficult period of the year for wildlife—the seven-month dry season. Yet we had not seen a single weak, emaciated, or crippled animal. Any ill or weakened creature would have been run down, killed, and devoured by the "sanitary brigade"—the ever-hungry and ever-searching carnivores. I thought of American parks, where mountain lions, wolves, and other predators have been practically eliminated and where underfed deer and antelopes may live for months before dying of starvation.

VICTOR H. CAHALANE (1901–1993), United States

Leopardess, Jean-Baptiste Oudry (1686–1755), France

24

A mirror of my own imagination

EACH TIME I LOOK into the eye of an animal, one as "wild" as I can find in its own element— or maybe peering through zoo bars will have to do . . . I find myself staring into a mirror of my own imagination. What I see there is deeply, crazily, unmercifully confused.

There is in that animal eye something both alien and familiar. There is in me, as in all human beings, a glimpse of the interior, from which everything about our minds has come.

The crossing holds all the power and purity of first wonder, before habit and reason dilute it. The glimpse is fleeting. Quickly, I am left in darkness again, with no idea whatsoever how to go back.

ELLEN MELOY (1946–2004), United States

Polar Bear, Sir Edwin Henry Landseer (1802–1873), England

IN AWE OF HIS PRESENCE
AND HIS BEAUTY

I USED TO ASK PEOPLE what would happen if someone met a lion in the bush. If that should happen, I would be told, one should walk purposefully away at an oblique angle without exciting the lion or stimulating a chase. Several times, people showed us how to do this. But at Gautscha we never met a lion. Although among us we spent at least parts of more than fifty person-years in the bush there, we never once had occasion to use the technique we had learned.

We saw it used, though. One day, in the close quarters of some heavy bush in the farthest waterless reaches of the Kalahari, my brother and I met a lion. He was all golden in the sunlight, with a golden mane. He seemed very large and, unlike many Kalahari animals today, he was in beautiful physical condition: he had no scars or scratches and had plenty of flesh on his bones. Stupefied, we gazed at him, in awe of his presence and his beauty. He stood still, gazing at us. How long we might have stayed this way I don't know. My brother and I were too dazzled to do anything. So the responsibility fell upon the lion. Moving calmly, confidently, purposefully, keeping us in view without staring at us aggressively, *he* walked purposefully away at an oblique angle. The effect of the encounter on us—or at least on me—was memorable. The lion was only a few feet away, and I could have become afraid for my life. Yet his intentions were so clear and his demeanor was so reassuring that I felt absolutely no fear, not even

Lion of Senegal, Karl Joseph Brodtmann (1787–1862), Switzerland

alarm—just interest and wonder. By his smooth departure and his cool, detached behavior, the lion apparently intended to save himself the risks of an unwanted skirmish. A man acting in a similar way under similar circumstances would have been considered refined, gentlemanly, polite. In our species, too, reassuring manners can bring desirable results, for exactly the same reasons.

That was the only time, as far as I can remember, that any of us saw a lion by chance. But it was not the only time we saw a lion. In fact, we often saw them. That, however, happened at their discretion, when they wanted to see us. Usually this happened on the first or second night we spent in a new area, or upon returning to a familiar area that we hadn't visited for a long time. As animals who keep close watch over all that happens in their sphere, the lions would inevitably come to check us out.

ELIZABETH MARSHALL THOMAS (1931–),
United States

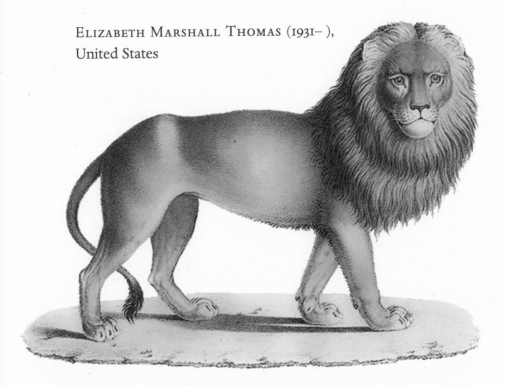

THE LITTLE WATER CEREMONY

THERE WAS ONCE A YOUNG HUNTER—a chief—who was greatly respected by the animals on account of the kindness he showed them. He never killed a deer that was swimming or a doe that had a fawn, or an animal that he took unawares or that was tired from long pursuit. For the predatory birds and animals he would always first kill a deer and skin it and cut it open and cry, "Hear, all you meat-eaters. This is for you." He would always leave some honey for the bears and some corn in the fields for the crows. The tripes of the game he killed he threw into the lakes and streams for the fish and the water animals.

One day, when cut off from his party, he was captured and scalped by the Cherokees. When they had gone, the Wolf smelled blood, and he came up and licked the bloody head. But when he recognized the Good Hunter, he howled for the

Church ornament, artist unknown, England

rest of the animals, who all came and gathered around and mourned for their lost friend. The Bear felt the body with his paws and on the chest found a spot that was warm. The birds had come, too, and they all held a council, while the Bear kept him warm in his arms, as to how they could bring the young hunter to life. The only dissenting voice was that of the Turkey Buzzard, who said, "Let's wait till he gets ripe and eat him." And they compounded a powerful medicine, to which each one contributed a "life-spark"—in some versions a bit of the brain, in others a bit of the heart. But the mixture of all these ingredients made an essence so concentrated that it could all be contained in an acorn shell, and it is called for this reason the Little Water.

Now the Owl said, "A live man must have a scalp," and who was to go for the scalp? In certain of the tellings of the story, a long discussion takes place. One animal after another is decided unfit. The quadrupeds will never do: what is needed is a clever bird. The Dew Eagle is sometimes chosen. He is the ranking bird of the Iroquois, who carries a pool of dew on his back and, when rain fails, can spill it as mist. One variant makes it the Hummingbird, who moves quickly and is almost invisible. But it is more likely to be the Giant Crow (*Gáh-ga-go-wa*), the messenger for all the bird, who plays a prominent role in the ceremony. He flies to the Cherokee village, and there he sees the good hunter's scalp, which has been stretched on a hoop and hung up to dry in the smoke that comes out of the smoke-hole. He swoops down and snatches it. The Cherokees see him and shoot their arrows at him, but the Crow flies so high that they cannot reach him.

When he has brought the scalp back to the council, they find it is too much dried out to be worn by a living man. The

Great Crow has to vomit on it and the Dew Eagle sprinkle on it some drops of his dew before it is supple and moist enough to be made to grow back on the hunter's head. He has already been given the medicine, and he feels himself coming to life. As he lies with his eyes still closed, he realizes that he is now able to understand the language of the animals and birds. They are singing a wonderful song, and he listens to it and finds later on that he is able to remember every word. They tell him to form a company and to sing it when their help is needed. He asks how they make the medicine, and they say that they cannot tell him because he is not a virgin. But someone will be given the secret, and they will notify this person by singing their song. The Bear helps the youth to his feet, and when he opens his eyes, there is nobody there: only a circle of tracks. It is dawn. He goes back to his people. . . .

EDMUND WILSON (1895–1972), United States

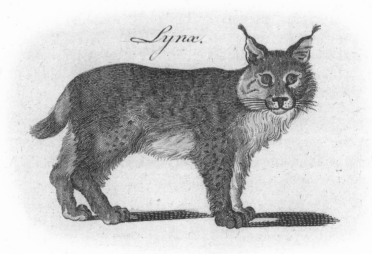

Lynx, artist unknown (19th century)

FROM BARBARIAN IN THE GARDEN

SOUTHERN FRANCE and northern Spain were the territories
where the new conqueror, *Homo sapiens*, created a civilization
later called the Franco-Cantabrian culture. It developed in the
early Palaeolithic, also named the 'reindeer' era. From the
mid-Palaeolithic the environment of Lascaux became a real
Promised Land, flowing not so much with milk and mead as
with the hot blood of animals. Like cities that later grew near
the trade routes, the stone-age settlements were founded on
the tracks of migrating animals. Every spring, herds of rein-
deer, wild horses, cows, bulls, bison and rhinoceri crossed this
territory to the green pastures of the Auvergne. The mysteri-
ous regularity and the blessed lack of memory in the animals,
who yearly followed the same trail to certain death, was as
miraculous for Palaeolithic man as the Nile floods for the
Egyptians. A powerful supplication for the eternal preser-
vation of the natural order can be read from the walls of
Lascaux. That is probably why the cave painters are the
greatest animal artists in history. Unlike the Dutch masters,
an animal for them was not an element in a tame landscape

Hand stencil, Chauvet, France

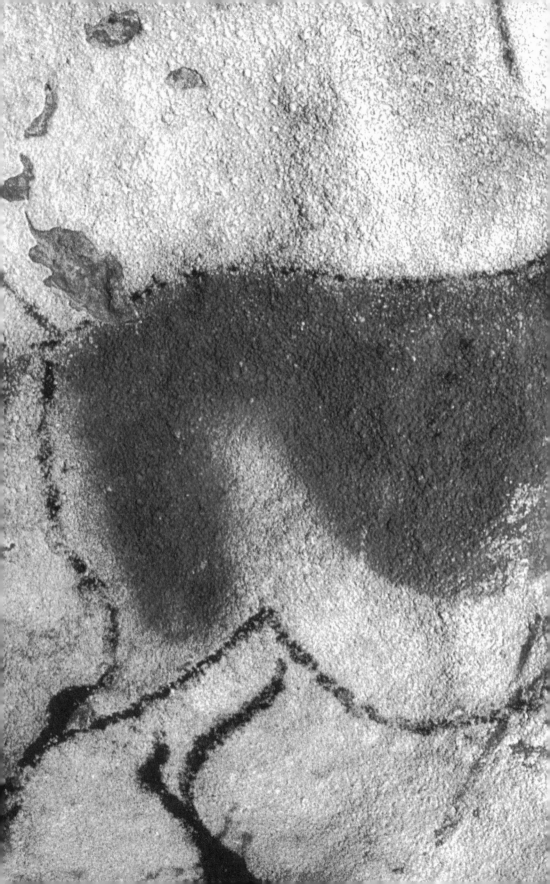

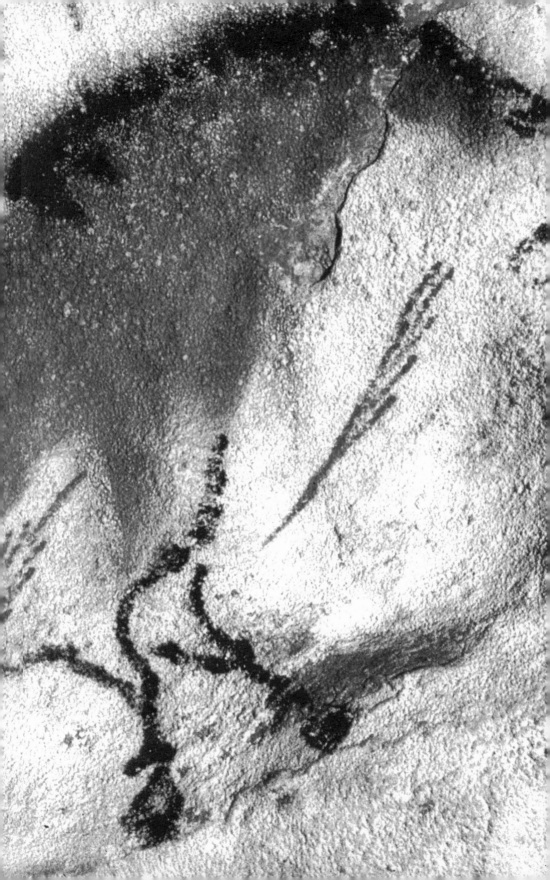

in pastoral Arcadia; they saw it in a flash, in dramatic flight, alive but marked for death. Their eye did not contemplate the object but fettered it in its outline with the precision of the perfect murderer. The first room was probably the site of hunting rituals. (They came here with stone cressets for their guttural rites.) It takes its name from four huge bulls, the largest being more than five metres long; these magnificent animals dominate a herd of horse-shapes and fragile deer. Their stampede blasts the cave; condensed, the harsh breathing in their inflated nostrils. The room leads into a blind, narrow corridor. *'L'heureux desordre des figures'* reigns. Red cows, small childish horses and bucks dance disarranged in all directions. A horse on its back, his hooves stretched towards the limestone sky, gives evidence of a pursuit still practised by primitive hunting tribes: animals are driven with fire and loud noise towards a high cliff and topple to their deaths. One of the most beautiful animal portraits in history is called the 'Chinese Horse'. The name does not signify its race: it is a homage to the perfection of the drawing of the Lascaux master. A soft black contour, at once distinct and vanishing, both contains and shapes the body's mass. A short mane, like that of a circus horse, impetuous, with thundering hooves. Ochre does not fill the body; the belly and legs are white.

I realize that all descriptions, all inventories are useless in the presence of this masterpiece, which displays such a blinding, obvious unity. Only poetry and fairy-tales possess the power of instant creation. One should say, 'Once upon a time, there was a beautiful horse from Lascaux.'

PREVIOUS PAGES: Chinese horse, Lascaux, France

34

How to reconcile this refined art with the brutal practices of the prehistoric hunters? How to consent to the arrows piercing the flesh of an animal, an imaginary murder committed by the artist? Before the revolution, hunting tribes from Siberia lived in conditions similar to those of the 'reindeer' era. Lot-Falck in *Les rites de chasse chez les peuples siberiens* writes: 'A hunter treated an animal as a creature at least equal to himself. Noting that an animal must hunt, like himself, in order to live, man thought that it had the same model of social organization. Man's superiority was manifest in the field of technology through his use of tools. In the sphere of magic, the animal was attributed with equal powers. Its physical strength, swiftness and perfected senses gave the animal a superiority highly praised by hunters. In the spiritual realm animals were credited with even greater virtues—a closer contact with the divine and with the forces of nature, which they embodied.' So far, we understand. The abyss of palaeo-psychology begins with the bond between the killer and his victim: 'The death of the animal depends, to some extent, on the animal itself; it must consent to be killed by entering into a relationship with its murderer. That is why the hunter cares for the animal and tries to establish a close union. If the reindeer does not love its hunter, it will not bow to its death.' Thus, our original sin and power are hypocritical. Only insatiable, murderous love explains the charm of the Lascaux bestiary.

ZBIGNIEW HERBERT (1924–1998), Poland

NATURE WILL INSTRUCT YOU

IF YOU DO NOT KNOW how to die, never trouble yourself; nature will in a moment fully and sufficiently instruct you; she will exactly do that business for you, take no care for it.

MICHEL DE MONTAIGNE (1533–1592), France

Grey Fox,
J.J. Audubon (1785–1851),
Haiti/United States

White Bushman

I REMEMBER, it came when I was in Africa making a film with a rhinoceros. I had noticed that in Africa many animals, when they get really old, go away on their own. I know that the common theory is that it is an evolutionary design to make quite certain that the herd is kept and bred by what is young, strong and brave. And the young bulls come and throw the old people out. Well, of course, there is rivalry among all animals in the mating season. They fight for the female, because there are more men around than are necessary. The bull has to fight for the right to procreate; and of course the older they become, the fewer their chances. But they are never more than pushed away from the women. They do not get chased out of the herd altogether.

So you sometimes see an elephant or a rhinoceros on its own who is kept away—miles from anyone. You might see a wildebeest or a buffalo, or a hartebeest or lion on his own. And lions do not grow quite as old as they could sometimes, because they have such problems in finding food in old age. For me, it's almost a religious pattern. It is almost as if when an animal has lived its life, has done his duty as a young animal and bull in protecting the herd, there comes a moment when

he feels he must do something in nature that he has to seek, find and experience on his own. They are what I call 'Sanyassin', after the name conferred in India on the men who renounce the world and all their possessions and take to the road on a great walkabout in search of resolution and holiness.

You pause as if you have something else in your mind.

As I came to the word *Sanyassin* I had a recollection, bright and electric as if it were lightning, of an old Kalahari lion I had once known over a period of days. There were, perhaps, somewhere over the horizon, other lions. It was lion country but I never saw any for days except this one, still great in his old age, a thick Titian red mane thrown almost nonchalantly over his tawny shoulder and every reason to walk in pride. And yet his bearing was without arrogance and his carriage of a certain dignity of profound meditation, and the last time I saw him was as he went over a yellow sand-dune and down behind it, and so into the heart of one of those deep mythological African sunsets we have talked about. Somehow he was heraldic for *Sanyassin*. Then in another place and another time I also met the rhinoceros *Sanyassin*.

How strange indeed . . . Of all the animal stories you know, which one has meant the most to you?

It will have to be about elephants—one of many, and I shall have to abbreviate it or I could be about it all day. It begins with the appearance on the rim of a blue day in Kenya of some bull elephants walking in single file across a great plain, not as elephants usually do but indifferent to all about them, as if something invisible ahead were drawing them. They did so for some three hours and there was nothing to explain their

Lion, William Home Lizars (1788–1859), England

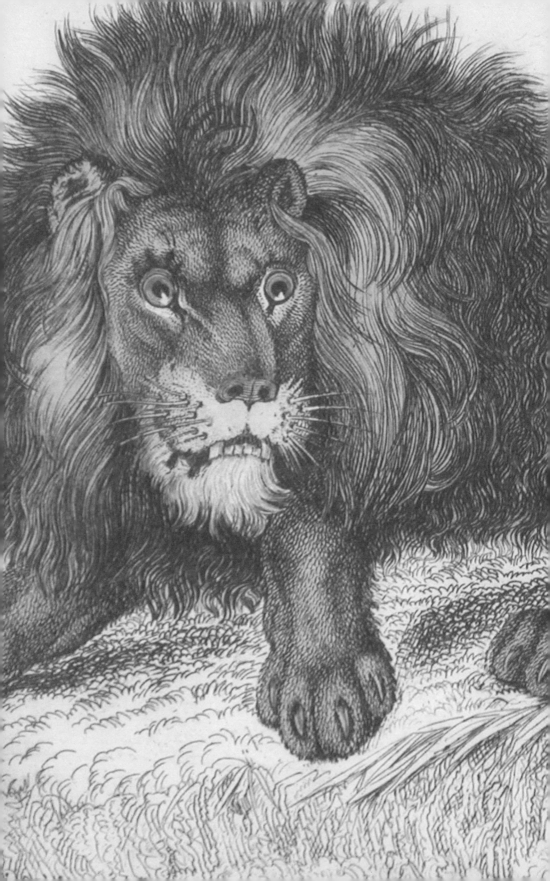

strange compulsive march, until a clump of trees and bushes appeared like an oasis in that waste of land. Then came an inkling of what it was all about. A ring of lions was slowly tightening round that circle of bush, but a tall manly bull, in the lead, walked straight through the pride of lion, vanished into the bush and some time later walked out of the bush with an elephant cow and her newly born calf, between them.

Oh . . .

Yes, the bulls took the cow and the calf into their keeping and they went off, without a backward glance. Now, how had they known?

LAURENS VAN DER POST (1906–1996), South Africa

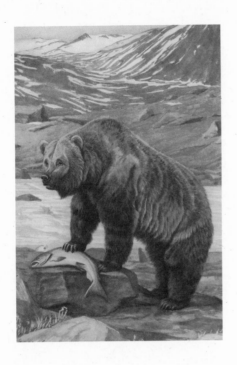

THIS POEM IS FOR BEAR

"As for me I am a child of the god of the mountains."

A bear down under the cliff.
She is eating huckleberries.
They are ripe now
Soon it will snow, and she
Or maybe he, will crawl into a hole
And sleep. You can see
Huckleberries in bearshit if you
Look, this time of year
If I sneak up on the bear
It will grunt and run

Alaska Brown Bear, Louis Agassiz Fuertes (1874–1927), United States

The others had all gone down
From the blackberry brambles, but one girl
Spilled her basket, and was picking up her
Berries in the dark.
A tall man stood in the shadow, took her arm,
Led her to his home. He was a bear.
In a house under the mountain
She gave birth to slick dark children
With sharp teeth, and lived in the hollow
Mountain many years.

 snare a bear: call him out:
honey-eater
forest apple
light-foot
Old man in the fur coat, Bear! come out!
Die of your own choice!
Grandfather black-food!
 this girl married a bear
Who rules in the mountains, Bear!
 you have eaten many berries
 you have caught many fish
 you have frightened many people

Twelve species north of Mexico
Sucking their paws in the long winter
Tearing the high-strung caches down
Whining, crying, jacking off
(Odysseus was a bear)

Bear-cubs gnawing the soft tits
Teeth gritted, eyes screwed tight
 but she let them.
Til her brothers found the place
Chased her husband up the gorge
Cornered him in the rocks.
Song of the snared bear:
 "Give me my belt.
 "I am near death.
 "I came from the mountain caves
 "At the headwaters,
 "The small streams there
 "Are all dried up.

—I think I'll go hunt bears.
 "hunt bears?
Why shit Snyder.
You couldn't hit a bear in the ass
 with a handful of rice!"

GARY SNYDER (1930–), United States

43

God Bless the Bear

How many of them die of old age?
They die of the tension of not knowing,
the apprehension.
 Fear sits in their guts,
thus the courage, the quickness, the shyness
of a deer asking Are you my death? The gopher
taking one last look. I want to know
what my death looks like
no matter how fast it comes.

Or the bear. God bless the bear,
arthritic as me, doing its death-clown act
on two legs, ready to embrace, saying
I'm just you in funny clothes.
Your clothes are funny too. Let's wrestle,
my little man, my little son, my little death, my brother.

John Newlove (1938–2003), Canada

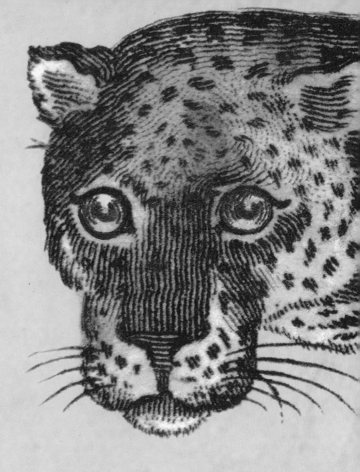

Netted Together

IF WE CHOSE TO LET CONJECTURE run wild, then animals, our fellow brethren in pain, diseases, death, suffering, and famine—our slaves in the most laborious works, our companions in our amusements—they may partake (of) our origins in one common ancestor—we may be all netted together.

CHARLES DARWIN (1809–1882), England

Leopard, artist unknown (19th century)

Finally, before setting out, all gnawed skulls of seals
caught from the site to be abandoned must be set out on
the ice a little way from the house. The same is done
with caribou recently shot. The heads must always face
in the direction in which the party is setting out. The
souls of the animals slain will then follow the same
course, and good hunting will result.

KNUD RASMUSSEN

2 —

DIET OF SOULS

"Take, eat; this is my body"

Calling the Animal Spirits, Simon Tookoome, Inuit (1934–), Canada

Take, eat; this is my body.

MATTHEW 26:26

A WIDE VARIETY OF CEREMONIAL BEHAVIOUR has always been associated with our human giving and taking of food, and it still is. From communion wafers and the saying of grace, to the turkey, goose or big joint of meat that takes its place at the heart of celebratory or official dinners, food carries substantial symbolic weight. In every culture, specific foods are forbidden while others are blessed. Guests are traditionally seated according to their perceived importance, and it is generally the erstwhile Hunter who carves the joint with a Big Knife at the head of the table, while the erstwhile gatherer serves vegetables at the other end. Even the traditional two or three vegetables that accompany the meat broadly reflects the ratio between the plant and animal kingdoms that typified the diet of our gathering and hunting forebears.

Although gathered foods, such as roots, leaves and nuts, made up more than two-thirds of a hunter-gatherer's diet, it was meat they celebrated—as do we. Even chimpanzees treat scraps of meat with a collective enthusiasm that seems out of all proportion to its volume or value. In light of this almost universal respect for flesh, it is appropriate that God would prefer Abel's gift of meat to Cain's

"fruit of the ground," for which the Lord "had not respect."

In the early days of sacrifice, there were few who would have hoped for success if they'd appealed to their deity with the sacrifice of a rutabaga or a bunch of celery, instead of the usual goat, bullock or eldest son. Like the Aztecs, the gods, it was believed, wanted a heart to stop beating.

Nowhere does the significance of meat become more highly charged than it does in the act of cannibalism. At various times and places throughout history, we humans have ritually eaten portions of enemy warriors—as an act of sympathetic magic—in order to partake of their strength and courage, much as others still eat tiger penises to enhance their virility. The eating of a victim's body by a group can also be a fierce way of sharing responsibility for the murder. In a "divine frenzy" the worshippers of Bacchus would dismember and devour their god. Other serial ritual killers, such as the Leopard-men in Africa who dispatched their victims with steel claws in the dead of night, were imitating leopards or jaguars in order to gain something of the sacred animal's magic.

AT THE SAME TIME, the apparent magical ability of some animals is genuinely moving. Standing alone on the top deck of a ship in Hudson Straight, with an easterly gale powering in just off the port bow, I noticed two Northern fulmars—marvellous gull-like birds of the open oceans. They were hanging motionless in the air eighty yards behind us. I watched them in my binoculars for ten minutes as they overtook the ship without a single flap of their wings. Arriving by the stern they noticed me, and imperceptibly changed course until they were twenty feet above my head. Side by side, they turned their faces down to look at me with dark eyes. Although their wings hadn't noticeably shifted at any point, I could now see that despite the apparent calm of their flight, their feathers were in constant

motion. Whether or not it was simply the power of the wind I do not know. Eventually, with their curiosity satisfied, they faced once more into the gale and sailed effortlessly on, leaving us ponderously behind. All this while the ship bucked and vibrated with the power of the great engines needed to drive us through the rising sea.

I HAVE KILLED FISH and various domestic animals, but only for our own table, and have had cattle slaughtered for the same reason; since the latter had been given names by my sons, we found ourselves referring with mixed feelings to Mable and Bonnie while admiring the taste and texture of their flesh. We expressed our thanks, of course, because that seemed the least we could do.

Despite this, I have never been a hunter. I went through that stage as a boy, like others my age, when I shot squirrels and rabbits with a Cooey .22 rifle, however that was killing for what we call sport, for fun if you like; I don't believe I was hunting. Having outgrown that, I took up target shooting, first in a club and then in the militia. I became quite good at it—which leads me to an experience that I found revealing.

A particularly devious groundhog had found a way into our vegetable garden and was causing enough damage for us to feel affronted. When everything else had failed we decided that something manly had to be done, so just before dawn I climbed onto our drive-shed roof, which overlooked the garden. The rifle I had was the same model Cooey .22 with which, as a boy, at least once I'd hit a running rabbit. The groundhog dutifully appeared and wriggled through an opening in the fence that appeared far too small for its plump body. It then began munching on our spinach. Taking careful aim, I fired—and missed. The animal paid no attention to the flat report of my gun, or the bullet hitting the soft earth beside it. I fired, and missed again. After a third or fourth failure it became

50

apparent to me that, without recognizing it, I hadn't wanted to kill the creature merely because it was breakfasting in our garden. Its hunger didn't seem a sufficient cause for the death sentence.

The ensuing struggle between our fence-improvement strategies and the groundhog's inventiveness lasted until one morning when our Irish wolfhound ambushed the creature behind the drive-shed. Problem solved, without my agency.

BECAUSE EARLY HUNTERS FEARED the prey's resentful spirit, with its capacity to deny us success in future hunts if we lacked respect, they originally honoured the animal itself by offering elaborate ceremonies as propitiation. Such displays of gratitude put to shame our contemporary indifference to the industrial slaughter of the animals we eat.

As Bruce Trigger tells us in *Handbook of North American Indians*,

After the [Chippewa] hunter had killed the bear, the head, liberally decorated with ribbons and beadwork, was laid out, with the hide, on a mat. A slice of the tongue was hung up for four days. The body was not chopped up but, to show the respect with which it was held, carefully disjointed with a knife. At the feast, although other food was provided, everyone ate some bear meat. Food bears eat, including maple syrup and berries, was laid next to the body. If it was a male, a nicely braided man's costume was placed next to the hide; if a female, a woman's costume. The speaker talked to the bear village, calling attention to the fine treatment accorded this visitor and promising that other bears would be similarly, and respectfully, welcomed. The bones were gathered up and buried, never left lying about.

ONCE WE DISCARDED ANIMAL SPIRITS and adopted anthropomorphic gods, we began to thank them—and, by implication, ourselves—instead of the creatures who gave their lives to feed us. This shift served to depersonalize our relationship with the meat on our plate, in the same way that technology later depersonalized the killing of the living beast.

Now, of course, few of us thank anything or anyone for the gift of our food. Which in the light of industrial agriculture seems appropriate: it would be adding insult to injury to offer thanks to a battery hen or turkey, considering the horrors we've inflicted upon it.

G.G.

Sable Antelope, William Home Lizars (1788–1859), England

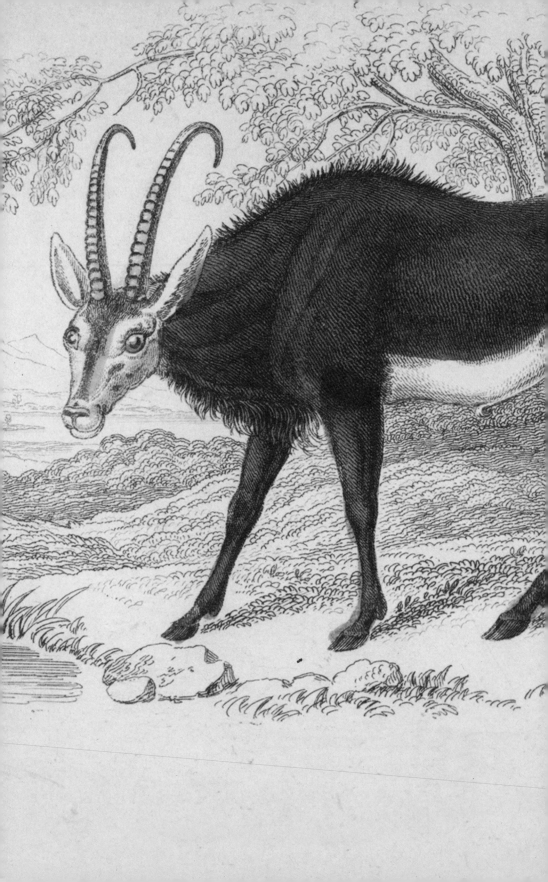

THE GREATEST PERIL

"ALL THE CREATURES that we have to kill and eat, all those that we have to strike down and destroy to make clothes for ourselves, have souls, like we have, souls that do not perish with the body, and which must therefore be propitiated lest they should revenge themselves on us for taking away their bodies."

SPOKEN BY AUA, AN INUIT ELDER
trans. Knud Rasmussen (1879–1933), Denmark/Greenland

Owl and Goose Become Human, Annie Kilabuk Jr. (1932–2005), Nunavut, Canada

54

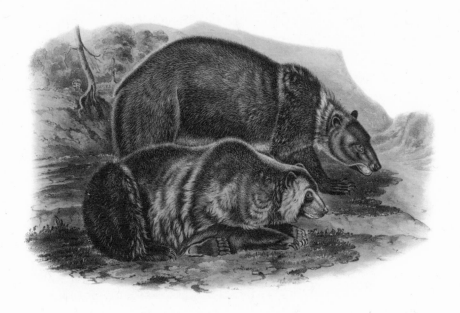

THE BEAR BEING DEAD . . .

ON RETURNING TO THE LODGE, I communicated my discovery; and it was agreed that all the family should go together, in the morning, to assist in cutting down the tree, the girth of which was not less than three fathom. The women, at first, opposed the undertaking, because our axes, being only of a pound and a half weight were not well adapted to so heavy a labour; but, the hope of finding a large bear, and obtaining from its fat a great quantity of oil, an article at the time much wanted, at length prevailed.

Accordingly, in the morning, we surrounded the tree, both men and women, as many at a time as could conveniently work at it; and here we toiled, like beaver, till the sun

Grizzly Bear, J.J. Audubon (1785–1851), Haiti/United States

went down. This day's work carried us about half way through the trunk; and the next morning we renewed the attack, continuing it till about two o'clock, in the afternoon, when the tree fell to the ground. For a few minutes, every thing' remained quiet, and I feared that all our expectations were disappointed; but, as I advanced to the opening, there came out, to the great satisfaction of all our party, a bear of extraordinary size, which, before she had proceeded many yards, I shot.

The bear being dead, all my assistants approached, and all, but more particularly my old mother (as I was wont to call her), took his head in their hands, stroking and kissing it several times; begging a thousand pardons for taking away her life; calling her their relation and grandmother; and requesting her not to lay the fault upon them, since it was truly an Englishman that had put her to death.

This ceremony was not of long duration; and if it was I that killed their grandmother, they were not themselves behind-hand in what remained to be performed. The skin being taken off, we found the fat in several places six inches deep. This, being divided into two parts, loaded two persons; and the flesh parts, were as much as four persons could carry. In all, the carcass must have exceeded five hundred weight.

As soon as we reached the lodge, the bear's head was adorned with all the trinkets in the possession of the family, such as silver arm-bands and wrist-bands, and belts of wampum; and then laid upon a scaffold, set up for its reception, within the lodge. Near the nose, was placed a large quantity of tobacco. The next morning no sooner appeared, than preparations were made for a feast to the manes. The lodge was cleaned and swept; and the head of the bear lifted up and

a new stroud blanket, which had never been used before, spread under it. The pipes were now lit: and Wawatam blew tobacco-smoke into the nostrils of the bear, telling me to do the same, and thus appease the anger of the bear, on account of my having killed her. I endeavoured to persuade my bene-factor and friendly adviser, that she no longer had any life, and assured him that I was under no apprehension from her displeasure; but, the first proposition obtained no credit, and the second gave but little satisfaction.

At length, the feast being ready, Wawatam commenced a speech, resembling, in many things, his address to the manes of his relations and departed companions; but, having this peculiarity, that he here deplored the necessity under which men laboured, thus to destroy their *friends*. He represented, however, that the misfortune was unavoidable, since without doing so, they could by no means subsist. The speech ended, we all ate heartily of the bear's flesh; and even the head itself, after remaining three hours on the scaffold, was put into the kettle.

ALEXANDER HENRY (?–1841), England/Canada

GIVING THANKS

. . . A COMMITTED MEAT-EATER may express affection and even gratitude towards his or her prey—a touching and thoroughly appropriate emotion for a creature for whom captured animal protein is the only source of food. Or so that emotion should seem to us, since in many human societies people do exactly the same thing when thanking or venerating an animal who has been killed for food. In a tender scene I happened to witness on the African savannah, a lion and some lionesses were rendering the carcass of a female kudu. The lion took the intact severed head of the kudu between his paws and, holding it upright so that she faced him, slowly licked her cheeks and eyes intimately and tenderly, as if her were grooming her. Rigor mortis had not yet stiffened her muscles—under his tongue her eyelids opened and shut in a lifelike manner. An infant lion pushed up under his father's elbow and helped to wash the kudu's face.

Even more touching was a scene that aired on public television several years ago. Shot through such a long telephoto lens that the image appears flat and blue with distance, the film shows a large male puma who evidently has just killed a large male bighorn sheep. The sheep is lying dead on his left side. The puma lies down full length on his right side, face to face with the sheep, gazes fondly into the sheep's eyes for a moment, then reaches out his paw and tenderly pats the sheep's face as a kitten might its mother.

ELIZABETH MARSHALL THOMAS (1931–),
United States

58

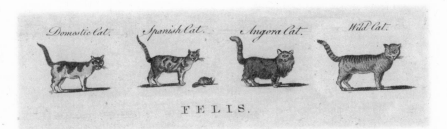

Domestic Cat. Spanish Cat. Angora Cat. Wild Cat.

FELIS.

DINNER IS SERVED

THE GREEKS ALSO KNEW the carving of a whole sacrificed animal, skinned and roasted, before the assembled company of diners. Here the group was clearly ranked according to the pieces allotted; these kept their whole original shape rather than being cut into collops. An especially good piece, such as a large chine of pork, was a geras, or gift denoting honour. The privilege represented by a piece of meat was expressed by the superiority in tenderness and savour of the portion, its size, or its singularity. (The viscera were prized for existing in smaller quantity than the rest of the meat, and also because there is only one heart and one liver; each of these could be presented to someone as a special privilege.)

The ancient Greek word for "fate," *moira*, means literally a portion, a piece of meat from the ritually sacrificed animal. This serving expressed the recipient's honour among the assembled guests, their estimation of him: it amounted symbolically to what we still call his "lot" or his "portion" in life,

Felis, artist unknown (19th century)

59

his "slice of the pie." A *moira*, as portion of a whole, could also be a piece of land, or a section of the universe. When the three eldest brothers, the greatest of the Olympian gods, drew lots for the three main divisions of the world, Zeus received the heavens, Poseidon the sea, and Hades the Underworld (Earth was herself a goddess, or, belonging to Gaia, was a portion already "served"). A shared sacrificial meal was a *dais* or "division," from the verb "to cut up"; it is meat which informs the metaphor. The distribution of meat, at a civilized meal or dais, was supposed always to be "equal." This meant either that everyone received the same amount (an egalitarian arrangement), or that everyone's part was equal to what he deserved (which is hierarchical or meritocratic). Both points of view might be expressed in the same meal, as we have seen, by the exclusive allocation of the "innards" to a privileged group, as opposed to the equal sharing of the "meat." The slight to one's honour which could be suffered through getting a portion of meat beneath one's due can be represented by the rage of Heracles when, after the completion of his Labours, he was invited to dinner but served a "lower" helping of meat than those given to the three sons of his tormentor, Eurystheus. He slew them all.

MARGARET VISSER (1940–), South Africa / Canada

60

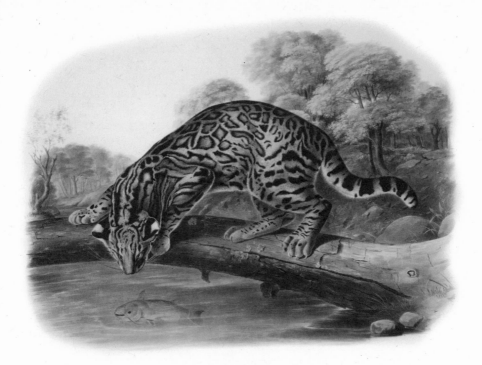

THE TROUT

Flat on the bank I parted
Rushes to ease my hands
In the water without a ripple
And tilt them slowly downstream
To where he lay, tendril light,
In his fluid sensual dream.

Bodiless lord of creation
I hung briefly above him
Savouring my own absence
Senses expanding in the slow
Motion, the photographic calm
That grows before action.

Ocelot, J.J. Audubon (1785–1851), Haiti / United States

As the curve of my hands
Swung under his body
He surged, with visible pleasure.
I was so preternatually close
I could count every stipple
But still cast no shadow, until

The two palms crossed in a cage
Under the lightly pulsing gills.
Then (entering my own enlarged
Shape, which rode on the water)
I gripped. To this day I can
Taste his terror on my hands.

JOHN MONTAGUE (1929–), Ireland

THE BEARS OF MT. NAMETOKO

KOJURO WAS SQUELCHING HIS WAY UP a valley and had climbed onto a rock to look about him when he saw a large bear, its back hunched, clambering like a cat up a tree directly in front of him. Immediately, Kojuro levelled his gun. The dog, delighted, was already at the foot of the tree, rushing round and round it madly. But the bear, who for a while seemed to be debating whether he should come down and set on Kojuro or let himself be shot where he was, suddenly let go with his paws and came crashing down to the ground. Immediately on his guard, Kojuro put his gun to his shoulder and went closer as though to shoot. But at this point the bear put up its paws and shouted, "What are you after? Why do you have to shoot me?"

"For nothing but your fur and your liver," said Kojuro. "Not that I shall get any great sum for them when I take them to town. I'm very sorry for you, but it just can't be helped. But when I hear you say that kind of thing, I almost feel I'd rather live on chestnuts and ferns and the like, even if it killed me."

Japanese Brown Bear, artist unknown

"Won't you wait two more years? For myself, I don't care whether I die or not, but there are still things I must do, so wait just two years. When two years are up, you'll find me dead in front of your house without fail. You can have my fur and my insides too."

Filled with an odd emotion, Kojuro stood quite still, thinking.

The bear got its four paws firmly on the ground and began, ever so slowly, to walk. But still Kojuro went on standing there, staring vacantly in front of him. Slowly, the bear walked away without looking back, as though it knew very well that Kojuro would never let fly suddenly from behind. For a moment, its broad, brownish black back shone bright in the sunlight falling through the branches of the trees, and at that same moment Kojuro gave painful groan and, crossing the valley, made for home.

It was just two years later. One morning, the wind blew so fiercely that Kojuro, sure that it was blowing down trees and hedge and all, went outside to see. The cypress hedge was standing untouched, but at its foot there lay something brownish black that he had seen before. His heart gave a turn, for it was just two years, and he had been feeling worried in case the bear should come along. He went up to it, and found the bear he had met that day, lying there as it had promised, dead, in a great pool of blood that had gushed from its mouth. Almost unconsciously, Kojuro pressed his hands together in prayer.

KENJI MIYAZAWA (1896–1933), Japan

64

CURIOSITY IN ANIMALS

YES, SAHIB, panthers are very bold and very cunning. Have you ever seen one catch a monkey? No. Well, I will tell you what four or five men of my village and I saw in the patch of jungle you beat through yesterday. We had been ploughing since dawn and sat down to rest under the big mango tree. There were some brown monkeys feeding quietly in the trees near by, and suddenly one of them gave the usual sharp alarm call. We then heard the grunt of a charging panther, and saw a big one rush half-way up one of the smaller trees and then down again as the monkeys left it for the safety of the large jamun. He then charged over to the foot of the jamun and

Pair of Leopards, artist unknown (mid-16th century), Benin

scratched up the grass and leaves round its roots. The excitement among the monkeys was now tremendous and they leapt about the branches in an agitated way, which was just what the panther expected and wanted. Had a monkey missed his hold or had a branch broken under one of them, the panther would have had his meal. But his luck was out and in a short time we saw him stretch himself out on the ground a few feet away from the tree and apparently go to sleep. The monkeys soon quieted down and we could see them looking down at the panther with the greatest interest. After a little while one of the bigger ones climbed right over him and began to drop leaves and twigs on to him; but still there was no sign of movement. The other monkeys then began collecting closer and closer above him, and it was obvious that they couldn't understand what had happened. One then climbed down a tree a short distance away and took a few steps towards the panther, but his nerve failed him and he dashed back to safety. There was still no movement from the panther, however, and soon three or four monkeys were on the ground, taking good care to keep well out of reach of claws and teeth. This continued for nearly half-an-hour, the monkeys drawing nearer and nearer, until at last one, bolder than the rest, actually touched the panther with his hand. This was what the patient hunter had been waiting for; he struck immediately and, seizing the inquisitive monkey, he quietly carried his victim away to the patch of thick thorn out of which the pig broke yesterday. That, Sahib, shows the cunning and the patience of a panther when he is hungry, and how the inquisitiveness of monkeys can lead them to their destruction.

F.W. CHAMPION (?–1970), England

Laws of the Mystery

O wonderful! O wonderful! O wonderful!
I am food! I am food! I am food!
I eat food! I eat food! I eat food!
My name never dies, never dies, never dies!
I was born first in the first of the worlds,
 Earlier than the gods, in the belly of what has no death!
Whoever gives me away has helped me the most!
I, who am food, eat the eater of food!
I have overcome this world!

He who knows this shines like the sun.
Such are the laws of the mystery!

 from Taittir`Iya Upanishad,
 author and translator unknown, India

Le Céraste, artist unknown (c.1860)

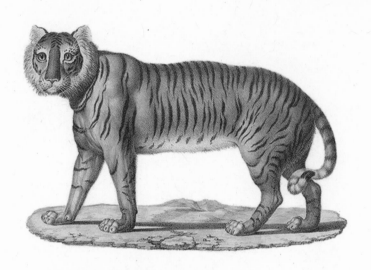

THE CHAMPAWAT MAN-EATER

THE ROAD FOR A FEW MILES on this side of Champawat runs along the south face of the hill, parallel to and about fifty yards above the valley. Two months ago a party of twenty of us men were on our way to the bazaar at Champawat, and, as we were going along this length of the road at about midday, we were startled by hearing the agonized cries of a human being coming from the valley below. Huddled together on the edge of the road we cowered in fright as these cries drew nearer and nearer, and presently into view came a tiger, carrying a naked woman. The woman's hair was trailing on the ground on one side of the tiger, and her feet on the other— the tiger was holding her by the small of the back and she was beating her chest and calling alternately on God and man to help her. Fifty yards from, and in clear view of the tiger passed with its burden, and when the cries had died away in the distance we continued on our way.

Royal Tiger, Karl Joseph Brodtmann (1787–1862), Switzerland

'And you twenty men did nothing?'

'No, sahib, we did nothing for we were afraid, and what can men do when they are afraid? And further, even if we had been able to rescue the woman without angering the tiger and bringing misfortune on ourselves, it would have availed the woman nothing, for she was covered with blood and would of a surety have died of her wounds.'

I subsequently learned that the victim belonged to a village near Champawat, and that she had been carried off by the tiger while collecting dry sticks. Her companions had run back to the village and raised an alarm, and just as a rescue party was starting the twenty frightened men arrived. As these men knew the direction in which the tiger had gone with its victim, they joined the party, and can best carry on the story.

'We were fifty or sixty strong when we set out to rescue the woman, and several of the party were armed with guns. A furlong from where the sticks collected by the woman were lying, and from where she had been carried off, we found her torn clothes. Thereafter the men started beating their drums and firing off their guns, and in this way we proceeded for more than a mile right up to the head of the valley, where we found the woman, who was little more than a girl, lying dead on a great slab of rock. Beyond licking off all the blood and making her body clean the tiger had not touched her, and, there being no woman in our party, we men averted our faces as we wrapped her body in the loincloths which one and another gave, for she looked as she lay on her back as one who sleeps, and would waken in shame when touched.'

JIM CORBETT (1875–1955), India

They Solemnly Beg his Pardon

The Indians have a very fanciful mythology, which would make exquisite machinery for poetry. It is quite distinct from the polytheism of the Greeks. The Greek mythology personified all nature, and materialized all abstractions: the Indians spiritualized all nature. They do not indeed place dryads and fauns in their woods, nor naiads in their streams; but every tree has a spirit; every rock, every river, every star that glistens, every wind that breathes, has a spirit; everything they cannot comprehend is a spirit; this is the resolution of every mystery, or rather makes everything around them a mystery as great as the blending of soul and body in humanity. A watch, a compass, a gun, have each their spirit. The thunder is an angry spirit; the aurora borealis, dancing and rejoicing spirits; the milky way is the path of spirits. Birds, perhaps from their aerial movements, they consider as in some way particularly connected with the invisible world of spirits. Not only all animals have souls, but it is the settled belief of the Chippewa Indians that their souls will fare better in another world, in the precise ratio that their lives and enjoyments are curtailed in this; hence they have no remorse in hunting, but when they have killed a bear or rattle-snake, they solemnly beg his pardon, and excuse themselves on the plea of necessity.

Anna Jameson (1794–1860), England

Chippewa Indians at Lake Superior (detail), Cornelius Kreighoff (1815–1872), Netherlands/Canada

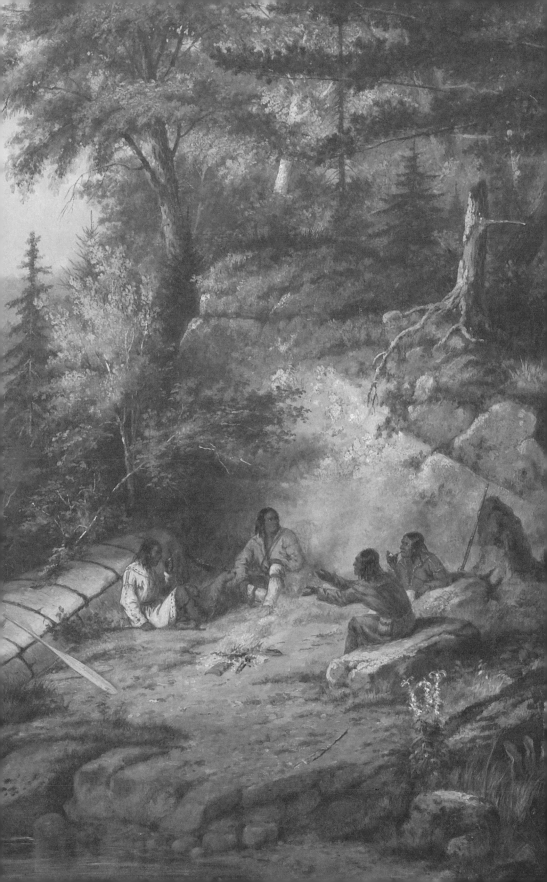

L. D. Luard

The Spirit of 1943

Eating the Heart of a Wolf

IN LAOS WHEN AN ELEPHANT HUNTER is starting for the chase, he warns his wife not to cut her hair or oil her body in his absence; for if she cut her hair the elephant would burst the toils, if she oiled herself it would slip through them. When a Dyak village has turned out to hunt wild pigs in the jungle, the people who stay at home may not touch oil or water with their hands during the absence of their friends; for if they did so, the hunters would all be "butter-fingered" and the prey would slip through their hands.

Elephant-hunters in East Africa believe that, if their wives prove unfaithful in their absence, this gives the elephant power over his pursuer, who will accordingly be killed or severely wounded. Hence if a hunter hears of his wife's misconduct, he abandons the chase and returns home. If a Wagogo hunter is unsuccessful, or is attacked by a lion, he attributes it to his wife's misbehaviour at home, and returns to her in great wrath.

The Spirit of 1943, Lowes Dalbac Luard (1872–1944), England

. . . The Miris of Assam prize tiger's flesh as food for men; it gives them strength and courage. But "it is not suited for women; it would make them too strong-minded." In Corea the bones of tigers fetch a higher price than those of leopards as a means of inspiring courage. A Chinaman in Seoul bought and ate a whole tiger to make himself brave and fierce. In Norse legend, Ingiald, son of King Aunund, was timid in his youth, but after eating the heart of a wolf he became very bold; Hialto gained strength and courage by eating the heart of a bear and drinking its blood.

SIR JAMES FRAZER (1854–1941), England

Sea-Satyr, Conrad Gessner (1516–1565), Switzerland

The Owl Speaks . . .

In the old days when I spoke, it was like a voice echoing through a hollow bow-handle . . . But now I am old and feeble.

'I want a messenger,' I said, 'a bold and clever speaker to carry my complaints to the Country of Heaven'. Someone entered very quietly and politely, and when I looked, there I saw the young water-ouzel in his god-like beauty, sitting on the seat at the left. Then tapping on the lid of my ironwood locker, I began all night and all day to instruct him about the terms of my complaint . . .

. . . What I had told him to say was to this effect: there is a famine among the people of the world and they are at the point of death. And what is the reason? The gods in the Country of Heaven that have charge of deer, the gods that have charge of fish, have agreed to send no more deer, to send no more fish.

Some days afterwards, I heard a faint noise in the sky, and when I looked, there was the ouzel, more lovely than before, full of dignity and grace, returned from the Country of Heaven to tell me how he delivered my complaint.

'The reason,' he said, 'why the god of the deer and the god of fish in the Country of Heaven are sending no deer and no fish is that when men took deer they beat them over the head with a stick, flayed them, and without more ado threw the

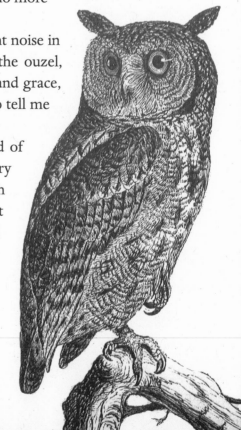

Screech Owl, Thomas McIlwraith (1824–1903), Scotland / Canada

head away into the woods; and when they caught fish, they hit them over the head with a piece of rotten wood. The deer, weeping bitterly, went to the god of the deer, and the fish with the rotten stick in their mouths went to the god of the fish. These two gods, very angry . . . agreed to send no more deer, no more fish. But if men would promise to treat the deer they take with courtesy, and the fish they catch with courtesy, the gods will send them deer and fish.'

So I visited men in their dreams when they were asleep and taught them never again to do such things. Then they saw that it was bad to do as they had done. They decked out the heads of the deer daintily, and made offerings before them. Henceforward the fish came happy and proud to the god of fish . . . and the deer came happy to make report to the god of deer. The gods of deer and fish were pleased, and sent plenty of fish, plenty of deer.

An Ainu Story, Japan
trans. Arthur Waley (1889–1966), England

OPPOSITE: Hunting lodge fresco (15th century), Italy

THE BEAR ON THE DELHI ROAD

Unreal tall as a myth
by the road the Himalayan bear
is beating the brilliant air
with his crooked arms
About him two men bare
Spindly as locusts leap

One pulls on a ring
in the great soft nose His mate
flicks flicks with a stick
up at the rolling eyes

They have not led him here
Down from the fabulous hills
to this bald alien plain
and the clamorous world to kill
but simply to teach him to dance

They are peaceful both these spare
men of Kashmir and the bear
alive is their living too
If far on the Delhi way
around him galvanic they dance
it is merely to wear wear
from his shaggy body the tranced
wish forever to stay
only an ambling bear
four-footed in berries

It is no more joyous for them
in this hot dust to prance
out of reach of the praying claws
sharpened to paw for ants
in the shadows of deodars
It is not easy to free
myth from reality
or rear this fellow up
to lurch lurch with them
in the tranced dancing of men

 EARLE BIRNEY (1904–1995), Canada

Is God Just to His Creatures?

MOODIE SHOOK HANDS with the old hunter, and assured him that we should always be glad to see him. After this invitation, Brian became a frequent guest. He would sit and listen with delight to Moodie while he described to him elephant-hunting at the Cape; grasping his rifle in a determined manner, and whistling an encouraging air to his dogs. I asked him one evening what made him so fond of hunting.

"'Tis the excitement," he said; "it drowns thought, and I love to be alone. I am sorry for the creatures, too, for they are free and happy; yet I am led by an instinct I cannot restrain to kill them. Sometimes the sight of their dying agonies recalls painful feelings; and then I lay aside the gun, and do not hunt for days. But 'tis fine to be alone with God in the great woods—to watch the sunbeams stealing through the thick

OVERLEAF: *Black-tailed Deer*, Louis Agassiz Fuertes (1874–1927), United States

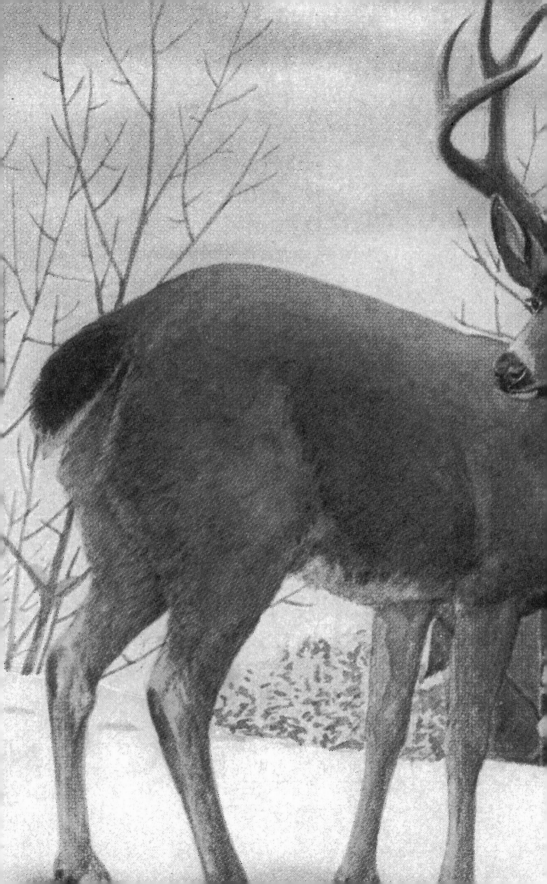

branches, the blue sky breaking in upon you in patches, and to know that all is bright and shiny above you, in spite of the gloom that surrounds you!"

After a long pause, he continued, with much solemn feeling in his look and tone, "I lived a life of folly for years, for I was respectably born and educated, and had seen something of the world, perhaps more than was good, before I left home for the woods; and from the teaching I had received from kind relatives and parents I should have known how to have conducted myself better. But, madam, if we associate long with the depraved and ignorant, we learn to become even worse than they are. I felt deeply my degradation—felt that I had become the slave to low vice; and in order to emancipate myself from the hateful tyranny of evil passions, I did a very rash and foolish thing. I need not mention the manner in which I transgressed God's holy laws; all the neighbours know it, and must have told you long ago. I could have borne reproof, but they turned my sorrow into indecent jests, and, unable to bear their coarse ridicule, I made companions of my dogs and gun, and went forth into the wilderness. Hunting became a habit. I could no longer live without it, and it supplies the stimulant which I lost when I renounced the cursed whiskey bottle.

"I remember the first hunting excursion I took alone in the forest. How sad and gloomy I felt! I thought that there was no creature in the world as miserable as myself. I was tired and hungry, and I sat down upon a fallen tree to rest. All was still as death around me, and I was fast sinking to sleep, when my attention was aroused by a long, wild cry. My dog, for I had not Chance then, and he's no hunter, pricked up his ears, but instead of answering with a bark of defiance, he

crouched down, trembling, at my feet. "What does this mean?" I cried, and I cocked my rifle and sprang upon the log. The sound came nearer upon the wind. It was like the deep baying of a pack of hounds in full cry. Presently a noble deer rushed past me, and fast upon his trail—I see them now, like so many black devils—swept by a pack of ten or fifteen large, fierce wolves, with fiery eyes and bristling hair, and paws that seemed hardly to touch the ground in their eager haste. I thought not of danger, for, with their prey in view, I was safe; but I felt every nerve within me tremble for the fate of the poor deer. The wolves gained upon him at every bound. A close thicket intercepted his path, and, rendered desperate, he turned at bay. His nostrils were dilated, and his eyes seemed to send forth long streams of light. It was wonderful to witness the courage of the beast. How bravely he repelled the attacks of his deadly enemies, how gallantly he tossed them to the right and left, and spurned them from beneath his hoofs; yet all his struggles were useless, and he was quickly overcome and torn to pieces by his ravenous foes. At that moment he seemed more unfortunate even than myself, for I could not see in what manner he had deserved his fate. All his speed and energy, his courage and fortitude, had been exerted in vain. I had tried to destroy myself; but he, with every effort vigorously made for self preservation, was doomed to meet the fate he dreaded! Is God just to his creatures?"

With this sentence on his lips, he started abruptly from his seat and left the house.

Susanna Moodie (1803–1885), England/Canada

Whenever you observe an animal closely, you feel as if
a human being sitting inside were making fun of you.
ELIAS CANETTI

. . . in every story the wolf comes at last.
BEATRICE WEBB

Totem & smoke
Speak to her

In her hair
Rabbit bone
Deer antler
ROBERT FLANAGAN

3 —

BEAUTY AND THE BEAST

Folktales and Parables

Little Red Riding Hood, Gustave Doré (1832–1883), France

When reason turns against the deeper needs of people,
people will turn against reason.
DAVID HUME

HUMANS HAVE A COMPLICATED RELATIONSHIP with all wild animals, and with dominant predators in particular: we fear and revere the latter while envying their strength and grace. We seek to empower kingdoms, nations, professional sports teams, and products such as beer and automobiles by associating them with lions, or sharks, hawks or eagles, bears or tigers; we pulverize their livers and bones, their teeth and genital organs, mixing them into magical or quasi-medicinal potions in the pathetic hope of acquiring some smidgen of their life force.

We also resent such carnivores as competitors for food, and because they occasionally eat commercial domesticates. As pastoralists and sport hunters, we're inclined to kill them when we can. And yet, and yet—we have ceremonially adorned ourselves with their fur, feathers, and body-parts from the earliest of times, and animal dances and masks have played essential parts in our most ancient and powerful rituals.

But ask now the beasts, and they shall teach thee;
And the fowls of the air, and they shall tell thee:
Or speak to the earth, and it shall teach thee;
And the fishes of the sea shall declare unto thee.

<div align="right">Job 12:7–8</div>

There has been a long and dynamic association between the great beasts and our gods, shamans and heroes: Buddha is the Lion of the Shakyas, for example, and Christ the Lion of Judah. Among northern peoples, bears are renowned spirit guides, and the ancestors of humanity. The Celestial Blue Wolf of the Chinese and Mongol dynasties was the mythic ancestor of Genghis Khan. The Malaysian healers said to turn themselves into tigers are only one example of such metamorphoses. As with all symbolic representations, animal-human blends can be either good or wicked, helpful or destructive, or a deceptive mixture of the two.

The figure of Dionysus is among the most mysteriously iconic of these manifestations. Torn from his dying mother's womb, then born from the thigh of Zeus, he was an enchanted figure, one who—"most terrible and most sweet to mortals"—was god of wine and drunkenness, of ritual ecstasy, theatre, and the world of the dead, with its hopes and promises for a sweet hereafter. Able to transcend most boundaries, he transformed himself with ease into lions or roaring bears, and even into vegetation.

The possibility of shape-changing, of souls moving easily between beasts and humans and back again, must have sprung originally from our consciousness of the now almost forgotten beast that dwells within us. The extraordinary psychic power that shamans possessed reflects the intense and deeply affecting relationship we could have with that inner animal. So does our fascination

with stories of werewolves, Wendigos and Yetis, along with a good many horror films featuring semi-human animal monsters such as King Kong and the Creature from the Black Lagoon.

Speaking of wolf-men, as Chevalier and Gheerbrant do in *The Penguin Dictionary of Symbols*, "According to Collin de Plancy, 'Bodin states brazenly that in 1542 one morning a hundred and fifty werewolves were to be seen in a square in Constantinople.'" What were they doing there? What were they wearing? How did people know they were werewolves? We are not told.

WEATHER DEITIES AND ANIMAL SPIRITS prepared the way for our anthropomorphic gods. The more self-conscious and tamed we became, the more we moved towards gods made in our own image: in abandoning the wild, we were leaving behind its more fearsome deities. Nevertheless various animal spirits have accompanied us, if only in domesticated forms. Predatory animals made friendly to us appear in countless children's stories: Aslan the divine lion in C.S. Lewis's *The Lion, the Witch and the Wardrobe* or the cowardly lion in L. Frank Baum's *The Wizard of Oz*; and the lovable bears such as Pooh and Teddy; and the Three Little Pigs and their eventually defeated Big Bad Wolf.

My ardour for a potential girlfriend in junior high school was cruelly dampened when I saw a photograph of her bedroom; it was littered with stuffed bears, giraffes, elephants, cats, more bears and dogs. All of them, of course, were cute, which is to say they were thoroughly domesticated. Perhaps I found that fuzzy menagerie so unsettling because each one seemed to be staring at the camera, as if inviting me to join them.

In "A Biological Homage to Mickey Mouse," Stephen Jay Gould describes how Mickey evolved from the sharp-nosed rodent of *Steamboat Willie* to the shorter-nosed, softer, big-eyed and therefore

childlike creature that our markets prefer. The atavistic mean-eyed rodent certainly would have failed, because as domesticated creatures ourselves, we identify with baby animals.

Domestication causes predictable physical and behavioural changes in animals. In *Nature and Madness*, Paul Shepard provides examples: domesticates are "plumper and more rounded . . . ," more docile, more submissive, far less hardy, and "complex behaviours (such as courtship)" are greatly simplified. The sum effect is arrested development, which is to say that domesticated animals have been infantilized.

What all domesticated animals have in common is dependence. Because wild self-sufficiency has been bred out of them, they must rely on their owners to provide. Tame creatures are also notable for their tendency to miss the signals of impending danger. In southern Ontario we often find white-tailed deer browsing in the same field as cattle. If a blue jay gives its sharp call of alarm, the deer immediately raises its head, fiercely attentive to possible threat, whereas the cow keeps munching placidly away.

Despite our "civilized" condition the unremembered animal past can rise within us, as when we're wakened by the snarls and sharp yips of raccoons in a darkened garden outside the window. There's absolutely no danger, but the sheer animality of those voices threatens us. As Walter Benjamin says, "The horror that stirs deep in man is an obscure awareness that in him something lives so akin to the animal that it might be recognized."

The dreams are true. By no slight effort have we made our way through the marshes. Something unseen has come along with each of us. The reeds sway shut, but not as definitively as we would wish. It is the price one pays for bringing almost the same body through two worlds. The animal's needs are

very old; it must sometimes be coaxed into staying in its new discordant realm.

<div align="right">

Loren Eiseley, *The Invisible Pyramid*

</div>

WE'D PITCHED OUR SMALL TWO-PERSON TENT by the lake, about a hundred yards from the cottage, which was full of relatives and friends. I left the group before my partner, and after watching the night sky over the lake and the darkened forest, I clambered into my sleeping bag and zipped the tent to keep out mosquitoes. Although there'd been reports of bears, I wasn't particularly concerned and was soon asleep—but was brutally awakened by a tearing sound and a quite ferocious noise, followed by my partner's cry of alarm. As my adrenaline level and heart rate subsided, she told me it was I that had snarled. I'd made that sound when she unzipped and opened the tent, with her face not a foot from mine. And it had scared the hell out of her because I'd sounded so bestial.

I wonder if that animal threat would have helped had she in fact been a bear. In the event, I know that I could never intentionally replicate that snarl. It came from somewhere else entirely. Somewhere in the dark, long ago, far away.

<div align="right">

G.G.

</div>

Beauty and the Beast (detail), Henri Rousseau (1844–1910), France

A Little Fable

"Alas," said the mouse, "the whole world is growing smaller every day. At the beginning it was so big that I was afraid, I kept running and running, and I was glad when I saw walls far away to the right and left, but these long walls have narrowed so quickly that I am in the last chamber already, and there in the corner stands the trap that I must run into."

"You only need to change your direction," said the cat, and ate it up.

Franz Kafka (1883–1924), Austria-Hungary

Desert Cat, artist unknown (c.1896)

The Man Who Married
the Bear-Goddess

THERE WAS A VERY POPULOUS VILLAGE. It was a village having both plenty of fish and plenty of venison. It was a place lacking no kind of food. Nevertheless, once upon a time, a famine set in. There was no food, no venison, no fish, nothing to eat at all; there was a famine. So in that populous village all the people died.

Now the village chief was a man who had two children, a boy and a girl. After a time, only those two children remained alive. Now the girl was the older of the two, and the boy was the younger. The girl spoke thus: "As for me, it does not matter even if I do die, since I am a girl. But you, being a boy, can, if you like, take up our father's inheritance. So you should take these things with you, use them to buy food with, eat it, and live." So spoke the girl, and took out a bag made of cloth, and gave it to him.

Then the boy went out on to the sand, and walked along the seashore. When he had walked on the sand for a long time, he saw a pretty little home a short way inland. Near it was lying the carcass of a large whale. The boy went to the house, and after a time entered it. On looking around, he saw a man of divine appearance. The man's wife, too, looked like

a goddess, and was dressed altogether in black raiment. The man was dressed altogether in speckled raiment. The boy went in, and stood by the door. The man said to him: "Welcome to you, whencesoever you may have come," Afterwards a lot of the whale's flesh was boiled, and the boy was feasted on it. But the woman never looked towards him. Then the boy went out and fetched his parcel, which he had left outside. He brought in the bag made of cloth which had been given to him by his sister, and opened its mouth. On taking out and looking at the things inside it, they were found to be very precious treasures. "I will give you these treasures in payment for the food," said the boy, and gave them to that divine-looking man-of-the-house. The god, having looked at them, said: "They are very beautiful treasures." He said again: "You need not have paid me for the food. But I will take these treasures of yours, carry them to my [other] house, and bring you my own treasures in exchange for them. As for this whale's flesh, you can eat as much of it as you like, without payment." Having said this, he went off with the lad's treasures.

Then the lad and the woman remained together. After a time the woman turned to the lad, and said: "You lad! listen to me when I speak. I am the bear-goddess. This husband of mine is the dragon-god. There is no one so jealous as he is. Therefore did I not look towards you, because I knew that he would be jealous if I looked towards you. Those treasures of yours are treasures which even the gods do not possess. It is because he is delighted to get them that he has taken them with him to counterfeit them and bring you mock treasures. So when he shall have brought those treasures and shall display

Polar Bear (detail), J.J. Audubon (1785–1851), Haiti/United States

94

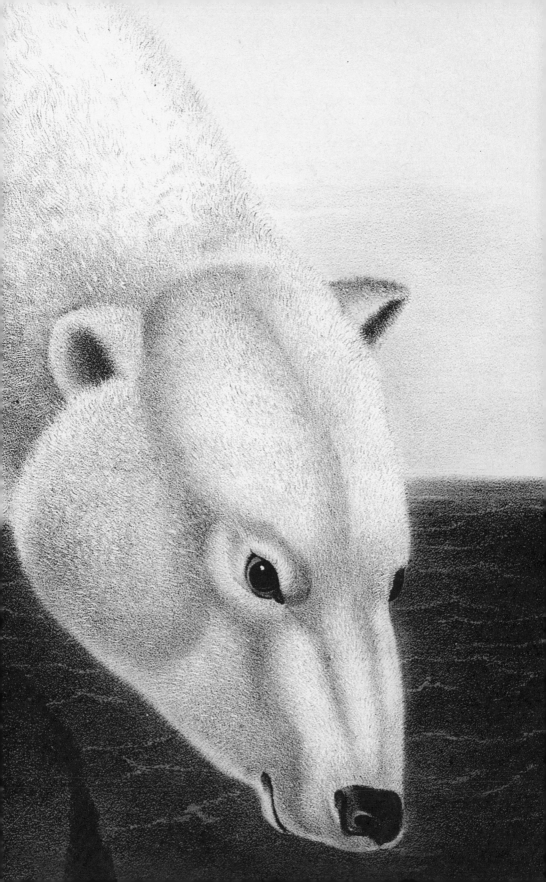

them, you must speak thus: 'We need not exchange treasures. I wish to buy the woman!' If you speak thus, he will go angrily away, because he is such a jealous man. Then afterwards we can marry each other, which will be very pleasant. That is how you must speak." That was what the woman said.

Then, after a certain time, the man of divine appearance came back grinning. He came bringing two sets of treasures, the treasures which were treasures and his own other treasures. The god spoke thus: "You, lad! As I have brought the treasures which are your treasures, it will be well to exchange them for my treasures." The boy spoke thus: "Though I should like to have treasures also, I want your wife even more than I want the treasures; so please give me your wife instead of the treasures." Thus spoke the lad.

He had no sooner uttered the words than he was stunned by a clap of thunder above the house. On looking around him, the house was gone, and only he and the goddess were left together. He came to his senses. The treasures were there also. Then the woman spoke thus: "What has happened is that my dragon-husband has gone away in a rage, and has therefore made this noise, because you and I wish to be together. Now we can live together." Thus spoke the goddess. Afterwards they lived together. This is why the bear is a creature half like a human being.

TOLD BY ISHANASHTE (1886), Ainu
trans. B.H. Chamberlain (1850–1935), England

Gorilla Carrying Off a Woman, Emmanuel Frémiet (1824–1910), France

Coyote Imitates Mountain Lion

Coyote was going along and saw a rock rolling down a hill. It rolled down towards some deer and they jumped. Coyote wondered who was rolling stones down and looked up at the top of the hill. Another stone came rolling down past Coyote toward the deer and the deer jumped again. Then a third stone came down and the deer jumped only a little. They knew it was only a stone.

The next moment another stone came by Coyote. But this was a soft rock. It was Mountain Lion who had rolled himself up like a rock and was rolling down the hill.

"What a funny rock," thought Coyote. "It doesn't make any noise when it rolls."

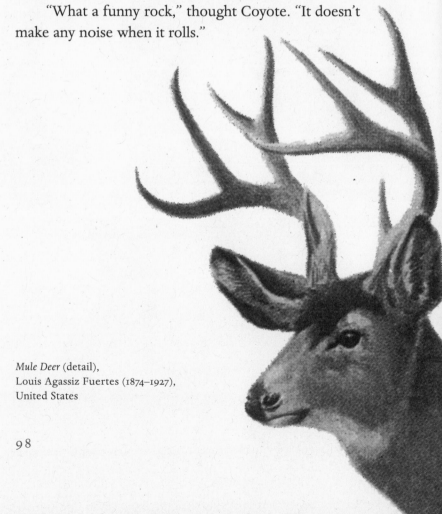

Mule Deer (detail),
Louis Agassiz Fuertes (1874–1927),
United States

Mountain Lion rolled right up to the deer who were not suspicious of the rolling rocks by this time. Then Coyote saw Mountain Lion get up, jump on a big deer and kill it. Mountain Lion picked up the deer and carried it up to a cliff where he could eat it and see the country all around. The rest of the deer ran off around the hill.

Coyote thought this would be a good way to get deer.

He rolled a stone down the hill to where the deer were and they jumped. He rolled another stone and they did not jump as far. When he rolled the third stone they only looked around to see that it was just another stone. Then Coyote rolled himself up in a ball like Mountain Lion and rolled down the hill. When he got there he jumped up and tried to get a deer but he couldn't. He was too dizzy. He just fell over and the deer ran away.

BARRY LOPEZ (1945–), United States

Here Followeth
the Life of S. George Martyr

S. George was a knight and born in Cappadocia. On a time he came in to the province of Libya, to a city which is said Silene. And by this city was a stagne or a pond like a sea, wherein was a dragon which envenomed all the country. And on a time the people were assembled for to slay him, and when they saw him they fled. And when he came nigh the city he venomed the people with his breath, and therefore the people of the city gave to him every day two sheep for to feed him, because he should do no harm to the people, and when the sheep failed there was taken a man and a sheep. Then was an ordinance made in the town that there should be taken the children and young people of them of the town by lot, and every each one as it fell, were he gentle or poor, should be delivered when the lot fell on him or her. So it happed that many of them of the town were then delivered, insomuch that the lot fell upon the king's daughter, whereof the king was sorry, and said unto the people: For the love of the gods take gold and silver and all that I have, and let me have my

St. George and the Dragon, Ralph Siferd (1951–), Canada

daughter. They said: How sir! ye have made and ordained the law, and our children be now dead, and ye would do the contrary. Your daughter shall be given, or else we shall burn you and your house.

When the king saw he might no more do, he began to weep, and said to his daughter: Now shall I never see thine espousals. Then returned he to the people and demanded eight days' respite, and they granted it to him. And when the eight days were passed they came to him and said: Thou seest that the city perisheth: Then did the king do array his daughter like as she should be wedded, and embraced her, kissed her and gave her his benediction, and after, led her to the place where the dragon was.

When she was there S. George passed by, and when he saw the lady he demanded the lady what she made there and she said: Go ye your way fair young man, that ye perish not also. Then said he: Tell to me what have ye and why weep ye, and doubt ye of nothing. When she saw that he would know, she said to him how she was delivered to the dragon. Then said S. George: Fair daughter, doubt ye no thing hereof for I shall help thee in the name of Jesu Christ. She said: For God's sake, good knight, go your way, and abide not with me, for ye may not deliver me. Thus as they spake together the dragon appeared and came running to them, and S. George was upon his horse, and drew out his sword and garnished him with the sign of the cross, and rode hardily against the dragon which came towards him, and smote him with his spear and hurt him sore and threw him to the ground. And after said to the maid: Deliver to me your girdle, and bind it about the neck of the dragon and be not afeard. When she had done so the dragon followed her as it had been a meek

beast and debonair. Then she led him into the city, and the people fled by mountains and valleys, and said: Alas! alas! we shall be all dead. Then S. George said to them: Ne doubt ye no thing, without more, believe ye in God, Jesu Christ, and do ye to be baptized and I shall slay the dragon. Then the king was baptized and all his people, and S. George slew the dragon and smote off his head, and commanded that he should be thrown in the fields, and they took four carts with oxen that drew him out of the city.

JACOBUS DE VORAGINE (c.1260), Italy

OVERLEAF: *A Tiger Hunt at Jhajjar*, Shulam Ali Khan (c.1820), India

The Human Soul that Lived in the Bodies of All Beasts

THERE WAS ONCE A WOMAN who gave birth to an abortion, and taking care that none should know, she threw the thing to the dogs, for she did not wish to observe all the troublesome rites imposed on women thus rendered unclean.

The abortion was eaten by a dog, and remaining in its body for some time, was ultimately born of the dog that had swallowed it, and lived as a dog. And when people threw out refuse from their houses, it would run up with the other dogs for something to eat. But it did not rightly understand how to be a dog, it could not push its way to the front, and thus it never got enough to eat. It grew thin, and the woman who had given birth to it at first, said: "Do not stay behind like that, but push your way to the front, or you will never get anything to eat."

And accordingly, it adopted the custom of the dogs, and pushed its way to the front wherever there was a chance of anything to be got, but often it got only blows for its pains. And at last it grew tired of being a dog, and changed from the body of one animal to another.

At one time it was a fjord seal. It lived down under the

ice, and had its blowhole like the other seals. The seals were not afraid of death, and therefore had no fear of man, but would agree among themselves which hunter they would allow to capture them. And then they would lie there under the blowholes waiting till a little thing like a drop of water should fall down on them. It pricked their bodies, and often hurt. The soul quite enjoyed being a seal, but all the same it felt it would like to be a wolf, and so it became a wolf. It stayed with the wolves for a time, but then it grew tired of that, for the wolves were always moving from one place to another, and never stayed anywhere for long, there was no time to spend in making love; they trotted and trotted about and knew no rest.

Then it became a caribou. The caribou were always feeding, and therefore it was pleasant to live among them, but on

Anonymous creature, artist unknown

the other hand they were always afraid, always in dread of some danger. So it left them and became a walrus. The walrus were good to live with. They too were always feeding; and they never went in fear of anything. But they had a way of beating one another on the snout with their tusks, and because of this, the soul grew dissatisfied with its life among them.

Thus it wandered from one animal form to another, and when it had passed through all of them, it returned to the seals, that it liked so much.

Then one day it allowed itself to be captured by a man whose wife was barren. He took the seal home to his wife, and as she stood over the carcase to cut it up, the soul slipped into her body. The woman became pregnant, and the child within her grew so fast that it made her ill. At last she gave birth to a boy, a fine, well-proportioned child, but when it tried to speak, all it could say was *"uha', uha'"*.

The boy grew up and became a skilful hunter. It was not long before he had a sealing float made from the whole skin of a bearded seal, for he was marvellously strong. And he went hunting, killing whale and seal and all manner of beasts.

Thus the woman's abortion became a human being again after having lived in the bodies of all beasts, and the young man proved a good son to his parents, hunting and finding meat for them till the end of their days.

TOLD BY NAUKATJIK, Inuit
trans. Knud Rasmussen (1879–1933),
Denmark/Greenland

Yellow Bear

To start at the end,
arriving at the start,

doesn't make the end
the beginning—

the radio rocking on my desk,
hot sun in window, remembering—

Polar Bear, Etuangat Aksayook (1901–1996), Canada

no image but the tree running,
suddenly before my sight

becoming a bear, so I stood
screaming in the night

beside a prairie lake,
unable to remember—

it was a yellow bear
high up in the tree

while lights went on
in all the cottages

and a woman came to take my hand
and lead me to safety—

it was my imagination
began it, thinking, That is like

a bear waiting at the top,
and watching it become the animal.

JOHN NEWLOVE (1938–2003), Canada

GLOVES

IN AN AVERSION TO ANIMALS the predominant feeling is fear of being recognized by them through contact. The horror that stirs deep in man is an obscure awareness that in him something lives so akin to the animal that it might be recognized. All disgust is originally disgust at touching. Even when the feeling is mastered, it is only by a drastic gesture that over-leaps its mark: the nauseous is violently engulfed, eaten, while the zone of finest epidermal contact remains taboo. Only in this way is the paradox of the moral demand to be met, exacting simultaneously the overcoming and the subtlest elaboration of man's sense of disgust. He may not deny his bestial relationship with animals, the invocation of which revolts him: he must make himself its master.

WALTER BENJAMIN (1892–1940), Germany

Bear/Sloth, Edward Topsell (c.1572–1625), England

Saving Man from Shame

ACCORDING TO ONE ANCIENT Greek account of creation, the careless god Epimetheus was given the responsibility for distributing the ingredients of biological creation among all the creatures, and he botched the job. Epimetheus lavished upon the wild animals gifts of beautiful fur and feathers, gracefulness of form, strength, and agility, to such an extent that he ran out of desirable characteristics by the time he came to man. His big brother Prometheus, mankind's special friend, then saved man from shame by endowing him with the tools of dominance over the other animals even though he was weaker and uglier than they. Like many since, Prometheus reasoned that a creature equipped with language and technology could get along well enough without beauty.

JOSEPH W. MEEKER (1932–), United States

Monkeys, Parker Library MS 53 (detail), England

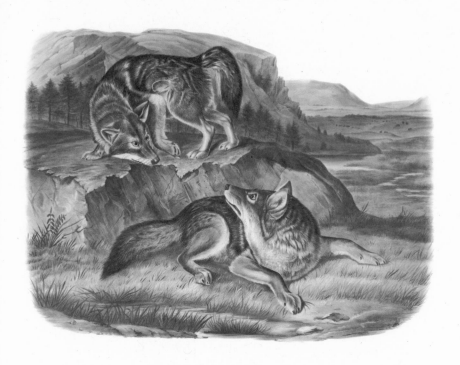

Coyote's Moon-Child

THE DESERT WOLF, the coyote, takes the place of the wolf in the Romulus and Remus theme. The Indians of the Pajarito village, one and all, went out to camp on the piñon flats to gather the pine nuts in the fall. During their stay a young girl secretly gave birth to what we would call an illegitimate baby boy. She feared the displeasure of her maternal uncle, who is always a child's special guardian; so when she returned to the pueblo, she left the baby there among the piñon trees.

Not long after that Coyote-woman in passing by heard the infant crying. Going to it, she lifted it carefully in her mouth and carried it to her den, where she had a litter of whelps. Here she nourished the human child, who grew with

Prairie Wolf, J.J. Audubon (1785–1851), Haiti/United States

the coyotes for nine years, learning to eat their food, to follow their ways, and to understand all the languages of different animals.

When the child was nine years old, the Indians from that same pueblo again came to this same piñon flat to gather nuts, for once more there was a big harvest of them. By accident a group of men came upon several coyotes with an Indian child, naked, wild, and with hair unkempt, in their midst. Calling the whole clan together, the men told of their strange find and begged anyone knowing aught of this child to speak. Then the young mother told about her deserted baby.

After much discussion the Indians decided that since the child was one of them, he should be caught and brought up as an Indian and not as a coyote. Forming a great circle, which gradually closed in, they trapped the child, who in fear fought savagely. When they took him back to the pueblo, they confined him in a room beneath the underground kiva until he could be tamed and taught to eat cooked food and to speak the Indian's tongue. Then he was freed and brought up with the other children of the village. Later this lad became a great cacique among his people, for the magic he had learned of the animals aided them in their hunts. Knowing the language of the animals, he could prophesy the weather, prepare for dry years, and for the great flood, and live with wisdom. He bore the name of "The Fox."

FRANK J. DOBIE (1888–1964), United States

The Coyote Teodora

Teodora, who knew the Devil's secrets, was married to a good, quiet, man. He farmed his plot and lived in peace. The couple had barely enough to live on. And yet, their kitchen overflowed with delicacies. Teodora always had a juicy roast to serve her husband and her little boy.

The husband wondered. But when he asked his wife where she could be getting such food, she acted as though she didn't hear. Or she would say, "I bought it" or "A friend gave it to me."

The woman's husband was no simpleton, and he thought, "Are these the facts?" Day by day his suspicions grew. He took to watching his wife at night, but at first he could see nothing.

One night, however, as he lay awake, he felt the bed tremble and sensed that his wife was getting up. In the darkness of their little room he heard her recite a prayer of a kind he had not heard before. She turned around three times to the right, then three times to the left. He dared to look and saw that she had become a coyote. Terror-stricken, he put his head under the covers and offered a prayer of his own, "St. Anthony and all the souls in purgatory, come save me!"

The next day, as usual, there were fryers and roasting hens on the kitchen shelf, and in the oven a suckling pig.

The husband was now on the alert. But the wife did not go out every night. A few days passed. Then one night, as before, she eased herself out of bed and recited her special words. This time her husband followed her tracks, and in the

distance he could see a coyote running to the neighbours' barnyards and henhouses and into their kitchens, gathering provisions for the next several days.

Now fully aware that his wife was a witch, the man went to the priest and reported what he had seen. As Christ's minister the priest knew his duty and gave the husband a rope of St. Francis and a little holy water. "At precisely the moment she changes to her human form,"the priest advised, "give her three lashes with the rope of St. Francis and sprinkle her with the holy water. She'll never be a coyote again."

The husband carried out the instructions. But as it happened, the next time the coyote returned from its midnight run and was just becoming a woman again, the husband delivered the lashes and sprinkled the water a moment too soon. The head and the upper body were restored to the form of a woman, as the husband already had seen, but the hindquarters were those of a coyote and could not be changed.

Unable to live as a human, the woman abandoned her husband and her little boy and fled to the woods, where she still roams, they say, as an example to witches everywhere.

PABLO (surname not given),
(dates unknown), Honduras
Editor, John Bierhorst

Funerary Figure, artist unknown (5th century)

FROM BEAR

ONE EVENING SHE TOOK HER SUPPER out to eat on the wood-shed stoop in the sun (the darkness of the kitchen seemed to indicate that whichever of the Carys had built the house had not consulted his woman). The bear sat as close to her as he could at the end of his chain. She unsnapped it and he came to sit by her knee. She reached out her hand and kneaded his scruff. His skin was loose on his back and his fur was thick, thick, thick, and beginning to gleam from the swimming. 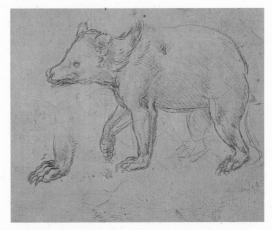 He stared at her earnestly, swinging his head from side to side, as if he could not see her with both eyes.

Later, she went upstairs again. She was deeply absorbed in the classification of a series of Victorian natural history manuals when she heard an unfamiliar sound downstairs and stiffened; froze; held her breath. A door squeaked open.

For a moment, defenceless, she felt panic. Then, without knowing why, she relaxed a little. The heavy tread that advanced was accompanied by a kind of scratching: claws clacking on the kitchen linoleum.

She heard him slaking his thirst at the enamel water pail.

She went to the top of the stairs. She saw him below in the darkness staring up at her. "Go back to bed," she told him.

Bear walking, Leonardo da Vinci (1452–1519), Italy

His thick legs pumped up the stairs towards her. She retreated to her desk and sat on it, hunching towards the window.

Inside the house, he looked very large indeed. At the top of the stairs he drew himself up to his full height, in that posture that leads the bear to be compared to the man, with his paws dangling: he's a cross between a king and a woodchuck, she thought as he moved his head short-sightedly around. Then he raised one hand in salutation or blessing, and folded himself down on all fours again. Deliberately he walked around the far end of the chimney wall and lay down in front of the fire.

He knows his way, she thought.

She went cautiously to him. He was wriggling like a dog, trying to get comfortable. "Well," she said to him, "you've got your nerve."

The room seemed darker now. She lit an extra lamp. The bear looked up when it hissed to a glow, then laid its head on its forepaws and appeared to go to sleep.

She discovered it was impossible to type with her back to him. She made nothing but mistakes. Therefore, she got herself a drink and a book and settled down on the sofa beside him, thinking of Homer's warning: "He's a wild animal, after all."

. . . The fire blazed. The bear slept wheezily, occasionally winking his fireward eye. She grew warm, kicked off her shoes, and found herself running her bare foot over his thick, soft coat, exploring it with her toes, finding it had depths and depths, layers and layers.

MARIAN ENGEL (1933–1985), Canada

THE WEREWOLF

IT IS A NORTHERN COUNTRY; they have cold weather, they have cold hearts.

Cold; tempest; wild beasts in the forest. It is a hard life. Their houses are built of logs, dark and smoky within. There will be a crude icon of the virgin behind a guttering candle, the leg of a pig hung up to cure, a string of drying mushrooms. A bed, a stool, a table. Harsh, brief, poor lives.

To these upland woodsmen, the Devil is as real as you or I. More so; they have not seen us nor even know that we exist, but the Devil they glimpse often in the graveyards, those bleak and touching townships of the dead where the graves are marked with portraits of the deceased in the naïf style and there are no flowers to put in front of them, no flowers grow there, so they put out small, votive offerings, little loaves, sometimes a cake that the bears come lumbering from the margins of the forest to snatch away. At midnight, especially on Walpurgisnacht, the Devil holds picnics in the graveyards and invites the witches; then they dig up fresh Corpses, and eat them. Anyone will tell you that.

Wreaths of garlic on the doors keep out the vampires. A blue-eyed child born feet first on the night of St John's Eve

Studies of a Werewolf, Charles Le Brun (1619–1690), France

will have second sight. When they discover a witch—some old woman whose cheeses ripen when her neighbours' do not, another old woman whose black cat, oh, sinister! follows her about all the time; they strip the crone, search for her marks, for the supernumerary nipple her familiar sucks. They soon find it. Then they stone her to death.

Winter and cold weather.

Go and visit grandmother, who has been sick. Take her the oatcakes I've baked for her on the hearthstone and a little pot of butter.

The good child does as her mother bids—five miles' trudge through the forest; do not leave the path because of the bears, the wild boar, the starving wolves. Here, take your father's hunting knife; you know how to use it.

The child had a scabby coat of sheepskin to keep out the cold, she knew the forest too well to fear it but she must always be on her guard. When she heard that freezing howl of a wolf, she dropped her gifts, seized her knife and turned on the beast.

It was a huge one, with red eyes and running, grizzled chops; any but a mountaineer's child would have died of fright at the sight of it. It went for her throat, as wolves do, but she made a great swipe at it with her father's knife and slashed off its right forepaw.

The wolf let out a gulp, almost a sob, when it saw what had happened to it; wolves are less brave than they seem. It went lolloping off disconsolately between the trees as well as it could on three legs, leaving a trail of blood behind it. The child wiped the blade of her knife clean on her apron, wrapped up the wolf's paw in the cloth in which her mother had packed the oatcakes and went on towards her grand-mother's house. Soon it came on to snow so thickly that the

120

path and any footsteps, track or spoor that might have been upon it were obscured.

She found her grandmother was so sick she had taken to her bed and fallen into a fretful sleep, moaning and shaking so that the child guessed she had a fever. She felt the forehead, it burned. She shook out the cloth from her basket, to use it to make the old woman a cold compress, and the wolf's paw fell to the floor.

But it was no longer a wolf's paw. It was a hand, chopped off at the wrist, a hand toughened with work and freckled with old age. There was a wedding ring on the third finger and a wart on the index finger. By the wart, she knew it for her grandmother's hand.

She pulled back the sheet but the old woman woke up, at that, and began to struggle, squawking and shrieking like a thing possessed. But the child was strong, and armed with her father's hunting knife; she managed to hold her grandmother down long enough to see the cause of her fever. There was a bloody stump where her right hand should have been, festering already.

The child crossed herself and cried out so loud the neighbours heard her and come rushing in. They knew the wart on the hand at once for a witch's nipple; they drove the old woman, in her shift as she was, out into the snow with sticks, beating her old carcass as far as the edge of the forest, and pelted her with stones until she fell down dead.

Now the child lived in her grandmother's house; she prospered.

ANGELA CARTER (1942–1995), England

The Bounds, the Scratches, and the Bites

HOWEVER SKILFUL SHE MIGHT BE in the arts and profession of the prostitute, she could not always have been as furious and ardent as she was that night, and which not even exceptional excitement or morbid desire would explain. Had she only just embraced the horrible profession, that she exercised it with so much ardour? There seemed so much of the wild beast about her, that one would have thought she either wished to lose her own life or take that of the other in each of her caresses. At that time the Parisian prostitutes, who did not think the pretty name of *lorette*, which literature had bestowed upon them, and Gavarni had immortalized, was sufficiently serious, had adopted the Oriental sobriquet of "panthers." Not one of them had a better right to be called a panther. She had all the suppleness, the activity, the bounds, the scratches, and the bites. Fressignies could testify that no woman who had ever been in his arms up to then had given him such indescribable sensations as this woman gave him in a delirium of lust which was contagious . . .

BARBEY D'AUREVILLY (1808–1889),
France

Reclining demimondaine (c. 1900), France

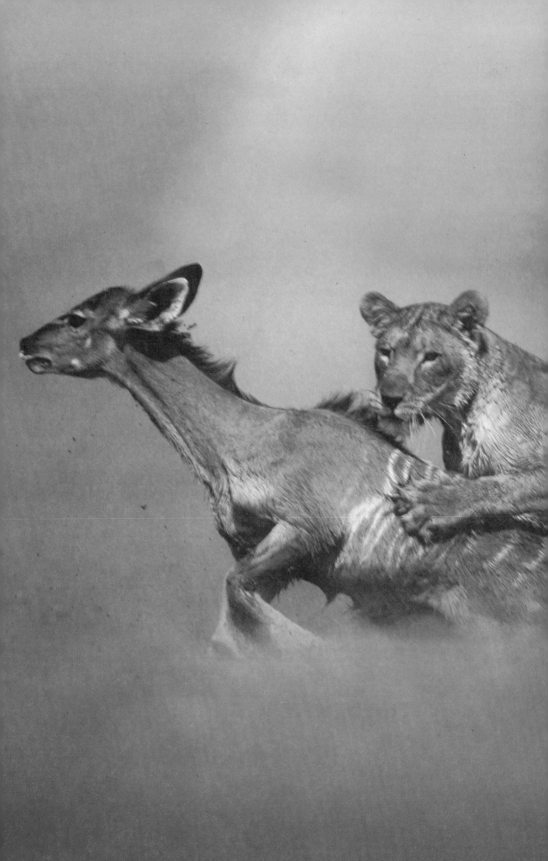

"There is a centre of power," said Candlish, "which it will be the point of our watching to find. It is individual; it is collective; it is nothing at all and everything at once. You can see it in ants, or in a single elephant walking a thousand miles to find a family that no longer exists. If you do not have the power yourself, you lack the base for right action. I suspect that when an animal lacks it entirely, then it must be killed. It invites being killed."

FRANKLIN RUSSELL

4 —

DEATH'S GOLDEN EYE

The Encounter

Lioness and Kudu, Martin Harvey (1955–), South Africa

It is difficult to act calmly if you are awakened by a bear's growl.
"Safety in Grizzly and Black Bear Country"

Physically weak and relatively slow, lacking tearing teeth or claws, our forebears were at first mostly prey rather than predators. They must have been cautious gatherers, who undoubtedly got their animal protein from scavenging whatever remained of a kill that beasts such as cave bears and scimitar cats had abandoned.

With the acquisition of primitive weapons and the strategy of collective hunting—which we probably learned from social animals such as lions and wild dogs—we humans eventually became very effective at predation. And we thereby changed the world.

Hunting, however, is a hard and dangerous activity, with an unpredictable outcome at best. As a result, we have always depended more on gathering than hunting. And until very recently in geological time, we certainly remained prey as well. The rich variety of predators, such as the big cats, wild dogs and some bears, made sure of that.

The fundamental interaction between predators and prey has developed during the long, exhaustive process of evolution. The cheetah and its identified antelope experience their brief encounter together—whether it ends in a kill or not—with what looks much

more like a focused urgency than like ferocity or terror. In truth, the unfolding drama is a commonplace, one that all participants understand and accept: it is the way life works, day by day. A herd animal is killed and eaten, and the others soon return to grazing. We ourselves have retained this kind of immunity to daily bloodshed: we see a dreadful accident on the highway, we sense someone walking on our grave as we pass the wreck, we briefly slow down but soon enough resume our daily speed. We don't spend much time worrying about the death we've just witnessed. So it is with the untouched prey in a herd.

Obviously, successful prey animals—and commuters—must take precautions. With a group of birdwatchers in Cuba, I watched a grey-headed quail dove cautiously approaching a bit of wetland in the forest for its evening drink. These are delicate, lovely birds, and are reputed to be tasty as well. We stood unmoving for almost half an hour while the dove picked its way from cover to cover, feeding sporadically as it circled the water, working to ensure there was no danger. Because the bird made no sound, and neither did we, it came to me that we were sharing that intense silence in which death can so often be met.

THE ONLY TIME I THOUGHT I might conceivably be eaten was in Queensland, Australia. It was an unpleasant feeling. Fourteen years old and fish-belly white after a Canadian winter, I was bobbing up and down in the surf with a small crowd of intimidatingly golden and confident youths—among them an older cousin who was trying to teach me to bodysurf. We were on a sandbar about a hundred yards from shore when someone called, *Sharks!* At that moment I was being lifted from the bar by a large wave: this allowed me to see three dark torpedo-like shapes darting within an even larger swell forty yards out to sea. The surf then lowered me between two walls

of water until my feet were on the sand again, where everything seemed quite a lot more sinister than it had the last time I was down there. I was then lifted again in time to see that all the others—except my cousin and one or two of his friends—were urgently and with enviable competence beating their way to shore.

"They're just porpoises," my cousin assured me; which wasn't much comfort, because, if so, why were we now alone? Deposited once more on the sandbar in what seemed even darker shadows, I sensed the jagged mouths of sharks in the water all around me. Rising to hang in another wave, which I was sure was the one that had contained whatever they were, I realized (with dismay) that I had to stick it out. There was far too much boyish pride at stake for me to head for shore alone.

I never discovered what the creatures were, and possibly it was a good thing I didn't. A month or so later, walking alone on the almost empty beach, I saw several men standing over an object on the tide-line ahead of me. It looked like a partially filled sack, or maybe a big fish. As I approached, they waved me away from what I then realized was the torn and broken body of a man. I was later told that they couldn't decide if he'd been taken by sharks, or if sharks had simply mauled him after he drowned.

Perhaps six years ago, I read an item about a man who was attacked by a mountain lion in British Columbia. As they generally do, the cat had seized him by the shoulder and taken him to the ground. I was intrigued by the fact that the victim reported feeling neither pain nor terror. What compelled him most, he said, were the cat's beautiful golden eyes, a hand's-breadth away, staring into his.

The more I've read, the more I'm persuaded that—at least with large predators—the victim of a carnivorous attack is often blessedly protected from the horror of the objective experience. In his *Missionary Travels and Researches in South Africa*, Dr. Livingstone

describes being seized by a lion. Growling horribly close to his ear, it shook him, he wrote, "as a terrier dog does a rat," yet he felt "no sense of pain nor feeling of terror," only one of dreaminess. Leo Tolstoy had a similar encounter with a bear: he too remained remarkably lucid, and made no mention of pain. Though, both men were seriously mauled.

While living and working on a farm in the 1970s, I regularly killed chickens and ducks for our table. In doing so, I discovered that when held upside down by their legs, the birds relaxed utterly— rather like Livingstone, or a mouse in the jaws of a cat. The same calm descends upon injured songbirds when you lie one on its back in the palms of your hands, with the fleshy part of your thumbs against its shoulders. If the bird is in pain, and clearly beyond help, you can gently collapse its lungs by steadily pressing the base of your thumbs together until, with an almost imperceptible shudder, the creature is dead. It is a melancholy exercise, but almost inevitably the bird remains passive throughout.

While Dr. Livingstone suggests it is the mercy of a beneficent God that lessens the distress and pain of death for his creatures, we'd probably attribute the absence of horror and pain to shock. In the event, it seems clear that our long history of interaction with predatory animals has accommodated us to a wider variety of deaths than we domesticated folk might suspect.

There are of course unpleasant exceptions, where the shock doesn't happen soon enough, perhaps because the attack doesn't immediately overwhelm: hyenas, wild hunting dogs and water shrews come to mind. Then there is our own harsh treatment of one another as murderers, as torturers—not to mention our behaviour towards animals. As Freud observed: " . . . a wild animal is cruel. But to be merciless is the privilege of civilized humans."

G.G.

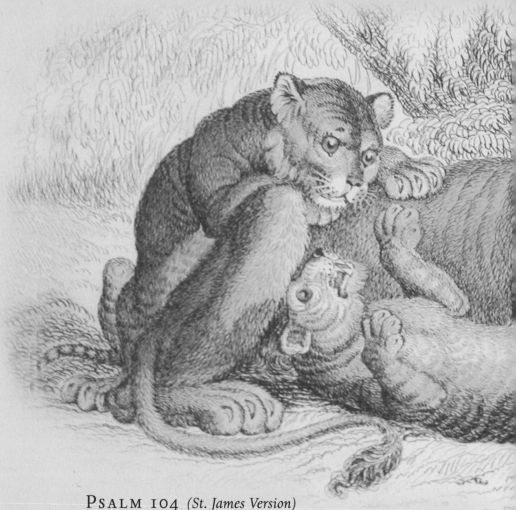

PSALM 104 (*St. James Version*)

20 Thou makest darkness and it is night: wherein all the beasts of the forest do creep forth.

21 The young lions roar after their prey, and seek their meat from God.

22 The sun ariseth, they gather themselves together, and lay them down in their dens.

23 Man goeth forth unto his work and to his labour until the evening.

24 Oh Lord, how manifold are thy works! in wisdom hast thou made them all: the earth is full of thy riches.

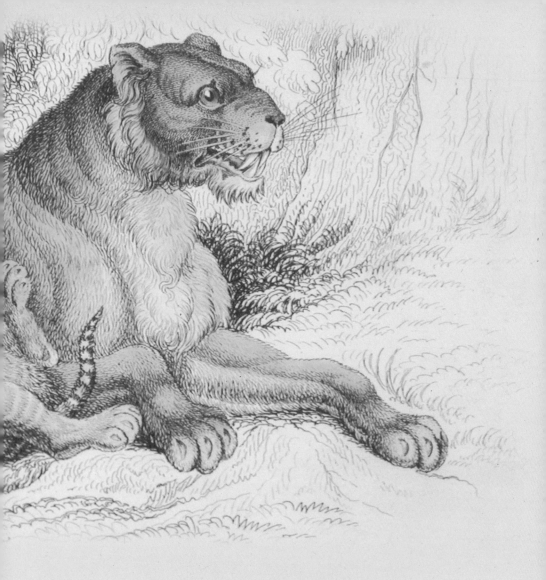

25 So is this great and wide sea, wherein are things
 creeping innumerable, both small and great beasts.
26 There go the ships: there is that leviathan, whom thou
 hast made to play therein.
27 These wait all upon thee; that thou mayest give them
 their meat in due season.

Lioness and Cubs, William Home Lizars (1788–1859), England

AMERICAN KESTREL
Falco sparverius cinnamomimus

High noon opened up:
the sun in the center, crowned.

The earth awaited indecisively
some movement in the sky
and everyone remained
indecipherably still.

At that slender second
the hawk hammered its flight,
cut loose from the firmament,
and swooped like a sudden shiver.

The landscape remained serene
and the woodlands were not
frightened,
the volcanoes were still aloof,
the river kept proclaiming
its abrupt and wet lineage:
everything kept throbbing
in that green-pattered pause
except a hare, a bird,
something that flew or ran,
something that used to live
on that blood-splattered spot.

PABLO NERUDA (1904–1973), Chile

Puma.

UNSEEN AND SILENT

BEYOND A DENSE BELT OF SPRUCE a small herd of whitetail deer is grazing in a clearing, pulling contentedly at the long grass but, us usual, nervously alert, their big ears flapping and swivelling, probing the evening sound waves in a constant search for danger signals.

The buck is a handsome fellow. He carries his antlers with regal air as he stands a little apart from the smaller does and between mouthfuls of grass pauses, holding his massive head high and flaring his black nostrils to test the wind for warning smells from down the canyon. The buck is nervous; he senses trouble, but is unsure of its direction and moves undecided on long slim legs that cover the ground in jerky strides and take him closer to the tree line.

Puma, artist unknown (19th century)

The evening is quiet; its sounds seemingly innocent: the scrunch of bitten grass, the occasional flutter of a grouse, the rustle of wind-tossed leaves. . . .

Suddenly a squirrel shrills in sharp anger and the buck freezes into a tense crouch, ready to leap away and lead his does to the safety of the trees. The squirrel, a red shape sitting in a young spruce, bunches his body into a small ball of fur and continues his chatter, a note of fear creeping into his petulant voice. But the buck is not yet sure, despite the squirrel's warning. Danger is about, and he knows it, but he must locate it before he can run from it.

The does are less alert, confident in his ability to protect them; they continue eating, glancing now and then towards him, waiting for his decision, and their erratic movements take them farther from the tree line and closer to an outcropping of rock which rises fifteen feet above the ground.

Unseen and silent, a tawny shape slides stealthily between tufted blueberry bushes. The big cat moves imperceptibly, inching foreword and pausing often to stare with baleful unblinking eyes at the squirrel. The cougar has not eaten for three days and though her two kittens suckled milk an hour before from her almost-dry dugs, they, too, are hungry and wait mewling in the cave that still serves them as home. Because of her need to provide for the kittens the cougar is more than usually careful this evening as she stalks the deer, subduing the eagerness that urges her to dash headlong into the band. She is down wind from the herd and safe from detection provided she is careful, and the rocky ledge offers a good jumping off platform that will let her land within striking reach of at least one of the animals.

A young doe edges closer to the outcrop. She pulls at

some grass, reaching for the green food with her rough tongue, curling it around a toft and drawing it into her mouth; the doe moves again, unaware that death lurks above. Seventy-five feet separate her from the hungry cat which is nervously bunching her powerful haunches, positioning her back legs for the mighty leap.

The time is now. For a split second the yellow body is still, then, like the sudden uncoiling of a mighty spring, her reflexes push her off the ledge, propelling the one-hundred-pound body through space. She seems to hang poised in mid-air, long tail arching over her body, legs spread, ready for the landing, but her shadow is a swiftly-travelling blur against the spruce trees.

She touches ground twenty feet short of the young doe, continues her forward movement, brings her hack legs down and forward until they are positioned between her front legs. She springs again and hits the deer and the deadly front paws strike the doe's shoulder and drive her front quarters away from the cat; the unexpected force of the powerful blow snaps the deer's neck forward. The crack of breaking bone is heard a fraction of a second before the does is hurtled to the ground fifteen feet away from where it was hit. The dear is dead before she knows what has happened.

R.D. LAWRENCE (1921–2003), Canada

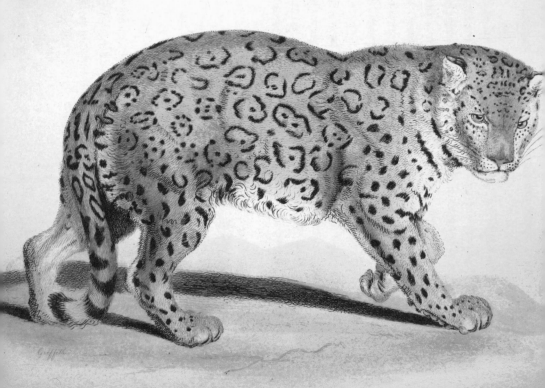

THE JAGUAR. *SMALL OR COMMON VAR.*

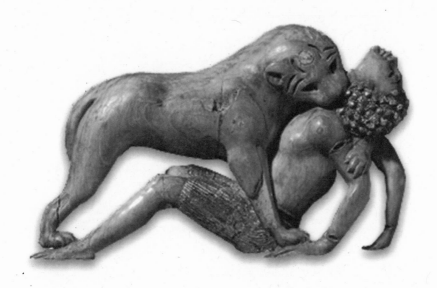

A Kind of Dreaminess

WE FOUND THE LIONS on a small hill about a quarter of a mile in length, And covered with trees. A circle of men was formed round it, and they gradually closed up, ascending pretty near to each other. Being down below on the plain with a native schoolmaster, named Mebalwe, a most excellent man, I saw one of the lions sitting on a piece of rock within the now closed circle of men. Mebalwe fired at him before I could, and the ball struck the rock on which the animal was sitting. He bit at the spot struck, as a dog does at a stick or stone thrown at him; then leaping away, broke through the opening circle and escaped unhurt. The men were afraid to attack him, perhaps on account of their belief in witchcraft. When the circle was re-formed, we saw two other lions in it; but we were afraid to fire lest we should strike the men, and they allowed

ABOVE: *Lioness Devours Boy* (c.9th–8th century), Phoenicia
OPPOSITE: *Small or common jaguar*, artist unknown

the beasts to burst through also. If the Bakatla had acted according to the custom of the country, they would have speared the lions in their attempt to get out. Seeing we could not get them to kill one of the lions, we bent our footsteps toward the village; in going round the end of the hill, however, I saw one of the beasts sitting on a piece of rock as before, but this time he had a little bush in front. Being about thirty yards off, I took a good aim at his body through the bush, and fired both barrels into it. The men then called out, "He is shot, he is shot!" Others cried, "He has been shot by another man too; let us go to him!" I did not see any one else shoot at him, but I saw the lion's tail erected in anger behind the bush, and, turning to the people, said, "Stop a little, till I load again." When in the act of ramming down the bullets, I heard a shout. Starting, and looking half round, I saw the lion just in the act of springing upon me. I was upon a little height; he caught my shoulder as he sprang, and we both came to the ground below together. Growling horribly close to my ear, he shook me as a terrier dog does a rat. The shock produced a stupor similar to that which seems to be felt by a mouse after the first shake of the cat. It caused a sort of dreaminess, in which there was no sense of pain nor feeling of terror, though quite conscious of all that was happening. It was like what patients partially under the influence of chloroform describe, who see all the operation, but feel not the knife. This singular condition was not the result of any mental process. The shake annihilated fear, and allowed no sense of horror in looking round at the beast. This peculiar state is probably produced in all animals killed by the carnivora; and if so, is a merciful provision by our benevolent Creator for lessening the pain of death. Turning round to relieve myself of the

weight, as he had one paw on the back of my head, I saw his eyes directed to Mebalwe, who was trying to shoot him at a distance of ten or fifteen yards. His gun, a flint one, missed fire in both barrels; the lion immediately left me, and, attacking Mebalwe, bit his thigh. Another man, whose life I had saved before, after he had been tossed by a buffalo, attempted to spear the lion while he was biting Mebalwe. He left Mebalwe and caught this man by the shoulder, but at that moment the bullets he had received took effect, and he fell down dead. The whole was the work of a few moments, and must have been his paroxysms of dying rage. In order to take out the charm from him, the Bakatla on the following day made a huge bonfire over the carcass, which was declared to be that of the largest lion they had ever seen. Besides crunching the bone into splinters, he left eleven teeth wounds on the upper part of my arm. A wound from this animal's tooth resembles a gun-shot wound; it is generally followed by a great deal of sloughing and discharge, and pains are felt in the part period-ically ever afterward. I had on a tartan jacket on the occasion, and I believe that it wiped off all the virus from the teeth that pierced the flesh, for my two companions in this affray have both suffered from the peculiar pains, while I have escaped with only the inconvenience of a false joint in my limb.

DR. DAVID LIVINGSTONE (1813–1873), Scotland

OVERLEAF: *Lion and Bull*, "Arabic version of the *Book of Kalilah and Dinana*," by Abdú Illah ibu n'l-Mugaffa, Parker Library MS 578 (14th century), Arabic

ى نجمة بنصہم نظر ي

وإلى العلامات التى ذكرها له د

The Malay Archipelago

The island of Singapore consists of a multitude of small hills, three or four hundred feet high, the summits of many of which are still covered with virgin forest. The mission-house at Bukittima was surrounded by several of these wood-topped hills, which were much frequented by wood-cutters and sawyers, and offered me an excellent collecting ground for insects. Here and there, too, were tiger pits, carefully covered over with sticks and leaves, and so well concealed, that in several cases I had a narrow escape from falling into them. They are shaped like an iron furnace, wider at the bottom than the top, and are perhaps fifteen or twenty feet deep, so that it would be almost impossible for a person unassisted to get out of one. Formerly a sharp stake was stuck erect in the bottom; but after an unfortunate traveller had been killed by falling on one, its use was forbidden. There are always a few tigers roaming about Singapore, and they kill on an average a Chinaman every day, principally those who work in the gambir plantations, which are always made in newly-cleared jungle. We heard a tiger roar once or twice in the evening, and it was rather nervous work hunting for insects among the fallen trunks and old sawpits, when one of these savage animals might be lurking close by, waiting an opportunity to spring upon us.

Three days after my arrival at Wonosalem, my friend Mr. Ball came to pay me a visit. He told me that two evenings before, a boy had been killed and eaten by a tiger close to Modjo-agong. He was riding on a cart drawn by bullocks, and was coming home about dusk on the main road; and when

not half a mile from the village a tiger sprang upon him, carried him off into the jungle close by, and devoured him. Next morning his remains were discovered, consisting only of a few mangled bones. The Waidono had got together about seven hundred men, and was in chase of the animal, which, I afterwards heard, they found and killed. They only use spears when in pursuit of a tiger in this way. They surround a large tract of country, and draw gradually together till the animal is enclosed in a compact ring of armed men. When he sees there is no escape he generally makes a spring, and is received on a dozen spears, and almost instantly stabbed to death. The skin of an animal thus killed is of course, worthless, and in this case the skull, which I had begged Mr. Ball to secure for me, was hacked to pieces to divide the teeth, which are worn as charms.

ALFRED RUSSEL WALLACE (1823–1913), England

Tiger, artist unknown (19th century)

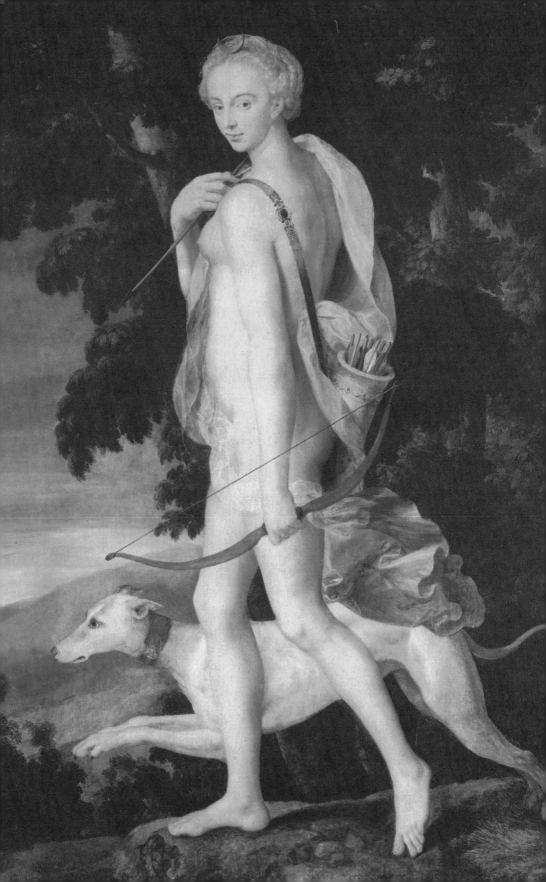

THE GREEN GRASSHOPPER

IT IS LATE and the Cicadae are silent. Glutted with light and heat, they have indulged in symphonies all the livelong day. The advent of the night means rest for them, but a rest frequently disturbed. In the dense branches of the plane-trees, a sudden sound rings out like a cry of anguish, strident and short. It is the desperate wail of the Cicada, surprised in his quietude by the Green Grasshopper, that ardent nocturnal huntress, who springs upon him, grips him in the side, opens and ransacks his abdomen. An orgy of music, followed by butchery.

JEAN-HENRI FABRE (1823–1915), France

Diana the Huntress, School of Fontainebleau (c.16th century), France

THE GRIM HUNTERS

EARLY LAST SUNDAY MORNING a great pack of wild hunting dogs swept through a portion of the park. Thirty to forty strong, these ruthless killers hunted an old impala ram. Twisting and turning as the old antelope tried, crossing ravines and bare sandy places, threading its way through other herds of game in an endeavour to confuse the scent; all to no purpose.

The grim hunters followed silent and tireless. Gradually he became exhausted, the leaders of the pack closed quickly and soon all was over. Just another tragedy of the bush. It seems cruel, and these hunting dogs spread terror in the areas they work, but it is all the balance of nature and serves its purpose in the end. Half-an-hour later all that remained was a patch of blood on the yellow grass with a solitary vulture hovering overhead.

K. DE P. BEATON, details unknown

Hyena, Peterborough Bestiary MS 53, (early 14th century)

EVERYONE WAS IN LOVE

One day, when they were little, Maude and Fergus
appeared in the doorway, naked and mirthful,
with a dozen long garter snakes, draped over
each of them like brand-new clothes.

Snake tails dangled down their backs,
and snake foreparts in various lengths
fell over their fronts, heads raised
and swaying, alert as cobras. They writhed their dry skins
upon each other, as snakes like doing
in lovemaking, with the added novelty
of caressing soft, smooth, moist human skin.
Maud and Fergus were deliciously pleased with themselves.
The snakes seemed to be tickled too.
We were enchanted. Everyone was in love.
Then Maud drew down off Fergus's shoulder,
as off a tie rack, a peculiarly
lumpy snake and told me to look inside.
Inside that double-hinged jaw, a frog's green
Webbed hind feet were being drawn,
like a diver's, very slowly as if into deepest waters.
Perhaps thinking I might be considering rescue,
Maud said, "Don't. Frog is already elsewhere."

GALWAY KINNELL (1927–), United States

Frog, artist unknown

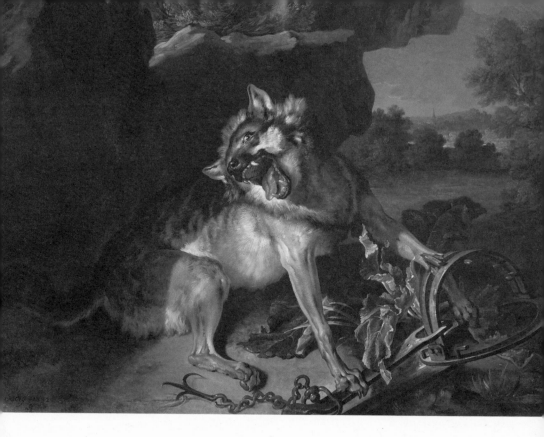

THE DEATH OF THE WOLF

THE CLOUDS WERE SCUDDING across the fire-red face of the moon like smoke chased upward by the heat of a great blaze, and the blackened woods stretched in an endless blanket towards the sky. We moved forward slowly through the damp grass and the dense, tall heather, until, among fir-trees like those that grow in the Landes, we came across the giant claw-marks of our quarry, the prowling wolves. . . .

Then we all drew our knives, hid away our glinting guns, and stole stealthily forward, parting the branches as we went. The three trackers in front stopped dead. I craned forward to

Wolf in a Trap, Jean-Baptiste Oudry (1686–1755), France

follow their gaze; and there, ahead, suddenly, I saw two flaming eyes, and beyond, on the moonlit heath, four nimbly-dancing forms, leaping about like greyhounds when they greet their master with yelps of joy.

The dance was similar, and so were the dancing shapes. Only, the play of the wolf's children was silent, well aware as they were of the presence of man close by, and knowing that this enemy, behind the shelter of his walls, is watchful even in repose.

The male wolf stood guard while, a little distance away, his mate lay resting against a tree-trunk. She seemed a marble statue—that She-Wolf of Rome against whose hairy flanks the twin founders of the city, half-divine Romulus and Remus, had been suckled. Then the wolf himself came and sat, holding his forelegs straight in front of him, and digging his curved claws deep into the sandy ground.

He knew that he was lost, that he had been taken unawares, that his line of retreat and his freedom of manoeuvre had alike been cut off. With a bound, therefore, he seized the neck of the nearest and most rash hound in his burning jaws; nor could our bullets as they ripped into his flesh, or our knives, sharp as pincers, as we plunged them into his sides, one across the other to tear at his great belly, cause his fangs to release the gasping cur from their iron grip until, first to die, she rolled over beneath his paws, her life choked out.

The wolf released her then, and turned his gaze upon us. Our knives, still buried up to their hilts in his sides, were pinning him to the ground. The grass was bathed in his blood. Our guns, in a sinister semi-circle, hemmed him in. Giving us one more glance he lay back again on the ground, licking the blood which filled his mouth; and at last, not deigning to

wonder how it had come about, he closed his great eyes and expired, making no sound.

Lost in thought, I leant my forehead on the muzzle of my unloaded weapon and could not bring myself to pursue the she-wolf and her sons. . .

ALFRED DE VIGNY (1797–1863), France

Papa! Here Is My First Rifle Shot, C.H. Barbant (mid-19th century), France

Leopard.

GOAT-BOY AND THE LEOPARD

A BOY, a fourteen-year-old orphan, was employed to look after a flock of forty goats. He was of the depressed-untouchable-class and each evening when he returned with his charges he was given his food and then shut into a small room with the goats. The room was on the ground floor of a long row of two-story buildings' and was immediately below the room occupied by the boy's master, the owner of the goats. To prevent the goats' crowding in on him as he slept, the boy had fenced off the far left-hand corner of the room.

This room had no windows and only the one door, and when the boy and the goats were safely inside, the boy's master pulled the door to and fastened it by passing the hasp, which was attached by a short length of chain to the door, over the staple fixed in the lintel. A piece of wood was then inserted in the staple to keep the hasp in place, and on his side of the door the boy, for his better safety, rolled a stone against it.

Leopard, artist unknown (19th century)

On the night the orphan was gathered to his fathers, his master asserts the door was fastened as usual, and I have no reason to question the truth of his assertion, for the door showed many deep claw marks. It is possible that in his attempts to claw open the door the leopard displaced the piece of wood that was keeping the hasp in place, after which it would have been easy for him to push the stone aside and enter the room.

Forty goats packed into a small room, one corner of which was fenced off, could not have left the intruder much space in which to manoeuvre, and it is left to conjecture whether the leopard covered the distance from the door to the boy's corner of the room over the backs of the goats or under their bellies, for at this stage of the proceedings all the goats must have been on their feet.

The assumption is that the boy slept through all the noise that must have been made by the leopard when trying to force open the door, and by the goats when the leopard had entered the room, and that he did not cry for help to deaf ears, only screened from him and the danger that menaced him by a thin plank.

After killing the boy in the fenced-off corner, the leopard carried him across the room—now empty of goats, which had escaped into the night—down a steep hillside and then over some terraced fields to a deep boulder-strewn ravine. It was here after the sun had been up a few hours that the master found all that the leopard had left of his servant.

Incredible as it may seem, not one of the forty goats had received so much as a scratch.

JIM CORBETT (1875–1955), India

The Alleged Cruelty of Tigers

A SAMBAR IS BROWSING HAPPILY in the full glory of life and freedom, deep in the beautiful forests which he has frequented from his earliest youth. A tiger on the hunt, passing stealthily near by, hears the sound of the contented munching of his intended prey. He crouches instantly, and the sambar remains completely in ignorance of his arrival, or of the certain death which is so near. Stealthily the tiger surveys the ground after the manner of the born hunter that he is, and then, having

Sambar, Lawrence Worcester (contemporary), United States

carefully chosen the best line of approach, he gradually draws nearer and nearer, taking the greatest care that the sambar shall remain totally unaware of his presence—for once the intended victim is warned the stalk is ruined. Nearer and nearer draws Death in feline form and yet the sambar passes the last few moments of his happy life in the peace and contentment of his chosen home. At last the tiger, after an infinity of care, has reached sufficiently close to enable him to make his final rush; he pauses and braces himself for the last act. Then he makes a lightning charge, so fast that the human eye can barely follow, and launches himself on his prey, using such terrific force that frequently he breaks his victim's neck almost instantly, and in very few cases do the struggles of the sambar last for more than a few seconds. Surely this is not cruelty in its worst form! The tiger must have his food, and he has been provided by the Creator to assist in maintaining that "balance of Nature" which is so essential to life in this world, and without which man himself would find his own position extremely precarious. Now let us see how man, the avowed hater of cruelty, obtains his meat: can he honestly claim to be as merciful as the tiger? A bullock, fattened to provide prime beef, is driven towards the slaughter-house, from which emanates a terrifying smell of stale blood. Some instinct warns him of danger, and he turns to escape. He is caught again and finally forced into the actual death-chamber, terrified and shaking in every limb. The human slaughterer has, perhaps, become callous from constant contact with death, and sits down to smoke his pipe, leaving the shivering beast to await his pleasure. After a few minutes he picks up the pole-axe, or whatever his weapon may be, and advances towards his prey. The bullock dodges, for the slaughterer's science in

154

killing is as nothing when compared with that of the tiger, and he misses his stroke. He tries again, and this time he inflicts a bad wound, but still the victim is far from dead. At the third blow, perhaps, he is successful, and the wretched beast's life is ended—ended in a miserable and protracted manner in order to provide man with meat. This is one method of man's killing, and is, perhaps, in the more civilized countries at any rate, rendered as painless as possible, although even under the best conditions it is far more cruel than that of the tiger. But there are other methods. How about the baskets of live fowls which are sent to the market or to the poulterer—fowls packed in some countries so closely that they can hardly move or breathe, much less obtain a drop of water? How about the export of worn-out horses—faithful servants who have spent a lifetime in the service of man—to the very dubious slaughterhouses on the Continent?

F.W. CHAMPION (?–1970), England

THE BULL MOOSE

Down from the purple mist of trees on the mountain,
lurching through forests of white spruce and cedar,
stumbling through tamarack swamps,
came the bull moose
to be stopped at last by a pole-fenced pasture.

Too tired to turn or, perhaps, aware
there was no place left to go, he stood with the cattle.
They, scenting the musk of death, seeing his great head
like the ritual mask of a blood god, moved to the other end
of the field and waited.

The neighbours heard of it, and by afternoon
cars lines the road. The children teased him
with alder switches and he gazed at them
like an old tolerant collie. The women asked
if he could have escaped from a Fair.

Moose Lunar, Charles Pachter (1942–), Canada

The oldest man in the parish remembered seeing
a gelded moose yoked with an ox for plowing.
The young men snickered and tried to pour beer
down his throat, while their girl friends
took their pictures.

And the bull moose let them stroke his tick-ravaged flanks,
let them pry open his jaws with bottles, let a giggling girl
plant a little purple cap
of thistles on his head.

When the wardens came, everyone agreed it was a shame
to shoot anything so shaggy and cuddlesome.
He looked like the kind of pet
women put to bed with their sons.

So they held their fire. But just as the sun dropped by the river
 the bull moose gathered his strength
like a scaffolded king, straightened and lifted his horns
so that even the wardens backed away as they raised their rifles.
When he roared, people ran to their cars. All the young men
leaned on their automobile horns as he toppled.

ALDEN NOWLAN (1933–1983), Canada

That Kindly Spoken, Smiling-faced, Motherly Old Lady

ONE WINTER when I happened to be spending a few days at Brunswick House an old Indian woman came to can upon the Hudson's Bay trader's wife, and, while she was having afternoon tea, she casually remarked that while on her way to the Post she had espied a bear wash. Digging down into its den with one of her snowshoes, she had killed the brute with her axe, and if the other guests would care to see her prize, it was lying on her sled, just outside the door. What a contrast to the way the Wild West movie actors would have done the deadly work with the aid of all their absurd artillery! Nevertheless, that kindly spoken, smiling-faced, motherly old lady—did the deed with nothing but her little axe.

ARTHUR HEMING (1870–1940), Canada

Medieval Women Hunting, artist unknown

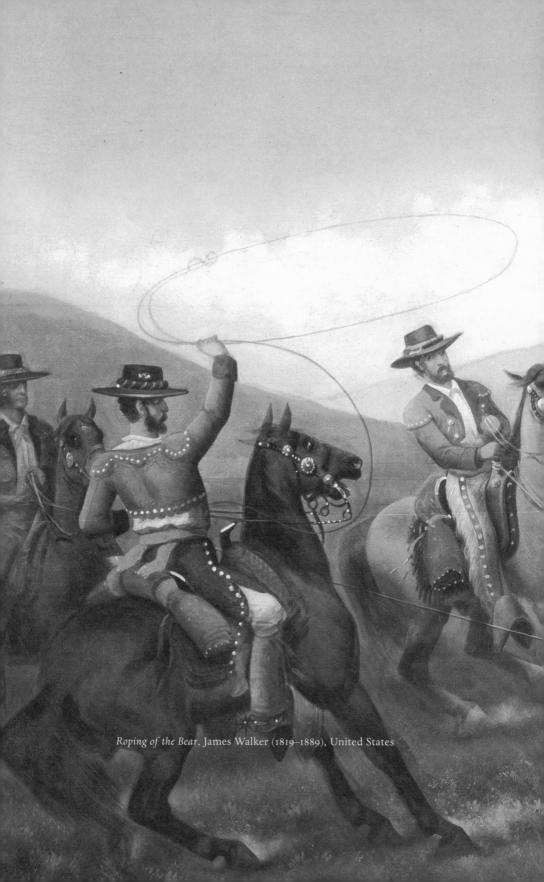

Roping of the Bear, James Walker (1819–1889), United States

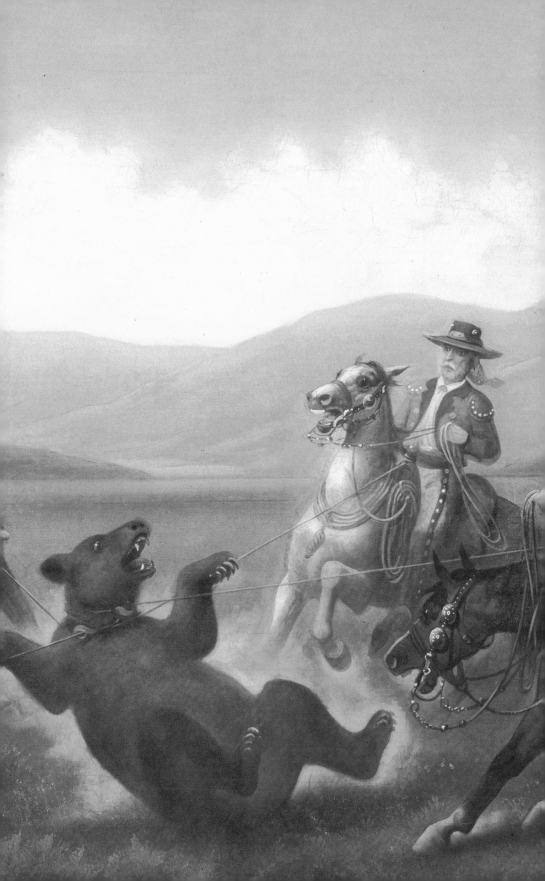

Leo Tolstoy and the Bear

But what is that?

Something was coming towards me like a whirlwind, snorting as it came; and I saw the snow flying up quite near me. I glanced straight before me, and there was the bear, rushing along the path through the thicket right at me, evidently beside himself with fear. He was hardly half a dozen paces off, and I could see the whole of him—his black chest and enormous head with a reddish patch. There he was, blundering straight at me, and scattering the snow about as he came. I could see by his eyes that he did not see me, but, mad with fear, was rushing blindly along; and his path led him straight at the tree under which I was standing. I raised my gun and fired. He was almost upon me now, and I saw that I had missed. My bullet had gone past him, and he did not even hear me fire, but still came headlong towards me. I lowered my gun, and fired again, almost touching his head. Crack! I had hit, but not killed him!

He raised his head, and laying his ears back, came at me, showing his teeth.

Cave bear, Chauvet, France

I snatched at my other gun, but almost before I had touched it, he had (borne) down at me and, knocking me over into the snow, had passed right over me.

"Thank goodness, he has left me," thought I.

I tried to rise, but something pressed me down, and prevented my getting up. The bear's rush had carried him past me, but he had turned back, and had fallen on me with the whole weight of his body. I felt something heavy weighing me down, and something warm above my face, and I realized that he was drawing my whole face into his mouth. My nose was already in it, and I felt the heat of it, and smelt his blood. He was pressing my shoulders down with his paws so that I

could not move: all I could do was to draw my head down towards my chest away from his mouth, trying to free my nose and eyes, while he tried to get his teeth into them. Then I felt that he had seized my forehead just under the hair with the teeth of his lower jaw, and the flesh below my eyes with his upper jaw, and was closing his teeth. It was as if my face were being cut with knives. I struggled to get away, while he made haste to close his jaws like a dog gnawing. I managed to twist my face away, but he began drawing it again into his mouth.

"Now," thought I, "my end has come!"

Then I felt the weight lifted, and looking up, I saw that he was no longer there. He had jumped off me and run away.

When my comrade and Damian had seen the bear knock me down and begin worrying me, they rushed to the rescue. My comrade, in his haste, blundered, and instead of following the trodden path, ran into the deep snow and fell down. While he was struggling out of the snow, the bear was gnawing at me. But Damian just as he was, without a gun, and with only a stick in his hand, rushed along the path shouting:

"He's eating the master! He's eating the master!"

And as he ran, he called to the bear: "Oh you idiot! What are you doing? Leave off! Leave off!"

The bear obeyed him, and leaving me ran away. When I rose, there was as much blood on the snow as if a sheep had been killed, and the flesh hung in rags above my eyes, though in my excitement I felt no pain.

My comrade had come up by this time, and the other people collected round: they looked at my wound, and put snow on it. But I, forgetting about my wounds, only asked:

"Where's the bear? Which way has he gone?"

Suddenly I heard: "Here he is! Here he is!"

And we saw the bear again running at us. We seized our guns, but before any one had time to fire he had run past. He had grown ferocious, and wanted to gnaw me again, but seeing so many people he took fright. We saw by his track that his head was bleeding and we wanted to follow him up; but, as my wounds had become very painful, we went, instead, to the town to find a doctor.

The doctor stitched up my wounds with silk, and they soon began to heal.

A month later we went to hunt that bear again, but I did not get a chance of finishing him. He would not come out of the circle, but went round and round growling in a terrible voice.

Damian killed him. The bear's lower jaw had been broken, and one of his teeth knocked out by my bullet.

He was a huge creature, and had splendid black fur.

I had him stuffed, and he now lies in my room. The wounds on my forehead healed up so that the scars can scarcely be seen.

LEO TOLSTOY (1828–1910), Russia

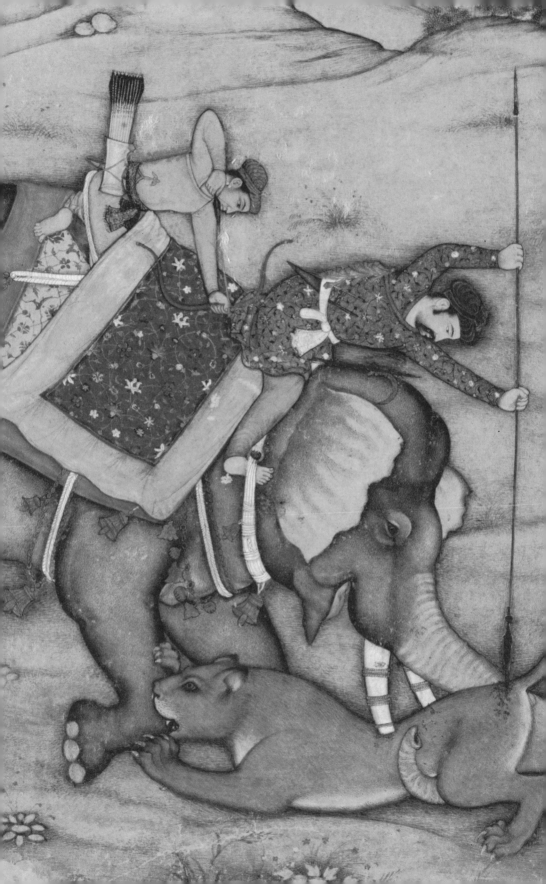

Solely to Avoid Looking a Fool

When I pulled the trigger I did not hear the bang or feel the kick—one never does when a shot goes home—but I heard the devilish roar of glee that went up from the crowd. In that instant, in too short a time, one would have thought, even for the bullet to get there, a mysterious, terrible change had come over the elephant. He neither stirred nor fell, but every line of his body had altered. He looked suddenly stricken, shrunken, immensely old, as though the frightful impact of the bullet had paralysed him without knocking him down. At last, after what seemed a long time—it might have been five seconds, I dare say—he sagged flabbily to his knees. His mouth slobbered. An enormous senility seemed to have settled upon him. One could have imagined him thousands of years old. I fired again into the same spot. At the second shot he did not collapse but climbed with desperate slowness to his feet and stood weakly upright, with legs sagging and head drooping. I fired a third time. That was the shot that did for him. You could see the agony of it jolt his whole body and knock the last remnant of strength from his legs. But in falling he seemed for a moment to rise, for as his hind legs collapsed beneath him he seemed to tower upward like a

A Mughal Prince, artist unknown (1605), India

huge rock toppling, his trunk reaching skyward like a tree. He trumpeted, for the first and only time. And then down he came, his belly towards me, with a crash that seemed to shake the ground even where I lay.

I got up. The Burmans were already racing past me across the mud. It was obvious that the elephant would never rise again, but he was not dead. He was breathing very rhythmically with long rattling gasps, his great mound of a side painfully rising and falling. His mouth was wide open—I could see far down into caverns of pale pink throat. I waited a long time for him to die, but his breathing did not weaken. Finally I fired my two remaining shots into the spot where I thought his heart must be. The thick blood welled out of him like red velvet, but still he did not die. His body did not even jerk when the shots hit him, the tortured breathing continued without a pause. He was dying, very slowly and in great agony, but in some world remote from me where not even a bullet could damage him further. I felt that I had got to put an end to that dreadful noise. It seemed dreadful to see the great beast lying there, powerless to move and yet powerless to die, and not even to be able to finish him. I sent back for my small rifle and poured shot after shot into his heart and down his throat. They seemed to make no impression. The tortured gasps continued as steadily as the ticking of a clock.

In the end I could not stand it any longer and went away. I heard later that it took him half an hour to die. Burmans were bringing dash and baskets even before I left, and I was told they had stripped his body almost to the bones by the afternoon.

Afterwards, of course, there were endless discussions about the shooting of the elephant. The owner was furious,

but he was only an Indian and could do nothing. Besides, legally I had done the right thing, for a mad elephant has to be killed, like a mad dog, if its owner fails to control it. Among the Europeans opinion was divided. The older men said I was right, the younger men said it was a damn shame to shoot an elephant for killing a coolie, because an elephant was worth more than any damn Coringhee coolie. And afterwards I was very glad that the coolie had been killed; it put me legally in the right and it gave me a sufficient pretext for shooting the elephant. I often wondered whether any of the others grasped that I had done it solely to avoid looking a fool.

George Orwell (1903–1950), England

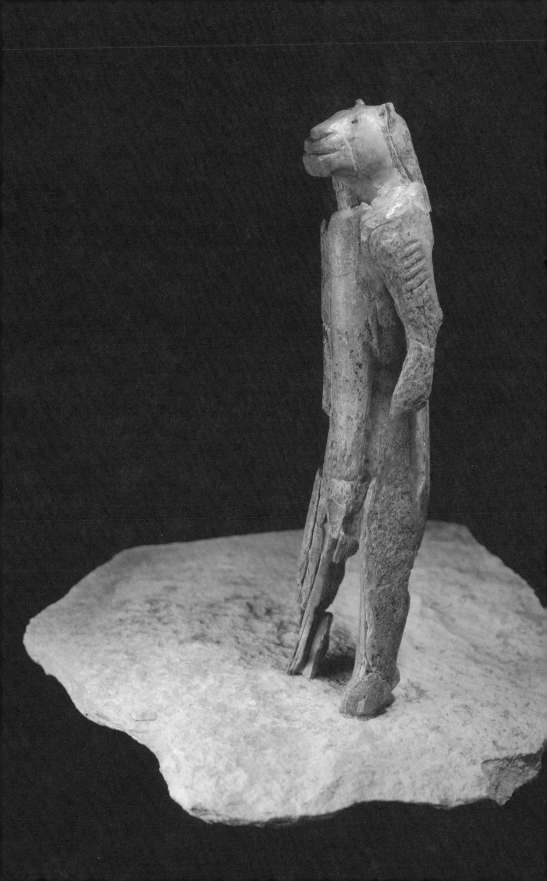

Known as the Löwenmensch (*the lion man*), the figurine has slanted marks on
its left arm suggesting scarring or tattoos. Whatever its sex, there is no doubt that
the figure is both human and animal at the same time. This not only reinforces
the great importance of felines to Palaeolithic people, but also highlights the fluid
nature of their belief system, in which borders separating humans and animals
were easy to cross. Could this figure be a shaman partially transformed into a
lion? A mythical being, a hero or god? Or perhaps a supernatural spirit?

JEAN CLOTTES

5 —

MIGHTY AND TERRIBLE

"I made this monstrous beast"

Man with lion's head, artist unknown (30,000–34,000 BP)

. . . the LORD hath his way in the whirlwind and in the storm,
and the clouds are the dust of his feet.

NAH. 1:3

THE ADOLESCENT FREEDOM I'd enjoyed in Australia—which I describe later in this book—culminated in the Spring of 1949, when we boarded the M/V *Parakoola*, a small passenger freighter bound for Vancouver, via Apia in Samoa. Not only was I going to sea— which had been a dream since reading *Treasure Island*—I was also guaranteed another six weeks before returning to school. The *Parakoola* carried a mere twelve passengers, and at the age of four- teen I had the run of the ship.

About five days out of Townsville we crossed paths with a hurricane. The sea grew surly, then turned an angry grey as the ship began to pitch and roll. Our sense of expectancy increased as the sea rose: the cook shut down his stoves, while the stewards soaked the tablecloths with water so that plates wouldn't slide. On deck, crewmen slung ropes so they could hang on while moving about when the full storm hit. My mother, who'd never been sea- sick in her life, seemed to find the whole prospect exhilarating.

My most vivid memory is of standing on the bridge when we were close to the heart of the storm: uncertain and awestruck

as the sea rose and fell mountainously around us, I watched the faces of the captain and crewmen at the wheel for signs of fear, but saw only concentration. This reassured me. Each time the *Parakoola*'s bow vanished into a wave, she shuddered heavily as her props lifted from the sea behind us, then sank again as the bow resurfaced. Ten-foot waves were breaking on the face of towering walls of water and the air was full of mist and what looked like smoke. By the second day of this, my everyday world had faded away, and it occurred to me I might never see it again. Waking in the night with the ship grinding and rattling as she swooped, then yawed in the darkness, I felt only excitement, and a strange new sense of importance.

But what was this importance, and why do I still value it sixty years later? The boy I was hadn't done anything; on the contrary. I'd simply had the extraordinary luck to be present when Nature flexed her very considerable muscles. As a result I'd experienced powers that utterly dwarfed me and my world—powers that preceded human life, and will certainly survive it. Although I only dimly understood it at the time, the encounter was transforming.

Edmund Burke describes such impressions this way: "The passion caused by the great and sublime in nature when their causes operate most powerfully is Astonishment; and astonishment is that state of the soul, in which all its motions are suspended, with some degree of horror. In this case the mind is so entirely filled with its object, that it cannot entertain any other."

AS EARLY HUMANS STRUGGLED to come to terms with their developing self-consciousness, their first ritualized expression of fear and awe must have focused on the unpredictable and apparently callous powers of Nature. What else could they have done in times of extended drought but appeal to whatever entity might be

withholding rain? Similarly, they must have struggled to find ways of propitiating the catastrophic force of great storms—the equivalents of our tsunamis and Katrinas—not to mention the plethora of voracious beasts that surrounded them, whether real or imagined.

Responding to a question about belief, a shaman quoted in *Intellectual Culture of the Iglulik Eskimos* told Knud Rasmussen, "We do not believe, we fear." If Bergson is right when he says that "the past collects in the fibre of the body," then this kind of fear lives deep within urban man as well. When a heavy wind rushes through the forest at night, howling its way among the trees, it is not hard to imagine that there's a primordial being out there, one we can't begin to understand.

Should a storm become uncomfortably violent, with close-by lightning strikes, we fervently wish it to stop, and some of us pray. Gods of storm are among the most ancient we know: Domfe, for example, the god of water and wind for the Kurumba people in Africa; or Indra, the Vedic god of thunder, whose weapon was a lightning bolt. Or there's Tinia, the Etruscan god of the sky, from which storms and thunderbolts always descend; or Fujin, the green-bodied Japanese god who carries a large bag stuffed full of winds on his shoulders. The problem with all such gods, of course, is that they might well have been the agency that visited the misfortune on us in the first place—as it was with Jehovah when his people had misbehaved.

When the gods replied—which wasn't always a good thing—they frequently did so to the full accompaniment of thunder, lightning, fire and smoke, thus confirming their original role as weather deities. In Exodus, God manifests himself to Moses with a full-blown *son et lumière*:

And it came to pass on the third day in the morning, that there were thunders and lightnings, and a thick cloud upon the mount, and the voice of the trumpet exceeding loud; so that all the people that *was* in the camp trembled.

And Moses brought forth the people out of the camp to meet with God; and they stood at the nether part of the mount.

And mount Sinai was altogether on a smoke, because the LORD descended upon it in fire: and the smoke thereof ascended as the smoke of a furnace, and the whole mount quaked greatly.

Ex.19:16–18

But weather gods aren't the only source of "mighty and terrible" fears. In this section I've placed figures that are deeply rooted in myth and Nature: Echidna, for example, who is "half a nymph with glancing eyes and fair cheeks, and half again a huge snake"; Dionysus, who at will manifests himself as a roaring lion and shaggy bear; not to mention Zeus, who, in the guise of a dragon, slithers into the room and seduces the sleeping Persephone.

In *The Songlines* Bruce Chatwin plays a nice riff on the terrible Beast that haunts our unconscious, and which may be lurking under our bed even now, or creeping behind us when we climb the cellar stairs. He tells us there's a fossil cat known as *Dinofelis*, which was the size of a large leopard or small lion. Built like a jaguar with thick forelimbs, it wouldn't have chased its prey, but grabbed it from ambush, as jaguars strive to do. It's been suggested that *Dinofelis* was one of the reasons our forebears fled the forest for open country.

The intriguing thing about *Dinofelis* is that the fossil record suggests it was a specialist predator upon the hominids—a carnivore

that lived deep within the same caves our forebears used for shelter in hard weather. Imagine it, our own deadly Beast stalking up from within the earth to seize us at night, just as jaguars are known to do with chimpanzees. If we carry such memories in our genes, it is small wonder that we have a mythic sense of monstrous creatures such as Beowulf, or the Beast of Revelation, or werewolves, and even, perhaps, Satan in his beastly guise.

Both Christ and Satan are described as lions—for from god to monster can be a very small step. In light of this, it is interesting to note that God created Leviathan "to humble man." Unfortunately the latter doesn't seem to have worked, although it just might be that, hunkered down in our domestication, we've not been paying attention.

G.G.

Monster Tamer, artist unknown (c.5000 BP), Ur

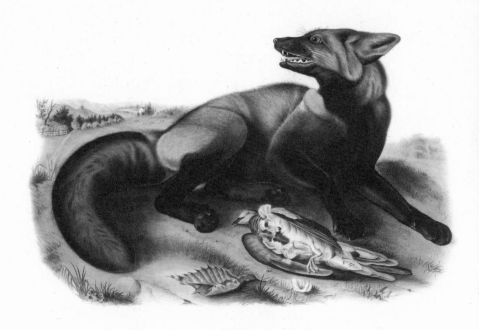

THE SONG OF THE LITTLE HUNTER

Ere Mor the Peacock flutters, ere the Monkey People cry,
 Ere Chil the Kite swoops down a furlong sheer,
Through the jungle very softly flits a shadow and a sigh—
 He is Fear, O Little Hunter, he is Fear!
Very softly down the glade runs a waiting, watching shade,
 And the whisper spreads and widens far and near.
And the sweat is on thy brow, for he passes even now—
 He is Fear, O Little Hunter, he is Fear!

Cross Fox, J.J. Audubon (1785–1851), Haiti / United States

Ere the moon has climbed the mountain, ere the rocks
are ribbed with light,

 When the downward-dipping trails are dank and drear,
Comes a breathing hard behind thee—snuffle-snuffle through
the night—
 It is Fear, O Little Hunter, it is Fear!
 On thy knees and draw the bow; bid the shrilling
arrow go;
 In the empty, mocking thicket plunge the spear!
But thy hands are loosed and weak, and the blood has left
thy cheek—
 It is Fear, O Little Hunter, it is Fear!

When the heat-cloud sucks the tempest, when the
slivered pinetrees fall,
 When the blinding, blaring rain-squalls lash and veer,
Through the war-gongs of the thunder rings a voice
more loud than all—
 It is Fear, O Little Hunter, it is Fear!
Now the spates are banked and deep; now the footless
boulders leap—
 Now the lightning shows each littlest leaf-rib clear—
But thy throat is shut and dried, and thy heart against
thy side
 Hammers: Fear, O Little Hunter—this is Fear!

RUDYARD KIPLING (1865–1936), India/England

THE MANTICORE

THERE IS IN INDIA a wild beast, powerful, daring, as big as the largest lion, of a red colour like cinnabar, shaggy like a dog, and in the language of India it is called *Martichoras*. Its face however is not that of a wild beast but of a man, and it has three rows of teeth set in its upper jaw and three in the lower; these are exceedingly sharp and larger than the fangs of a hound. Its ears also resemble a man's, except that they are larger and shaggy; its eyes are blue-grey and they too are like a man's, but its feet and claws, you must know, are those of a lion. To the end of its tail is attached the sting of a scorpion, and this might be over a cubit in length; and the tail has stings at intervals on either side. But the tip of the tail gives a fatal sting to anyone who encounters it, and death is immediate. If one pursues the beast it lets fly its stings, like arrows, sideways, and it can shoot a great distance; and when it discharges its stings straight ahead it bends its tail back; if however it shoots in a backward direction, as the Sacae do, then it stretches its tail to its full extent. Any creature that the missile hits it kills; the elephant alone it does not kill. These stings which it shoots are a foot long and the thickness of a bulrush. Now Ctesias asserts (and he says that the Indians confirm his

words) that in the places where those stings have been let fly others spring up, so that this evil produces a crop. And according to the same writer the Mantichore for choice devours human beings; indeed it will slaughter a great number; and it lies in wait not for a single man but would set upon two or even three men, and alone overcomes even that number. All other animals it defeats: the lion alone it can never bring down. That this creature takes special delight in gorging human flesh its very name testifies, for in the Greek language it means man-eater, and its name is derived from its activities. Like the stag it is extremely swift.

CLAUDIUS AELIANUS (170–c.235), Rome

Manticore, artist unknown

TO DIONYSUS: HYMN 7

Of Dionysus, far-famed Sémele's son,
listen how once near jutting promontories
beside the barren sea he walked, resembling
a flowering youth, his long hair floating darkly
downward, a purple robe flung round his sturdy
shoulders. Soon afterward, Tyrsenian pirates
sailing their stout ship on the wine-dark sea
came swiftly, led by evil fate. They saw him,
signalled each other, leapt out, seized upon him,
and put him jubilantly aboard their ship—
thinking he was the son of kings descended
from Zeus—and sought to bind him with strong vines,
which could not hold him. As they dropped away
from hands and feet he sat impassively
smiling with dark eyes. Then at once the helmsman,
seeing this, cried aloud to his companions:

Magical Spirit, from Nineveh, artist unknown (C.645 BC), Assyria

"Madmen! What mighty god have you attempted
to capture? No stout ship can ever hold him!
He must be Zeus, or silver-bowed Apollo,
Or else Poseidon: like no mortal man
he looks, but like the gods upon Olympus.
Come, set him free at once on the dark shore
and lay no hand upon him lest, in anger,
he stir wild winds up to tempestuous frenzy."
 Disdainfully the captain answered him:
"Madmen, observe the favouring breeze, hoist sail,
haul on the sheets: leave him for men to handle!
He's bound for Egypt, I suppose, or Cyprus,
the Hyperboreans, or beyond. At length
he'll tell us all about his friends, possessions
and brothers, since fate puts him in our hands."
 Speaking thus, up he hoisted mast and sail.
Wind bellied out the sail, the crew hauled sheets
taut: and soon marvellous deed were done among them.
First sweetly fragrant wine ran murmuring through
the swift black ship, ambrosial fumes arose,
astonishing the wonder-stricken sailors.
Then all at once a vine spread from the sail-top
this way and that, thick-clustered grapes hung downward
and round the mast dark ivy tendrils twisted,
bursting with flowers and voluptuous berries;
garlands bedecked with the oarlocks. Seeing this
the pirates finally bade the helmsman land,
but now the god turned to a savage lion
high on the prow, and fiercely roared; amidships
he made a shaggy bear miraculously
rear up with ravening jaws, while from the fo'c's'le

the lion glared hideously. The crew stampeded
astern and crowded terrified around
the sober helmsman. Then the lion sprang
and seized the captain: seeing this, all leapt
over board to escape their evil fate,
and turned to dolphins. On the gladdened helmsman
the god showed mercy, held him back, and told him:

"Courage, good man! For you have pleased my heart.
I am loud-roaring Dionysus, he
whom Cadmus' child Sémele bore for love of Zeus."

Hail, lovely Sémele's son: one who forgets you
never again will modulate sweet song!

Trans. H.G. EVELYN-WHITE (?–1924), England

Head of Dionysus, cameo (1st century AD); pendant (c.1730), Germany
(OVERLEAF) *Nebuchadnezzar*, William Blake (1757–1827), England

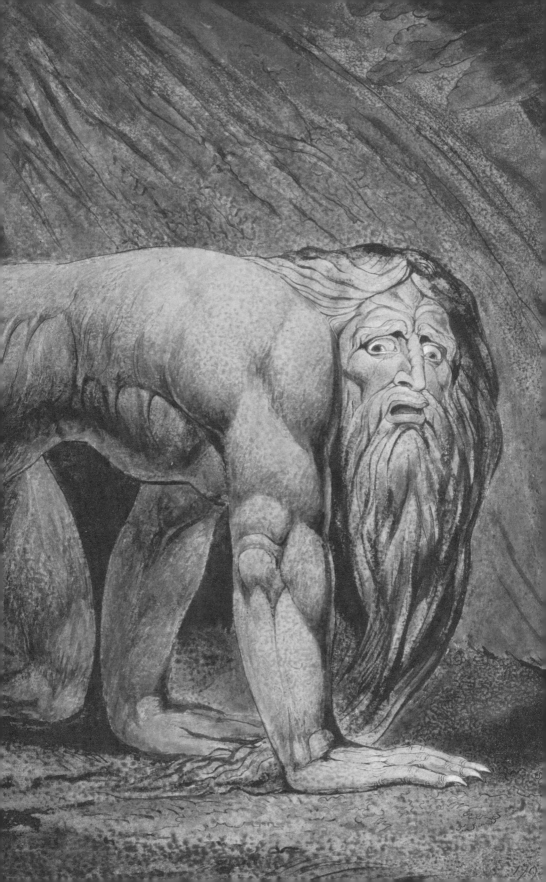

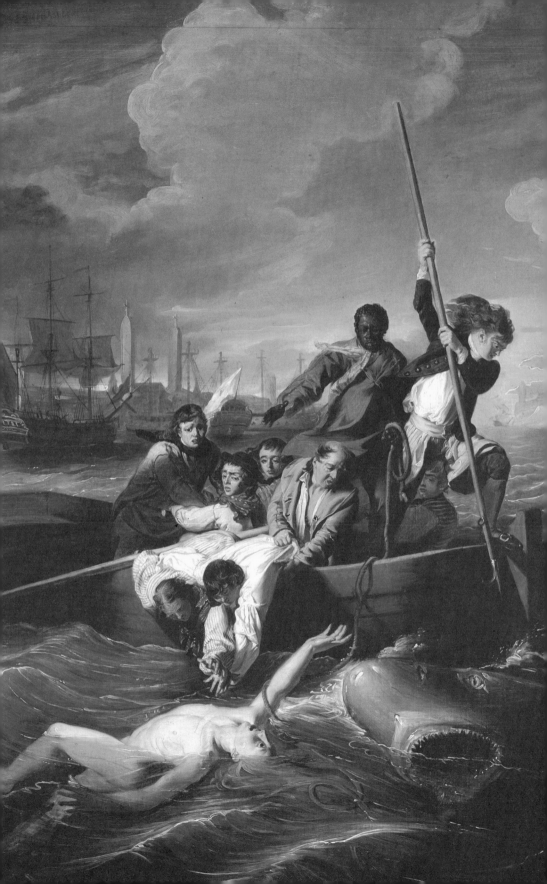

SNIFFING OUT DANGEROUS WATERS

SHARKS SMELL BY SAMPLING the contents of the water they swim through. Water flows in through openings on the outside of the shark's nostrils. Inside the shark's head, the water passes through a funnel-shaped passage into the nasal sacs, which are lined with receptor cells. The sharks do use their other senses, like sight and hearing, to home in on the victims, but smell is their strongest tool to assist them with location. Their ability to smell is remarkably sensitive—they are normally capable of detecting dilutions down to one part blood in twenty-five million parts seawater. Under special circumstances it can be even more sensitive. We have done experiments with black-tipped sharks that had not eaten in a while and were good and hungry. They could detect concentrations of only one part blood in ten billion parts seawater. At that sensitivity, they are capable of detecting blood at quite a distance—at least a hundred metres.

TIM LOW (contemporary), Canada

Watson and the Shark, John Singleton Copley (1738–1815), United States

SHIVA

There is a hawk that is picking the birds out of our sky.
She killed the pigeons of peace and security,
She has taken honesty and confidence from nations and men,
She is hunting the lonely heron of liberty.
She loads the arts with nonsense, she is very cunning,
Science with dreams and the state with powers to catch them at
 last.
Nothing will escape her at last, flying nor running.
This is the hawk that picks out the stars eyes.
This is the only hunter that will ever catch the wild swan;
The prey she will take last is the wild white swan of the beauty of
 things.
Then she will be alone, pure destruction, achieved and supreme,
Empty darkness under the death-tent wings.
She will build a nest of the swan's bones and hatch a new brood,
Hang new heavens with new birds, all will be renewed.

ROBINSON JEFFERS (1887–1962), United States

The Five-Faced Shiva, artist unknown (c.1735), India

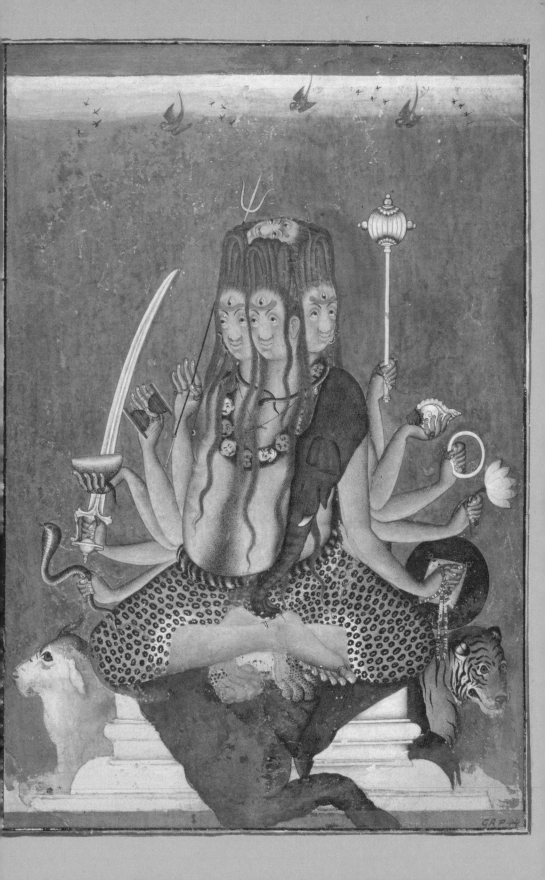

A Child-eating Giant of the Forest

Dzoonokwa is a giant of the forest, or Wild Woman of the Woods. She eats children, stops people from fishing, and encourages war. In one story a young woman comes across a Dzoonokwa catching salmon; she kills her and her family and uses the mother's skull as a bath for her own daughter's ritual empowerment. They were not all evil though; when a Dzoonokwa came across young men she may give them supernatural gifts—a self-paddling canoe, or the water of life.

British Museum Web Citation
author unknown, England

Mask of Dzoonokwa, artist unknown (c.19th century), British Columbia

FROM BEOWULF

Then a powerful demon, a prowler through the dark,
nursed a hard grievance. It harrowed him
to hear the din of the loud banquet
every day in the hall, the harp being struck
and the clear song of a skilled poet
telling with mastery of man's beginnings,
how the Almighty had made the earth
a gleaming plain girdled with waters;
in His splendor He set the sun and the moon
to be the earth's lamplight, lanterns for men,
and filled the broad lap of the world
with branches and leaves; and quickened life
in every other thing that moved.

So times were pleasant for the people there Grendel, a
monster descended
until finally one, a fiend out of hell, from 'Cain's clan',
begins to prowl
began to work his evil in the world.
Grendel was the name of this grim demon
haunting the marches, marauding round the heath
and desolate fens; he had dwelt for a time

in misery among the banished monsters,
Cain's clan, whom the Creator had outlawed
and condemned as outcasts. For the killing of Abel
the Eternal Lord had exacted a price:
Cain got no good from committing that murder
because the Almighty made him anathema,
and out of the curse of his exile there sprang
ogres and elves and evil phantoms
and the giants too who strove with God
time and again until He gave them their reward.

 So, after nightfall, Grendel set out Grendel attacks
Heorot
for the lofty house, to see how the Ring-Danes
were settling into it after their drink,
and there he came upon them, a company of the best
asleep from their feasting, insensible to pain
and human sorrow. Suddenly then
the God-cursed brute was creating havoc:
greedy and grim, he grabbed thirty men
from their resting places and rushed to his lair,
flushed up and inflamed from the raid,
blundering back with the butchered corpses.

 Then, as the dawn brightened and the day broke,
Grendel's powers of destruction were plain:
their wassail was over, they wept to heaven
and mourned under mourning. Their mighty prince,
and storied leader, sat stricken and helpless,
humiliated by the lost of his guard,
bewildered and stunned, staring aghast

at the demon's trail, in deep distress.
He was numb with grief, but got no respite
for one night later merciless Grendel
struck again with more gruesome murders.
Malignant by nature, he never showed remorse.
It was easy then to meet with a man
shifting himself to a safer distance
to be in the bothies, for who could be blind
to the evidence of his eyes, the obviousness
of the hall-watcher's hate? Whoever escaped
kept a weather-eye open and moved away. . . .

 So Grendel waged his lonely war,
inflicting constant cruelties on the people,
atrocious hurt. He took over Heorot,
haunted the glittering hall after dark,
but the throne itself, the treasure-seat,
he was kept from approaching; he was the Lord's outcast.

 AUTHOR UNKNOWN (C.521)
 trans. Seamus Heaney (1939–), Ireland

Altarpiece dragon, Sir Ninian Comper (1864–1960), Scotland

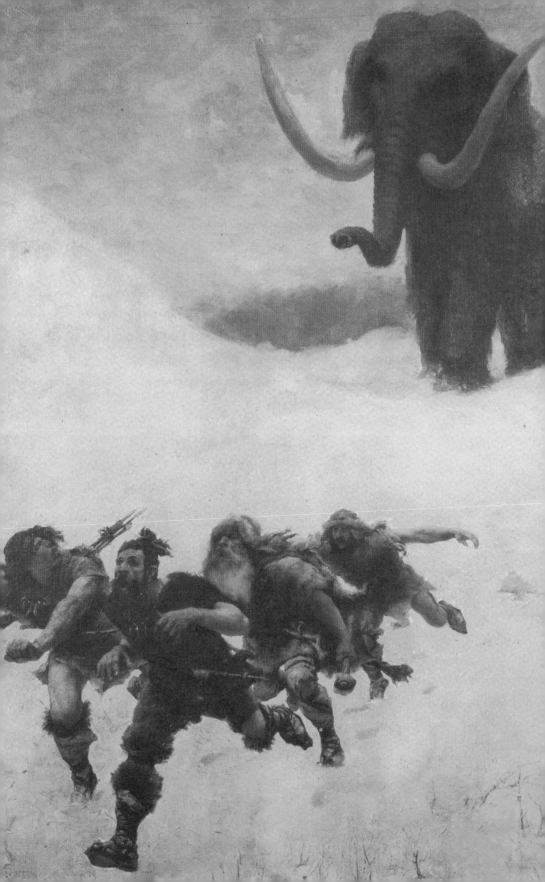

FROM THE THEOGONY OF HESIOD

(ll. 295-305) And in a hollow cave she bare another monster, irresistible, in no wise like either to mortal men or to the undying gods, even the goddess fierce Echidna who is half a nymph with glancing eyes and fair cheeks, and half again a huge snake, great and awful, with speckled skin, eating raw flesh beneath the secret parts of the holy earth. And there she has a cave deep down under a hollow rock far from the death-less gods and mortal men. There, then, did the gods appoint her a glorious house to dwell in: and she keeps guard in Arima beneath the earth, grim Echidna, a nymph who dies not nor grows old all her days.

(ll. 306-332) Men say that Typhaon the terrible, outrageous and lawless, was joined in love to her, the maid with glancing eyes. So she conceived and brought forth fierce offspring; first she bare Orthus the hound of Geryones, and then again

ABOVE: *A description of the nature of four-footed beasts* or *Manticore*, Joannes Jonstonus (1603–1675), Poland

OPPOSITE: *Flight from the Mammoth*, Paul Joseph Jamin (1813–1903), France

she bare a second, a monster not to be overcome and that may not be described, Cerberus who eats raw flesh, the brazen-voiced hound of Hades, fifty-headed, relentless and strong. And again she bore a third, the evil-minded Hydra of Lerna, whom the goddess, white-armed Hera nourished, being angry beyond measure with the mighty Heracles. And her Heracles, the son of Zeus, of the house of Amphitryon, together with warlike Iolaus, destroyed with the unpitying sword through the plans of Athene the spoil-driver. She was the mother of Chimaera who breathed raging fire, a creature fearful, great, swift-footed and strong, who had three heads, one of a grim-eyed lion; in her hinderpart, a dragon; and in her middle, a goat, breathing forth a fearful blast of blazing fire. Her did Pegasus and noble Bellerophon slay; but Echidna was subject in love to Orthus and brought forth the deadly Sphinx which destroyed the Cadmeans, and the Nemean lion, which Hera, the good wife of Zeus, brought up and made to haunt the hills of Nemea, a plague to men. There he preyed upon the tribes of her own people and had power over Tretus of Nemea and Apesas: yet the strength of stout Heracles overcame him.

HESIOD (c.700 BC), Greece

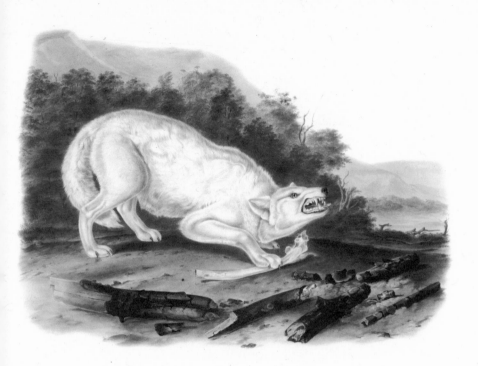

THE WOLVES

There are wolves in the next room waiting
With heads bent low, thrust out, breathing
At nothing in the dark; between them and me
A white door patched with light from the hall
Where it seems never (so still is the house)
A man has walked from the front door to the stair.
It has all been forever. Beasts claw the floor.
I have brooded on angels and archfiends
But no man has ever sat where the next room's
Crowded with wolves, and for the honour of man
I affirm that never have I before. Now while
I have looked for the evening star at a cold window

White Wolf, J.J. Audubon (1785–1851), Haiti / United States

And whistled when Arcturus spilt his light,
I've heard the wolves scuffle, and said: So this
Is man; so—what better conclusion is there—
The day will not follow night, and the heart
Of man has a little dignity, but less patience
Than a wolf's, and a duller sense that cannot
Smell its own mortality. (This and other
Meditations will be suited to other times
After dog silence howls his epitaph.)
Now remember courage, go to the door,
Open it and see whether coiled on the bed
Or cringing by the wall, a savage beast
Maybe with golden hair, with deep eyes
Like a bearded spider on a sunlit floor
Will snarl—and man can never be alone.

ALLEN TATE (1899–1979), United States

FROM STEPPENWOLF

WHEN HARRY FEELS HIMSELF to be a were-wolf, and chooses to consist of two hostile and opposed beings, he is merely availing himself of a mythological simplification. He is no were-wolf at all, and if we appear to accept without scrutiny this lie which he invented for himself and believes in, and tried to regard him literally as a two-fold being and a Steppenwolf, and so designated him, it was merely in the hope of being more easily understood with the assistance of a delusion, which we must no endeavour to put in its true light.

The division into wolf and man, flesh and spirit, by means of which Harry tries to make his destiny more comprehensible to himself is a very great simplification. It is the forcing of a truth to suit a plausible, but erroneous, explanation of that contradiction which this man discovers in himself and which appears to himself to be the source of his by no means negligible sufferings. Harry finds in himself a "human being", that is to say, a world of thoughts and feelings, of culture and tamed or sublimated nature, and besides this he finds within himself also a "wolf", that is to say, a dark world of instinct, of savagery and cruelty, of unsublimated or raw nature.

HERMAN HESSE (1877–1962), Germany

Of the Wolf, Edward Topsell (c.1572–1625), England

A Dragon's Mate

AH, MAIDEN PERSEPHONEIA! You could not
find how to escape your mating! No, a dragon
was your mate, when Zeus changed his face and came, rolling
in many a loving coil through the dark to the corner of the
maiden's chamber, and shaking his hairy chaps: he lulled to
sleep as he crept the eyes of those creatures of his own shape
who guarded the door. He licked the girl's form gently with
wooing lips. By this marriage with the heavenly dragon, the
womb of Persephone swelled with living fruit, and she bore
Zagreus the horned baby, who by himself climbed upon the
heavenly throne of Zeus and brandished lightning in his little
hand, and newly born, lifted and carried the thunderbolts in
his tender fingers.

NONUS (5th century AD), Greece

Dragon, Peterborough Bestiary MS 53 (early 14th century)

The Lampaluaga

When evening came we were all wide awake and sat till a very late hour round the fire we had made in the hollow, sipping maté and conversing. We were all in a talkative mood that evening, and after the ordinary subjects of Banda Oriéntal conversation had been exhausted, we drifted into matters extraordinary-wild creatures of strange appearance and habits, apparitions, and marvellous adventures.

"The manner in which the lampalagua captures its prey is very curious," said one of the company, named Rivarola, a stout man with an immense fierce-looking black beard and moustache, but who was very mild-eyed and had a gentle, cooing voice. We had all heard of the lampalagua, a species of boa found in these countries, with a very thick body and extremely sluggish in its motions. It preys on the larger rodents,

Le Devin, artist unknown (c.1860)

and captures them, I believe, by following them into their burrows, where they cannot escape from its jaws by running.

"I will tell you what I once witnessed, for I have never seen a stranger thing," continued Rivarola. "Riding one day through a forest I saw some distance before me a fox sitting on the grass watching my approach. Suddenly I saw it spring high up into the air, uttering a great scream of terror, then fall back upon the earth, where it lay for some time growling, struggling, and biting as if engaged in deadly conflict with some invisible enemy. Presently it began to move away through the wood, but very slowly and still frantically struggling. It seemed to be getting exhausted, its tail dragged, the mouth foamed, and the tongue hung out, while it still moved on as if drawn by an unseen cord. I followed, going very close to it, but it took no notice of me. Sometimes it dug its claws into the ground or seized a twig or stalk with its teeth, and it would then remain resting for a few moments till the twig gave away, when it would roll over many times on the ground, loudly yelping, but still dragged onwards. Presently I saw in the direction we were going a huge serpent, thick as a man's thigh, its head lifted high above the grass, and motionless as a serpent of stone. Its cavernous, blood-red mouth was gaping wide, and its eyes were fixed on the struggling fox. When about twenty yards from the serpent, the fox began moving very rapidly over the ground, its struggles growing feebler every moment, until it seemed to fly through the air, and in an instant was in the serpent's mouth. Then the reptile dropped its head and began slowly swallowing its prey."

"And you actually witnessed this yourself?" said I.

"With these eyes," he returned, indicating the orbs in question by pointing at them with the tube of the maté-cup

he held in his hand. "This was the only occasion on which I have actually seen the lampalagua take its prey, but its manner of doing it is well known to everyone from hearsay. You see, it draws an animal towards it by means of its power of suction. Sometimes, when the animal attacked is very strong or very far off—say two thousand yards—the serpent becomes so inflated with the quantity of air inhaled while drawing the victim towards it—"

"That it bursts?" I suggested.

"That it is obliged to stop drawing to blow the wind out. When this happens, the animal, finding itself released from the drawing force, instantly sets off at full speed. Vain effort! The serpent has no sooner discharged the accumulated wind with a report like a cannon—"

"No, no, like a musket! I have heard it myself," interrupted Blas Aria, one of the listeners.

"Like a musket, than it once more brings its power of suction to bear; and in this manner the contest continues until the victim is finally drawn into the monster's jaws. It is well known that the lampalagua is the strongest of all God's creatures, and that if a man, stripped to the skin, engages one, and conquers it by sheer muscular strength, the serpent's power goes into him, after which he is invincible."

I laughed at this fable, and was severely rebuked for my levity.

W.H. HUDSON (1841–1922), Argentina/England

THE GRIFFIN

THIS IS CALLED A GRIFFIN, because it is both a feathered
animal and a quadruped. This kind of creature is born in
southern regions or in mountains. In all parts of its body it is
like a lion; its wings and head are like those of an eagle. It is
extremely dangerous to the horse; and it tears apart any men
it sees.

PETERBOROUGH BESTIARY

Griffin, Peterborough Bestiary MS 53 (early 14th century)

he held in his hand. "This was the only occasion on which I have actually seen the lampalagua take its prey, but its manner of doing it is well known to everyone from hearsay. You see, it draws an animal towards it by means of its power of suction. Sometimes, when the animal attacked is very strong or very far off—say two thousand yards—the serpent becomes so inflated with the quantity of air inhaled while drawing the victim towards it—"

"That it bursts?" I suggested.

"That it is obliged to stop drawing to blow the wind out. When this happens, the animal, finding itself released from the drawing force, instantly sets off at full speed. Vain effort! The serpent has no sooner discharged the accumulated wind with a report like a cannon—"

"No, no, like a musket! I have heard it myself," interrupted Blas Aria, one of the listeners.

"Like a musket, than it once more brings its power of suction to bear; and in this manner the contest continues until the victim is finally drawn into the monster's jaws. It is well known that the lampalagua is the strongest of all God's creatures, and that if a man, stripped to the skin, engages one, and conquers it by sheer muscular strength, the serpent's power goes into him, after which he is invincible."

I laughed at this fable, and was severely rebuked for my levity.

W.H. HUDSON (1841–1922), Argentina/England

THE GRIFFIN

THIS IS CALLED A GRIFFIN, because it is both a feathered animal and a quadruped. This kind of creature is born in southern regions or in mountains. In all parts of its body it is like a lion; its wings and head are like those of an eagle. It is extremely dangerous to the horse; and it tears apart any men it sees.

PETERBOROUGH BESTIARY

Griffin, Peterborough Bestiary MS 53 (early 14th century)

MALICIOUS FROGS

BUT BEFORE I PROCEED FURTHER, I am to tell you, that there is a great antipathy betwixt the Pike and some frogs; and this may appear to the reader of Dubravius, a bishop in Bohemia, who, in his book *Of Fish and Fish-ponds*, relates what, he says he saw with his own eyes, and could not forbear to tell the reader, which was:

"As he and the Bishop Thurzo were walking by a large pond in Bohemia, they saw a frog, when the Pike lay very sleepily and quietly by the shore side, leap upon his head; and the frog having expressed malice or anger by his swollen cheeks and staring eyes, did stretch out his legs and embrace the Pike's head, and presently reached them to his eyes, tearing with them, and his teeth, those tender parts: the Pike, moved with anguish, moves up and down the water, and rubs himself against weeds and whatever he thought might quit him of his enemy; but all in vain, for the frog did continue to ride triumphantly, and to bite and torment the Pike till his

Frog, artist unknown

strength failed, and then the frog sunk with the Pike to the bottom of the water: then presently the frog appeared again at the top, and croaked, and seemed to rejoice like a conqueror, after which he presently retired to his secret hole. The bishop, that beheld the battle, called his fisherman to fetch his nets, and by all means to get the Pike that they might declare what had happened: and the Pike was drawn forth, and both his eyes eaten out; at which when they began to wonder, the fisherman wished them to forbear, and assured them he was certain that Pikes were often so served."

IZAAC WALTON (1593–1683), England

Rao Umed Singh Hunting a Boar, artist unknown (c.1790), India

The squirrel that you kill in jest, dies in earnest.
HENRY DAVID THOREAU

Strange to say, he himself was beginning to realize
that his growing sensitivity to the process of nature
also made him more sensitive to the wickedness of men.
JOSEPH ROTH, *Weights and Measures*

6 —

KILLING WITHOUT EATING

The Tablecloth of Civilization

Eisbergfreistadt Souvenir Deck of Cards, Nicholas Kahn and Richard Selesnick (1923/2008)

Santa Fe is a quiet little town, and is kept clean and in good order.
The governor, López, was a common soldier at the time of the revolution,
but now has been seventeen years in power. The stability of government is
owing to his tyrannical habits, for tyranny seems as yet better adapted to
these countries than republicanism. The governor's favourite occupation is
hunting Indians; a short time since he slaughtered forty-eight and sold
the children at the rate of three or four pounds apiece.
CHARLES DARWIN, *The Voyage of the Beagle*

The assumption that animals are without rights and the illusion
that our treatment of them has no moral significance is a
positively outrageous example of Western crudity and barbarity . . .
ARTHUR SCHOPENHAUER, *On the Basis of Morality*

LIKE MOST BOYS OF MY GENERATION I played "guns" or "good guys
and bad guys" with a gang of friends. All of us engaged in the
battle with an earnestness that verged on solemnity. That we were
playing this particular game during the early days of the Second
World War must have given our mock killing and dying a partic-
ular resonance. What I recall even better than the games is my
mother listening to the news, often with other women whose hus-
bands were overseas, as if they didn't want to listen alone. I can still

remember the undercurrent of fear I picked up from them, the fear that their men might be killed, and that Hitler would defeat us.

Four years after the war I had a real gun, my Cooey .22 rifle that was known as a "plinker" because of the sound it made when you hit a tin can. On holidays I wandered the countryside with it, searching for rabbits, squirrels and the occasional crow, although the latter were generally too wary. I was fourteen years old, and I wouldn't call this activity of mine a "killing spree," exactly, but I was certainly callous.

In particular I remember a black squirrel pressed flat against the bole of a tree: holding on with its small legs stretched out on either side of its body, its face turned towards me, its mouth uttering a rattling call of alarm, it flicked its tail angrily. All of this activity stopped when I squeezed the trigger. It's quite possible I didn't even go over to see where it fell. Being an accurate shot, I knew it would be dead, I had no doubt of that, and I certainly wasn't going to eat it or make a hat out of it. I killed atavistically, because I wanted to or needed to. Moreover, killing was easy because I could do it impersonally, without touching flesh and blood. Had I caught a rabbit in my hands, I wouldn't have bludgeoned it to death, or cut its throat.

So what was I up to?

Our long human history of hunting, and our much shorter history of war and pillage, informs many of our games as children. In common with that of most young mammals, our play contains modified elements of risky and often dangerous later adult behaviour. Wolf cubs chase one another, biting at the legs of their fellows as mature wolves do when pursuing a moose, whose hooves in flight can cause serious injury. Puppies nipping at the heels of older dogs—and amenable humans—and kittens elaborately stalking each other or springing playfully onto their mother are acting out

innocent versions of encounters that could have been—in their dark evolutionary past—both dangerous and critically important to them as adults. When I played "guns" as a child, my country was fighting a war that in a very few years could have thrown me into lethal combat: by 1944, when I was ten, the fathers of three close friends had been killed overseas.

Paul Shepard says it this way: "Among the common games of boys is the dramatization of stalking and being stalked, killing and being killed. At about the age of ten the boy's taste for killing and dying is uninhibited and unlimited. In this way the largest and potentially most ominous unknown of his life is taken out of the incomprehensible adult envelope and incorporated as an actuality in his life in a reassuring way—as an event from which he recovers."

OVER THE YEARS my partner and I have regularly gathered wild foods: fiddlehead ferns from quiet riverbanks, young dandelion leaves, lamb's quarters, morels and puffballs, blueberries and wild strawberries. Much of the pleasure involved—apart from the taste and freshness—is the sense that nobody owns the food. It is there for the taking. Perhaps nobody even owns the land in any meaningful way. It's been the same with fishing on canoe trips; we've caught and eaten many a bass and pickerel, which we enjoyed a good deal more than the packaged macaroni and cheese or the tinned luncheon meats that we'd carted with us.

Returning to reliable foraging spots, we've occasionally found that others had been there before us; when that happened, we simply tried somewhere else, because the wild foods weren't ours, at least not until we'd gathered them. Similarly, if you find yourself fishing in the same bay with another boat, and the other fellow pulls up a whopper, you don't feel that he's taken your fish: it's nobody's fish until it is caught.

Our relations with foodstuffs that come from gardens, pastures and barnyards are radically different. Somebody owns all of that, and most likely they've fenced it in. "Good fences make good neighbours," they say, although that probably depends on who it was that built the fence, and why. Significantly the original meaning of the word *fence* is the same as that of *defence*, the act of defending. But *fencing* can also mean an aggressive act, as in the use of a sword.

When she was in grade three in Tuscaloosa, Alabama, our daughter learned the following version of Woody Guthrie's classic song:

> This land is my land, this land ain't your land,
> I've got a shotgun, and you ain't got one.
> If you don't get off, I'll blow your head off
> This land belongs to me alone.

Even the kids knew that good fences made dead neighbours, if those neighbours crossed the property line without permission. Cole Porter's "Don't Fence Me In" is another song, but this one praises the unfettered nomadic life, and laments the way fences constrict us.

When did we begin to fence ourselves in? In 1987 Jared Diamond published an article entitled, "The Worst Mistake in the History of the Human Race." In it he demolishes the progressivist view that the agricultural revolution freed our hunter-gatherer forebears from lives that were "nasty, brutish and short." Using evidence from the work of paleopathologists, Diamond tells us that life expectancy for hunter-gatherers was about twenty-six years, whereas that of early farmers fell to nineteen years. Similarly the height of five-foot-nine for men and five-foot-five for

women that was average towards the end of the ice ages fell to five-foot-three and five-foot for men and women after the agricultural revolution. Skeletons of the period reveal a 50-percent increase in signs of malnutrition, a fourfold increase in signs of anemia, and "a threefold rise in bone lesions reflecting infectious diseases in general . . ."

The evidence is now overwhelming that settling in family groups on specific areas of land was not only bad for our health, but it imposed a regime of relentless drudgery and want, and led to overpopulation and widespread inequalities. All of which continue to bedevil the vast majority of us human animals.

Moreover, the agricultural revolution fundamentally transformed our relationship to the wild natural world. With our growing dependence on the domesticated animals and plants within

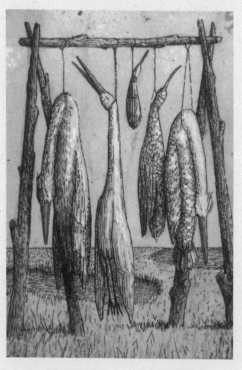

our fences, we came to resent and fear all that we had not bred or planted—all that we had not "cultivated" and "civilized." We came to use the words interchangeably, just as we came to believe that the land and its produce were ours, and that the real animals, the valuable animals, were in our barnyards or pastures, or curled up by our fire.

Wild animals who trespassed for food—coyotes taking sheep, for example, or groundhogs munching spinach—were considered vermin, to be shot on sight. Indeed we decided it was best to kill them before they'd discovered our property: we

have a history of placing bounties on the heads of such wild animals. Over time this practice has morphed into recreational hunting—hunting and killing for fun.

One of the main justifications for so-called "sport"—as opposed to subsistence—hunting, is the cash it brings into rural communities; this argument, of course, is just another way of saying that wild animals are as much ours to dispose of as feedlot cattle and battery hens. They are merely a "resource."

As we have become largely dependent on monocultures, and on our dull, slavishly exploited and commercially useful animal domesticates—and as we have come to share many of these qualities ourselves—we've lost touch with the magic animals of our past, and with them the dynamic and redemptive sense of our collective place in the extraordinary event that is life on earth.

G.G.

Eisbergfreistadt Souvenir Deck of Cards,
Nicholas Kahn and Richard Selesnick (1923/2008)

THE TABLECLOTH OF CIVILIZATION

I RARELY GO TO THE COUNTRY, and almost never for a whole day or to spend the night. But since the friend in whose house I'm staying wouldn't let me turn down his invitation, today I came out here, feeling all embarrassed, like a bashful person going to a big party. I arrived here in good spirits, I've enjoyed the fresh air and wide-open landscape, I ate a good lunch and supper, and now, late at night, in my unlit room, the uncertain surroundings fill me with anxiety.

The window of the room where I'm to sleep looks out on to the open field, on to an indefinite field that is all fields, on to the vast and vaguely starry night, in which a breeze that cannot be heard is felt. Sitting next to the window, I contemplate with my senses the nothingness of the universal life outside. There is, at this hour, a disquieting harmony, extending

Evening Clouds, Graeme Gibson (1934–), Canada

from the visible invisibility of everything to the slightly rough wood of the white sill, where my left hand rests sideways on the old, cracked paint . . .

I don't know if it happens only to me or to everyone who, through civilization, has been born a second time. But for me, and perhaps for other people like me, it seems that what's artificial has become natural, and what's natural is now strange. Or rather, it's not that what's artificial has become natural; it's simply that what's natural has changed.

FERNANDO PESSOA (1888-1935), Portugal

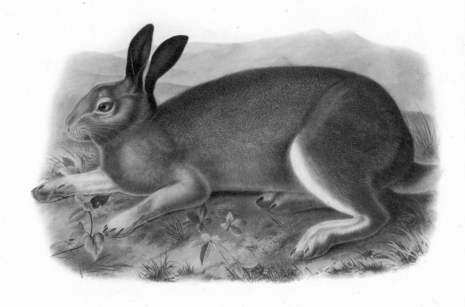

RABBIT CATASTROPHE

No DOUBT THE LADY had just the day before stepped out of the window display of a department store; her doll's face was so dainty, you would have liked to stir it up with a teaspoon just to see it in motion. But you yourself wore shoes with showy, slick, honeycomb soles, and knickers as if tailor-made to measure. At least you delighted in the wind. It pressed the dress against the lady and made a sorry little skeleton of her, a dumb little face with a tiny mouth. Of course she feigned a dauntless look for the benefit of the observer.

Little jackrabbits live unawares beside the white pleats and the thin-as-teacups skirts. Dark green like laurel, the island's epic surrounds them. Flocks of seagulls nest in the

Polar Hare, J.J. Audubon (1785–1851), Haiti / United States

heath hollows like snow blossoms swept by the wind. The lady's little, white-fur-collared, miniature, long-haired terrier is rummaging through the bush, its nose a finger's width above the ground; far and wide there's no other dog to sniff out on the island, there's nothing here but the vast romance of many little, unknown paths that crisscross the island, In this solitude the dog grows huge, a hero. Aroused, he barks dagger-sharp and bares his teeth like some sea monster. Hopelessly, the lady purses her lips to whistle; the wind tears the tiny attempt at a sound from her mouth.

I've already covered glacier paths with just such an impetuous fox terrier; we humans smoothly on our skis, him bleeding, his belly collapsed, cut up by the ice, and nonetheless enlivened by a wild, insatiable bliss. Now this one here has picked up the scent of something; his legs gallop like little sticks, his bark becomes a sob. It's amazing at this moment how much such a flat, sea-swept island can remind one of the great glens and highlands of the mountains. The dunes, yellow as skulls and smoothed by the wind, sit like craggy peaks. Between them and the sky lies the emptiness of unfinished creation. Light doesn't shine on this and that, but spills out over everything as from an accidentally overturned bucket. One is always astonished that animals inhabit this solitude. They take on a mysterious aspect; their little, soft, woolly and feathery breasts shelter the spark of life, It's a little jackrabbit that the terrier is chasing, A little, weather-beaten mountain type; he'll never catch him, I bet. A memory from geography class comes to mind: island? Are we actually standing here on the peak of a high ocean mountain? We ten or fifteen idly observant vacationers, in our colourful madhouse jackets, as the fashion prescribes. I change my mind again and say to

myself, it would all be nothing but inhuman loneliness: Bewildered as a horse that has thrown its rider is the earth wherever man is in the minority; moreover, nature proves itself to be not at all healthy, downright mentally disturbed in the high mountains and on tiny islands. But to our amazement, the distance between the dog and the hare has diminished; the terrier is catching up, we've never seen such a thing: a dog catching up with a hare! This will be the first great triumph of the canine world! Enthusiasm spurs on the hunter, his breath sobs in gulps, there's no longer any doubt that in a matter of seconds he will have caught his prey. The hare pirouettes. Here I recognize in it a certain softness, because the crucial cut is missing in its turn, that it's not a grown rabbit at all, but a harelet, a rabbit child.

I feel my heart; the dog turned too and hasn't lost more than fifteen steps; in a matter of seconds the rabbit catastrophe will occur. The child hears the hunter hot on its tail, it is tired. I want to jump between them, but it takes such a long time for the will to slide down my pant pleats and into my smooth soles; or perhaps the resistance was already in my head. Twenty steps in front of me—I would have had to have imagined it, if the baby rabbit hadn't stopped in despair and held its neck out to the hunter. He dug in with his teeth, swung it a few times back and forth, then flung it on its side and buried his mouth two or three times in its breast and belly.

I looked up. Laughing, heated faces stood around. It suddenly felt like four in the morning after you've danced through the night. The first one of us to wake up from this blood lust was the little terrier. He let go, squinted diffidently to the side, pulled back; after a few steps he fell into a short, timid gallop, as though he expected a stone to come flying

after him. But the rest of us were motionless and disturbed. The insipid air of cannibalistic platitudes hovered around us, like "fight for survival" or "the brutality of nature." Such thoughts, like the shoals of an ocean bottom, though risen from great depths, are shallow. I would have loved to go back and slap the silly little lady. This was a noble sentiment, but not a good one, and so I kept still and thereby joined the general uncertainty and the swelling silence. But finally a tall, well-to-do gentleman picked up the hare with both his hands, showed its wounds to the onlookers and carried the corpse, swiped from the dog, like a little coffin into the kitchen of the nearby hotel. The man was the first step out of the unfathomable and had Europe's firm ground beneath his feet.

ROBERT MUSIL (1880–1942), Austria/Switzerland

(OVERLEAF) *Common Wild Cat*, J.J. Audubon (1785–1851), Haiti/United States

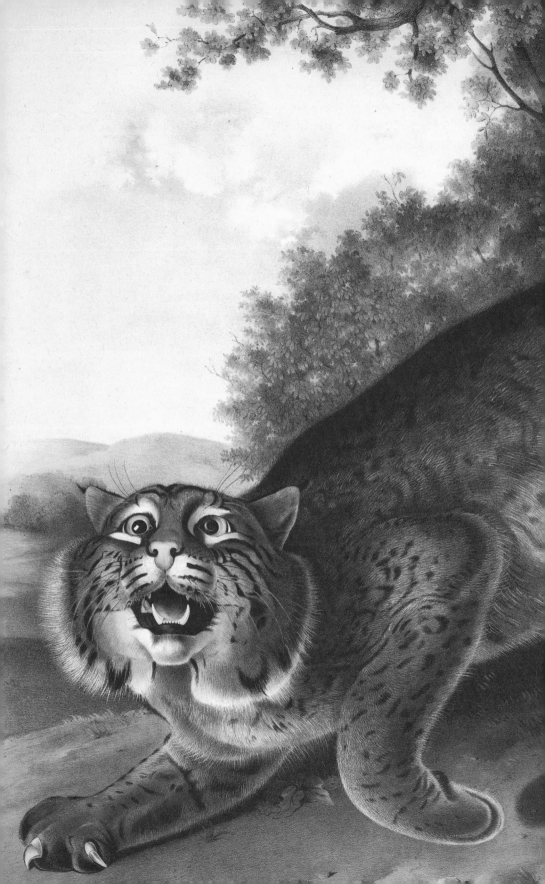

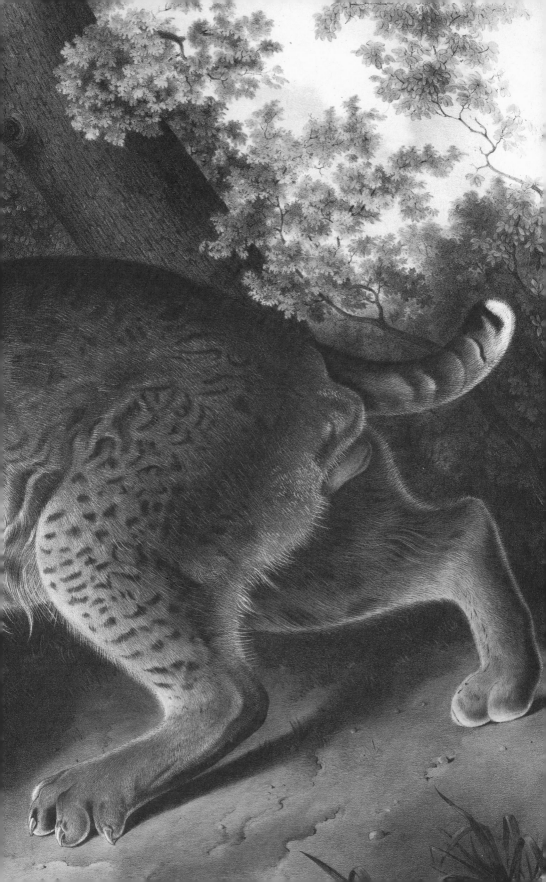

A POSITIVE WAR ON TIGERS

I HAVE NOT BEEN ABLE to locate records of tiger kills of the eighteenth century, but in the nineteenth century, when there was a positive war on tigers, there is no lack of evidence. One George Udney Yule of the Bengal Civil Service killed 400 tigers in 25 years in Bengal after which, although he continued to shoot, he did not think it worth while to continue recording them. In 1830 groups of British soldiers on foot shot 17 tigers during a short summer leave near Booranpur. Colonel Rice, during summer vacations 1850-4, killed and wounded 93 tigers in open forests near Nimach Cantonment. Colonel Nightingale shot nearly 300 tigers up to 1868. A young cavalry officer of the 7th Hussars shot 42 tigers in two summer vacations. Gordon Cumming shot 73 tigers in one district of Narbada in two years (1863-4), sometimes killing two in one day over a period of five days. Montague Gerard had accounted for 227 tigers in Central India and Hyderabad by 1903.

This slaughter, though undeniably done for "sport", was justified in the murderers' eyes since the tiger had been declared vermin. A bounty was paid and the "pariah" people of the hill tribes of Bengal took up tiger killing as a profession. In Bombay Presidency (Maharashtra) 1053 tigers were killed by villagers between 1821-8. These claimed their reward, but there must have been as many tigers killed in remote places where it was impossible to claim the bounty.

Even poison was resorted to, and in 1874 no less than 93 tigers died in this way under an operation conducted by the official tiger-slayer Captain Caulfield and approved by the British Government. Captain Caulfield's job was to locate and poison the tiger's own kills, but he also resorted to poisoning baits which not only killed tigers and tigresses but cubs as well. It was a war waged on the species as a whole.

In Mysore State the bounty paid for killing a tiger was RS 60, which was twelve times higher than the monthly salary of a forest guard. The incentive to kill can be imagined, and any lethal method likely to gain results was promptly adopted.

The traditional Mughal type of hunting was replaced by the Western style during the time of the British Raj, and the wealthy nawabs, rajas and maharajas joined with the British in the slaughter. Each one of them wanted the status symbol of scoring a century, and then to repeat it as many times as possible.

The late Maharaja of Surguja killed 1707 tigers during his lifetime (up till 1958), and held the record for the "highest score". In the small States of Bundi and Kotah the slaughter between the late twenties and early sixties was appalling. Only in the Alwar forests was tiger hunting limited to the killing of four to six per year because the Maharaja appears to have known the principles of harvesting and replacement. He was declared insane (for other reasons also!) by the British Government and removed from power, whereupon the regency government started killing tigers with a vengeance.

KAILASH SANKHALA (1925–1994), India

SURPLUS KILLING

WOLVES SOMETIMES KILL all out of proportion to their need for food. That this is also an eerie human trait is suggested by the behaviour of buffalo hunters in the nineteenth century. Under peculiar circumstances, having to do with wind, perhaps—no one really knows—a herd of buffalo would remain placid while a hunter dropped animal after animal in its midst. The sight of blood and the bellowing of the wounded did nothing to disturb them. They remained oblivious until something—a gust of wind, the sight of so many carcasses—finally stampeded them. A hunter would commonly shoot until his gun barrel overheated and threatened to explode. The men who made such stands later recalled being absolutely mesmerized by the apparent oblivion, that the moment seemed utterly suspended. When the buffalo finally reacted, the almost mindless impulse to shoot abated immediately and a feeling of remorse overcame them.

BARRY LOPEZ (1945–), United States

The Hunters at the Edge of Night (detail), René Magritte (1898–1967), Belgium

The Curse

HE KILLED BEARS WITH A KNIFE, bulls with a hatchet, and wild boars with a spear; and once, with nothing but a stick, he defended himself against some wolves, which were gnawing corpses at the foot of a gibbet.

One winter morning he set out before daybreak, with a bow slung across his shoulder and a quiver of arrows attached to the pummel of his saddle. The hoofs of his steed beat the ground with regularity and his two beagles trotted close behind. The wind was blowing hard and icicles clung to his cloak. A part of the horizon cleared, and he beheld some rabbits playing around their burrows. In an instant, the two dogs

King Ashurnasirpal, Neo-Assyrian frieze (883–859 BC), Iraq

were upon them, and seizing as many as they could, they broke their backs in the twinkling of an eye.

Soon he came to a forest. A woodcock, paralysed by the cold, perched on a branch, with its head hidden under its wing. Julian, with a lunge of his sword, cut off its feet, and without stopping to pick it up, rode away.

Three hours later he found himself on the top of a mountain so high that the sky seemed almost black. In front of him, a long, flat rock hung over a precipice, and at the end two wild goats stood gazing down into the abyss. As he had no arrows (for he had left his steed behind), he thought he would climb down to where they stood; and with bare feet and bent back he at last reached the first goat and thrust his dagger below its ribs. But the second animal, in its terror, leaped into the precipice. Julian threw himself forward to strike it, but his right foot slipped, and he fell, face downward and with outstretched arms, over the body of the first goat.

After he returned to the plains, he followed a stream bordered by willows. From time to time, some cranes, flying low, passed over his head. He killed them with his whip, never missing a bird. He beheld in the distance the gleam of a lake which appeared to be of lead, and in the middle of it was an animal he had never seen before, a beaver with a black muzzle. Notwithstanding the distance that separated them, an arrow ended its life and Julian only regretted that he was not able to carry the skin home with him.

Then he entered an avenue of tall trees, the tops of which formed a triumphal arch to the entrance of a forest. A deer sprang out of the thicket and a badger crawled out of its hole, a stag appeared in the road, and a peacock spread its fan-shaped tail on the grass—and after he had slain them all, other

deer, other stags, other badgers, other peacocks, and jays, blackbirds, foxes, porcupines, polecats, and lynxes, appeared; in fact, a host of beasts that grew more and more numerous with every step he took. Trembling, and with a look of appeal in their eyes, they gathered around Julian, but he did not stop slaying them; and so intent was he on stretching his bow, drawing his sword and whipping out his knife, that he had little thought for aught else. He knew that he was hunting in some country since an indefinite time, through the very fact of his existence, as everything seemed to occur with the ease one experiences in dreams. But presently an extraordinary sight made him pause.

He beheld a valley shaped like a circus and filled with stags which, huddled together, were warming one another with the vapour of their breaths that mingled with the early mist.

For a few minutes, he almost choked with pleasure at the prospect of so great a carnage. Then he sprang from his horse, rolled up his sleeves, and began to aim.

When the first arrow whizzed through the air, the stags turned their heads simultaneously. They huddled closer, uttered plaintive cries, and a great agitation seized the whole herd. The edge of the valley was too high to admit of flight; and the animals ran around the enclosure in their efforts to escape. Julian aimed, stretched his bow and his arrows fell as fast and thick as raindrops in a shower.

Maddened with terror, the stags fought and reared and climbed on top of one another; their antlers and bodies formed a moving mountain which tumbled to pieces whenever it

The Hind in the Wood, Walter Crane (1845–1915), England

233

displaced itself. Finally the last one expired. Their bodies lay stretched out on the sand with foam gushing from the nostrils and the bowels protruding. The heaving of their bellies grew less and less noticeable, and presently all was still.

Night came, and behind the trees, through the branches, the sky appeared like a sheet of blood.

Julian leaned against a tree and gazed with dilated eyes at the enormous slaughter. He was now unable to comprehend how he had accomplished it.

On the opposite side of the valley, he suddenly beheld a large stag, with a doe and their fawn. The buck was black and of enormous size; he had a white beard and carried sixteen antlers. His mate was the colour of dead leaves, and she browsed upon the grass, while the fawn, clinging to her udder, followed her step by step.

Again the bow was stretched, and instantly the fawn dropped dead, and seeing this, its mother raised her head and uttered a poignant, almost human wail of agony. Exasperated, Julian thrust his knife into her chest, and felled her to the ground.

The great stag had watched everything and suddenly he sprang forward. Julian aimed his last arrow at the beast. It struck him between his antlers and stuck there.

The stag did not appear to notice it; leaping over the bodies, he was coming nearer and nearer with the intention, Julian thought, of charging at him and ripping him open, and he recoiled with inexpressible horror. But presently the huge animal halted, and, with eyes aflame and the solemn air of a patriarch and a judge, repeated thrice, while a bell tolled in the distance: "Accursed! Accursed! Accursed! some day, ferocious soul, thou wilt murder thy father and thy mother!"

Then he sank on his knees, gently closed his lids and expired.

At first Julian was stunned, and then a sudden lassitude and an immense sadness came over him. Holding his head between his hands, he wept for a long time.

His steed had wandered away; his dogs had forsaken him; the solitude seemed to threaten him with unknown perils. Impelled by a sense of sickening terror, he ran across the fields, and choosing a path at random, found himself almost immediately at the gates of the castle.

That night he could not rest, for, by the flickering light of the hanging lamp, he beheld again the huge black stag. He fought against the obsession of the prediction and kept repeating: "No! No! No! I cannot slay them!" and then he thought: "Still, supposing I desired to?—" and he feared that the devil might inspire him with this desire.

GUSTAVE FLAUBERT (1821–1880), France

It's Autumn

It's autumn. The nuts patter down.
Beechnuts, acorns, black walnuts—
tree orphans thrown to the ground
in their hard garments.

Don't go in there,
into the faded orange wood—
it's filled with angry old men
sneaking around in camouflage gear
pretending no one can see them.

Some of them aren't even old,
they just have arthritic foreheads,
or else they're drunk,
but something's got to suffer
for their grudges, their obscure sorrows:
the more blown-up flesh, the better.

They'll shoot at any sign of movement—
your dog, your cat, you.
They'll say you were a fox or skunk,
or duck, or pheasant. Maybe a deer.

They aren't hunters, these men.
They have none of the patience of hunters,
none of the remorse.
They're certain they own everything.
A hunter knows he borrows.

I remember the long hours
crouching in the high marsh grasses—
the grey sky empty, the water silent,
the hushed colours of distant trees—
waiting for the rush of wings,
half-hoping nothing would happen.

MARGARET ATWOOD (1939–), Canada

From *Tacuinum Sanitas*, artist unknown

KILL AND NOT EAT

COMMANDING GENERAL OF THE ARMY William Tecumseh Sherman wrote that the expansion of the open-range cattle industry was a decisive factor for the United States' conquest of the Far West. "This was another potent agency in producing the result we enjoy to-day," he wrote, "in having in so short a time replaced the wild buffaloes by more numerous herds of tame cattle, and by substituting for the useless Indians the intelligent owners of productive farms and cattle-ranches". . .

Plains Indians had long hunted the buffalo, and the level of their hunting greatly increased with the development of an equestrian Indian culture in the eighteenth century. From a peak of perhaps thirty million, the number of buffalo had declined to some ten million by the mid-nineteenth century.

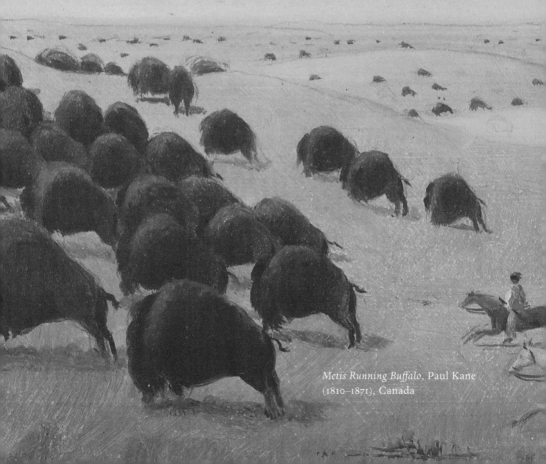

Metis Running Buffalo, Paul Kane
(1810–1871), Canada

This occurred partly as a result of Indians over-hunting them, but also because growing herds of wild horses increased their environmental competition and because cattle crossing with settlers on the Overland Trail introduced bovine diseases to the herds. By overgrazing, cutting timber, and fouling water sources, overland migrants also contributed significantly to the degeneration of habitats crucial for the buffalo's health and survival. By the 1860s, the confluence of these factors produced a crisis situation for buffalo-hunting Indians. Tribal spokesmen protested the practice of hunters who killed for robes, leaving the meat to rot on the Plains. "Has the white man become a child," the Comanche Chief Satanta complained to an army officer in 1867, "that he should recklessly kill and not eat!" But such actions were more due to cynical guile than childish whim. "Kill every buffalo you can!" Colonel Richard Dodge urged a sport hunter in 1867. "Every buffalo dead is an Indian gone."

WILLIAM TEMPLE HORNADAY
(1854–1937), United States

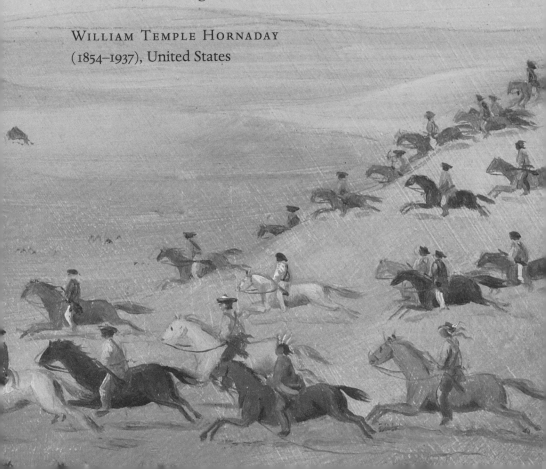

CIRCUS

Look, your longing swung from the trapeze.
The clown is you as well and the tame tiger
who begs for mercy calls someone to mind.
Even the tin-pot music
Has its charm; it seems
you're starting to make peace
with your times (everyone else has,
why not me?—you say).
So why then does the circus tent
rise above an ancient graveyard?

ADAM ZAGAJEWSKI (1945–), Poland

Lion and porcupine, Villard de Honnecourt (1190–1235), France

LEO

Veci · i · lion si com
on le voit p devant
z saciés bien q̃l fu
contrefais al vif.

Veci · i · porc espi ·
c'est une biestelete
q̃ lance se soie q̃nt
ele ⁊ corecie ·

KILLERS IN OUR MIDST

IN MARCH 2001, an Alberta television station aired a newscast depicting Alvin Harter and his wife, Lucy, engaging in their favourite weekend pastime: killing coyotes. The camera took us along on one of the Harters' outings. It showed them spotting a coyote and letting their six hunting dogs out of their cages in the back of their truck. It followed the Harters and their dogs as they bounded across the prairie after their quarry, baying excitedly (the dogs, that is, although the Harters were fairly agitated, too). It closed in graphically on four of the dogs grabbing each of the coyote's legs while the other two chewed on her throat and belly. "Good boys", we heard Alvin Harter say off-camera. Then it was back in the truck to find another victim. The dogs caught four coyotes in a single afternoon, When they were too slow to kill one of them, a female in oestrus, Lucy herself waded into the melee to finish the job with a hammer.

The Harters had been hunting coyotes in this fashion for many years—"It keeps us young," said the seventy-three-year-old Alvin—adding that they were welcome on most farms in

PREVIOUS PAGES: *A Sandringham Banquet,* artist unknown, England

244

the Edmonton area. "The only people who object to it are little ladies with pink hats who live in apartment buildings," he said, which isn't quite true unless the SPCA and Alberta's environment ministry are people entirely with little ladies in pink hats. When Al Gibson, a wildlife biologist with the ministry, deplored the Harters' hobby as "an archaic practice," Alvin replied, "I don't want to kill all the coyotes in the area, I just want to have fun."

WAYNE GRADY (1948–), Canada

A deer hunt mosaic, signed Gnosis (late 4th century BC), Pella

A Form of Vandalism

SOMEDAY HUNTING BIG GAME may come to be regarded as a form of vandalism, and the remaining big creatures of the wilderness will skulk through restricted reserves wearing radio transmitters and numbered collars, or bearing stripes of dye, as many elephants already do, to aid the busy biologists who track them from the air. Like a vanishing race of trolls, more report and memory than a reality, they will inhabit children's books and nostalgic articles, a special glamour attaching to those, like mountain lions, that are geographically incalculable and may still be sighted away from the preserves. Already we've become enthusiasts. We want game about us— at least at a summer house; it's part of privileged living. There is a precious privacy about seeing wildlife, too. Like meeting a fantastically dressed mute on the road, the fact that no words are exchanged and that he's not going to give an account makes the experience light-hearted; it's wholly ours. Besides, if anything out of the ordinary happened, we know we can't expect to be believed, and since it's rather fun to be disbelieved—fishermen know this—the privacy is even more

Englishman on an Elephant, artist unknown (c.1830), India

complete. Deer, otter, foxes are messengers from another condition of life, another mentality, and bring us tidings of places where we don't go.

Ten years ago at Vavenby, a sawmill town on the North Thompson River in British Columbia, a frolicsome mountain lion used to appear at dusk every ten days or so in a bluegrass field alongside the river. Deer congregated there, the river was silky and swift, cooling the summer air, and it was a festive spot for a lion to be. She was thought to be a female, and reputedly left tracks around an enormous territory to the north and west—Raft Mountain, Battle Mountain, the Trophy Range, the Murtle River, and Mahood Lake—territory on an upended, pelagic scale, much of it scarcely accessible to a man by trail, where the tiger lilies grew four feet tall. She would materialize in this field among the deer five minutes before dark, as if checking in again, a habit that may have resulted in her death eventually, though for the present the farmer who observed her visits was keeping his mouth shut about it. This was pioneer country; there were people alive who could remember the time when poisoning the carcass of a cow would net a man a pile of dead predators—a family of mountain lions to bounty, maybe half a dozen wolves, and both black bears and grizzlies. The Indians considered lion meat a delicacy, but they had clans which drew their origins at the Creation from ancestral mountain lions, or wolves or bears, so these massacres amazed them. They thought the outright bounty hunters were crazy men.

EDWARD HOAGLAND (1932–), United States

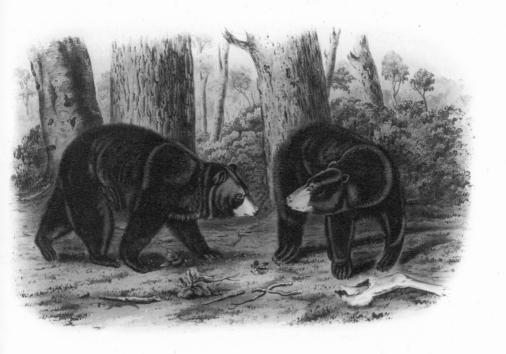

FROM "THE GENERATION OF HUNTERS"

WE HAD ALWAYS BEEN BOTHERED by bears while berry pick-
ing. That year my father left me with the 306 and just four
shells. "Don't waste anything you don't have to," he said.
"You're in a war."

That war had been going on for what seemed forever to
me. As soon as it was over I was going to get to practise real
shooting again, instead of just sighting and squeezing. As
soon as it was over, I told myself, a lot of things would
change. It was 1943; I was fifteen years old.

"Take care of yourselves," my father said.

Black Bears, J.J. Audubon (1785–1851), Haiti/United States

Ginny cried some. The other girls were older.

"Don't tire yourself out on the drill floor," my mother said to him.

Which wasn't what she meant. In late summers like this, when the blueberries came ripe, we would go to my father's hunting shack for what my mother called a shit-and-haddock vacation. "Shit-and-haddock vacations," she would say, "are what you get when you marry a drill sergeant instead of a pilot lieutenant."

Aunt Virginia had married a bush pilot from Duluth who was now overseas and sending back more money than enough. She got around all the bars in Duluth and told tales to my mother. "What he's drilling during the day," she would say, "may be wearing pants; but let me tell you honey, at night the drilling ain't through khaki. Cotton, or maybe silk. Midnight black or sin time red. Better believe it, honey."

Out on the blueberry hills at least we kept to our own schedule. We escaped the driving rages my father brought home from the drill hall. We escaped the bitterness my mother mortared back at him. Early in the morning we found a rich area and picked until noon. Then we went back to the shack for lunch and sorted the berries into two grades. In the afternoon we would sometimes go out again for more. Or swim in the river.

With the 306 in my hands, I didn't feel like a picker. I was the sentry and there were Germans everywhere. Always four of them. I would get the first three quick, always in a vital. Instantaneous death. Heart or head for hellshots; legs for the lazy; stomachs for sadists. I didn't even know what a sadist was. I was a hellshot.

Except if I didn't pick, my mother drove Ginny and the

other girls something terrible. It was her only way of getting to me.

"Come on, general," she would say. "We need one man, at least."

I would lay the 306 nearby and pick, with my eyes roving through the woods like a searchlight. Or so I thought. We weren't bothered until the Saturday of the third week. My father was due Sunday morning. The two cubs and the old lady had got half way to the big bush we were working on before I saw them. It was almost like I had planned. I moved off from the bush to keep my line clear. My stomach was on the moss; my elbows on flat granite. I remembered everything my father had showed me those years before the war, when he knew the war was coming and didn't know how long it would last and wanted me to be a hellshot before shells got too rationed.

I hit the first cub clean, and while the old lady bent over him, I hit the second one clean. And she roared at that; a sound like a dog trying to say ground. She came toward the sound of the gun; stood up on her back legs to see where I was. So I got her in the stomach. It wasn't where I'd wanted to, but it was where I'd hit her. I could almost see her pain. Like the first time I'd had beer. She went back to the cubs and then she went back to the woods. Loping like a man hid in a gorilla suit.

I knew she wouldn't go far, which was my mistake. Because I could have got her in the head, through the back of the brain, easy enough. But I wanted to have that fourth shell still there when my father got back, and instead it was a week and a day before we found that old lady. Alone, I lost her even before it got dark.

All that next Sunday my father made me walk with him and didn't say a word, so that I felt like I lived in a house with a stopped-up toilet. Which was what he wanted. All that week I didn't pick because I was sure I could find her, but I couldn't.

And the next Sunday, when we did find her, I found out what my father meant about gut-shots, about stomachs for the sadists. She was in a little swampy hollow. "Any animal goes low to die," my father said. And she was covered with swarms of blackflies; so that trying to see her was like trying to get to your bed in a strange room. My father took out the skull and cleaned it. The stench made me want to be sick, but I knew what he would say. I got the gun ready. For then he did what I knew he would do. He set the skull up at 100 yards and made me put the shell I'd thought I'd saved into it, into the shattering bone and brain matter.

"Sometimes you have to waste something," he said.

When the war was over, my father left for Oregon. "Your mother can look after the girls," he told me. "You'll be okay on your own." I knew I would be.

DAVE GODFREY (1938–), Canada

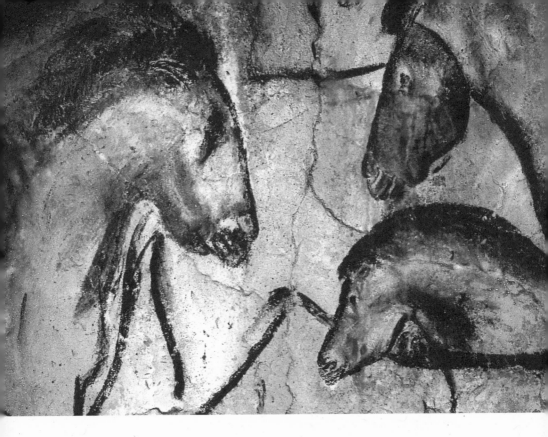

1667 August 20

THERE WAS NOW A VERY GALLANT HORSE to be baited to death with doggs, but he fought them all, so as the fiercest of them, could not fasten on him, till they run him thro with their swords. This wicked and barbarous sport, deserv'd to have ben published in the cruel Contrivers, to get money, under pretence the horse had killed a man, which was false. I would not be perswaded to be a Spectator.

JOHN EVELYN (1620–1706), England

Cave horses, Chauvet, France

TO A CHEETAH IN THE MOSCOW ZOO

Furs this expensive you normally only find wrapped around
the shoulders
Of gangsters' molls outside the casino, movements this slinky
Only on the catwalk from the androgynous models,
Eyes dilating in the flashbulbs. As lean a feline
As Pisanello once painted with a ravished brush
(The fur spotted, whiskery, a golden fleece).
She sashays swishing up and back. Her spine measures out
The least movement.

Cheetah Siesta, Robert Bateman (1930–), Canada

<div align="center">To change direction</div>

Millimeters in front of the ditch is something for which
She doesn't even need eyes. There's nothing out there
For the ear or the sensitive nose but the noise and sweat
Beyond the wire fence, where those monkeys congregate
With their baby carriages at visiting time. Her breath
Coming hard, she magics the fetor of the metropolis
Into a charmed ozone . . . the white ribbons
In the girls' hair into strips of gazelle meat. Her fine head,
No bigger than your fist, keeps its alert posture
As she spies zebras in the flickering at the gates of Moscow.
Then she yawns, the prisoner of the cement.

DURS GRÜNBEIN (1962–), Germany

Spreading Terror Among The Ladies . . .

A SIMILAR HAIRLESS BUFFALO is used in the "tiger versus buffalo" fights which are a national pastime in Java. The contest takes place on any open space; neither time nor expense is entailed in making the enclosure, which is formed by the bodies and weapons of the spectators. The tigers are brought to the ground in long, narrow, bamboo cages like Gargantuan rat traps, and through the open lattice are prodded to fury before their release upon the buffalo, which defends itself with its horns. The buffalo usually wins, to the great delight of the Javanese, who consider it typical of themselves, just as the tiger is taken as a type of their Dutch masters.

The Rampoc, or tiger fight waged against men, is a Court ceremonial no doubt developed from the charges and occa-

Pistrix, Giovanni Vendremin Severo (15th century)

sional escapes of the tiger in the sort of encounter described above. The royal bodyguard, in four ranks and armed with long pikes, forms a square of fifty yards, in the centre of which the tiger cage is deposited covered with straw. The door is held in place by a rope of equally inflammable material.

The Court being assembled, two officials of high rank walk in sedately to the sound of music, fire the straw, and return equally composedly back to the ranks that open to receive them. Meanwhile, the tiger, maddened by burns and fear, is bounding frantically in the cage until the door falls, when it is sure to leave at once. Outside it may, and often does, hesitate; it looks round for a foe on which to vent its fury, and dashes, as a rule, for the two men whose isolation marks them for attack. It is received on the spears, and not uncommonly is impaled by its own leap and weight.

It may dash, again and again, against the serried ranks before it meets death, or, on very rare occasions, it may avoid the foremost spears and fall mangled and infuriated outside the square, spreading terror among the ladies, who are there watching the fight from their carriages.

GEORGE JENNISON (1872–1938), England

Bears, Peterborough Bestiary MS 53 (early 14th century)

FOUR HUNDRED BEARS

IN 1749, white settlement of the county began in earnest. Narrow farms (only 177 metres wide) were surveyed along the Detroit River north of River Canard. The establishment of the Indian and French settlements, along with the need to provision the fort, initiated the succession of local extinction that continues today. Elk, bear, cougar and beaver were the first to succumb. Pierre Charlevoix, one of the Jesuits, claimed that 400 bears were killed at Point Pelee in the winter of 1791 alone!

GERALD WALDRON (1947–), Canada

No one thinks of a herd of bears, a drove of tigers, or a flock of eagles. Our image of these animals is as individuals, as part of a singular grandeur, whose uniqueness of powers and spirit would be degraded by their gathering in crowds.

<div align="right">PAUL SHEPARD</div>

7 —

WHAT
IMMORTAL HAND
OR EYE

Great Hunters

Tiger, John Dickson Batten (1860–1932), England

At one time in this world of prey, predators, co-predators and camp followers
there was a perfect balance, without conflict. Even man was in tune with
nature, hunting with his crude weapons and also feeding on the left-overs
which he shared with jackals and vultures. He was part of the ecology of
tigerland. But now, with his population explosion, technical achievements and
greed in storing for the future, he has become not only the dominant predator
in tigerland but a consumer of the actual habitat. From his position it
is obvious that he is no more a part of the ecology of tigerland but a
defier of natural laws. The result is clear: his own position is in peril.
KAILASH SANKHALA

THERE CAN BE NO WILDERNESS without alpha predators. Their role at the top of the food chain is a necessary precondition for the rich and complex web of interdependency that characterizes all spaces that are truly wild. By taking the weaker animals, predators maintain the health of prey communities; as a result, they strengthen its gene pool. Where wolves have been extirpated, the deer population explodes, and over-browsing transforms a traditional woodland. Not only is vegetation growing on the forest floor consumed, but so are leaves and branches as high as the deer can reach. As a consequence, forest regeneration is seriously impeded. In such cases, one might say the deer have begun to domesticate the wilderness.

An unregulated deer population produces an increasing number of hungry and eventually debilitated animals, thus weakening the collective gene pool. Hunting by humans isn't the answer, if only because we invariably try to kill the genetically important individuals—animals with the most fat, for example, or bucks with the largest racks of antlers.

HUMANKIND HAS BEEN PREYED UPON by large flesh-eating hunters since the beginning. We have been their meat, and they our nightmares. At the same time, we have revered their authority and their apparent assurance, along with their unequalled physicality; as a result we have taken them to represent the royal virtues of nobility, courage and grace. The lion, according to Dr. Johnson's dictionary, is "the fiercest and most magnanimous of four-footed beasts."

Great predators have always been more than mere animals in the bestiary of our psyches: the lion's strength, its hunting efficiency and its traditional association with humans ranks it among the symbolic descendants of *Dinofelis*, that specialist devourer of our forebears. Like Leviathan, the Biblical dragon—or crooked serpent " . . . who is a king over all the children of pride"—carnivorous beasts have traditionally served to humble human beings.

THE MACKENZIE MOUNTAIN BARRENS lie where the disintegrating Canol Road—built after Pearl Harbor in the Second World War to facilitate an inland oil pipeline—crosses from Canada's Northwest Territories into the Yukon. At 5000 feet, the area is a majestic, relatively undisturbed landscape of tundra encircled by snow-capped mountains. Expansive and treeless, it's the kind of place where you can watch your dog running away for three days, as they say on the Prairies.

One summer my partner identified more than forty varieties of wildflowers in bloom at once. The perfectly shaped poppies are less than two inches tall, and on the high ground ninety-year-old willow trees—their boles no bigger than my little finger—lie flat on the ground like skeletal fans. Wolves, white-phase gyrfalcons, wolverine, caribou and ptarmigan are all to be seen. Although grizzly bears are sensibly elusive, they're out there on the land: returning from walks we'd find their formidable paw tracks covering the imprints left by our boots on the way out. Whether the animals were following us or merely using the abandoned road is unknown.

From the lodge on a modest hill the land appears flat and open, but once you descend into it there are mounds and ridges, some of them more than twelve feet high. Circling around one of them our small group was confronted by an astonishing sight: the whole back of the palsa—a raised peat mound—had been destroyed by a grizzly in search of ground squirrels in their burrows and tunnels. Unable to catch any, the bear obviously had lost its temper: it looked as if a bulldozer had ploughed more than twenty yards along the base of the mound, slicing six feet into the earth to a height of eight feet or more, but that extraordinary animal had done it with its claws alone, casting the soil violently behind it as it went. Contemplating the power involved in moving all that earth, and imagining the quality of the animal's rage, we stood in awe. Even our companions—biologists who had often worked with both grizzly and polar bears—were impressed.

We'd been on the land nearby when this literally earth-shaking event had occurred. Where was the bear? During the week we'd encountered its tracks on the road, and a substantial pile of fresh scat by a rocky outcrop. We'd later seen moisture still seeping into deep paw marks in the spongy tundra. But there'd been no sign of the beast itself, although we'd felt its potential threat everywhere.

This sense of an august and dangerous presence out there on the land—one that doesn't reveal itself except by leaving warning signs—is haunting. It isn't hard to imagine how our earliest ancestors arrived at the need to appease unseen powers.

When we finally did see the grizzly it was at some distance, and moving smartly away up the side of a long hill. It must have smelled our approach, because from time to time it paused, raising and turning its head in our direction and sniffing the air before setting off again at a faster pace. These bears are hunted in the Barrens, as they are almost everywhere else, so the animal's concern was understandable. But if indeed it was the same creature that had been leaving tracks near the lodge, why had it come so close? Was its curiosity about us equal to ours about it, or was it simply hungry?

Until about 10,000 years ago, our forebears lived and hunted in small family groups, just as wolves and lions do. Indeed we may possibly have adopted our social structure from them when we left the forest for the savannah. In the event, 10,000 years is a blink of an eye. As Ronald Wright observed, "If we picture the 5 or 6 million years since humans and other apes parted company as a single day, we have achieved civilization in the last minute and a half. And industrial civilization—which is not much older than the United States itself—arose only in the last five seconds."

For ages we humans lived with all the benefits enjoyed by small-group species moving on the land. Jared Diamond (among others) has pointed out that we were relatively free from the epidemic diseases that need large groups or herds in which to breed; we faced far less chance of death by starvation because we had a more varied diet, and more freedom to move than the farmers that followed; and, perhaps most important, we regulated, and therefore stabilized our population growth.

Paul Shepard makes an excellent case that our respect for the individual also evolved in that unhurried passage of time. "The primate order, to which man belongs, has carved out a way of life based on the intense interaction of individuals. The large carnivorous mammals the world over also live in such a personal cosmos, having the capacity to function in isolation and as group members. Human ecology emerged with the addition of the knife edge of carnivore cunning to the elegant foundation of primate sociality."

What's happened to us since we've become civilized? While those of us with resources and opportunity have a sense of comfort and relative security, the growing majority of the poor on earth have no such hope. After evolving as light-footed, individualistic species, we find ourselves increasingly living like ants, which is doing us no good. Max Beerbohm once remarked, "The ant sets an example to us all, but it is not a good one." In exchange for the deeply mixed values of civilization, we've lost much of our elemental sense of belonging, along with the skills and sense of reverence for nature that evolved during our long evolutionary past.

G.G.

Crocodilus, Mark Catesby (1682–1749), England

Lacertus.

The Tyger, William Blake (1757–1827), England

Those Yellow Eyes Miss Nothing . . .

PRIDES OF LIONS HAVE AGAIN been on view to visitors this week in the forest, on White Grass ridge, and in the Sosian valley. I watch a pride hunting at dusk one evening. The technique they employ is always the same.

They will be lying about to all appearances half asleep, but those yellow eyes miss nothing. Suddenly a lioness will get to her feet and stare intently in one direction. The others watch her. She will then move stealthily forward taking advantage of every scrap of cover, a few paces at a time, stopping frequently, one paw up-lifted very like a pointer at work when hot on the scent of a bird. Forward she will go until the last bit of cover is reached and then sinking to the ground remains immobile.

Meanwhile her companions will fan out to right and left and take up similar positions fifty to a hundred yards apart. It will be observed that they pay special attention to the wind taking care never to risk even a cross wind. If the pride is accompanied by cubs the little fellows pack down close together and never a movement is seen.

The big lion do not appear to take an active part if there are sufficient lionesses. They are usually seen some distance back watching the proceedings from a vantage point.

When all are in position, and not before, one of the flanking lionesses will move in a wide detour coming up to windward of the quarry. At once ears are pricked and the herd will start moving off stopping every now and then to stare back at the driving lioness. Their pace will quicken and then they will break into a trot straight into the line of waiting death.

A short rush at incredible speed, and a cloud of dust drifting away on the wind. As the dust clears a lioness will be seen sniffing round the fallen beast, which still kicks spasmodically, deciding where to start the feast. The rest of the pride close in quickly and the air is filled with the low, rumbling, growling purr of feeding lions.

When lions are hunting singly or in pairs they rely entirely on stalking. They will hunt game in country which lends itself to a close approach or lie in wait, hiding close to some water hole or game trail. In the park their main food is wildebeest or zebra, but they will kill anything that offers and I have found kills by lion of almost all the antelopes in the area.

A careless francolin or guinea-fowl does not live to tell the tale and one morning a lioness was seen carrying a jackal in her mouth, obviously taking it back for her cubs to eat.

After having fed, lions will go to water to drink and it is then, their thirst quenched, that they often give vent to their satisfaction in that marvellous roar.

The natives say if you listen to a lion roaring you can hear what he says *"He-e-e inchi ya nani? Yangu. Yangu. Yangu."* (Whose country is this? Mine. Mine. Mine.)

K. DE P. BEATON, details unknown

THE HUNTERS

DONALD THOMSON WAS ONE OF THE FIRST white men to enter the Arafura Swamp and take part in the hunt for the magpie geese. Ten canoes set out on the first expedition which he accompanied and twelve canoes in the second. The hunters soon scattered. vanishing from sight behind a screen of reeds or the light foliage of the melaleuca trees, but keeping in contact with the cry, *hee-ee hee-ee*, which travelled far across the silent swamp. On a successful day a hunter might spear six or seven geese, and he stood in a carnage of black and white feathers as he poled his canoe in the late afternoon towards the camping site. The common clutch of eggs was six to ten, and if two geese had laid in the same nest the aboriginals' catch might be slightly larger. The white eggs were usually piled in the shoe-shaped bow: shell against shell with nothing to prevent breakages if the canoe hit a hidden log.

Magpie Goose, H. Goodchild (dates unknown), Australia

The canoeists, out of sight of each other for much of the day, came together in the late afternoon. A secure camp was needed before sunset, when the mosquitoes in the middle of the swamp became unbearable. The ideal camping site was a clump of melaleuca trees, each with branches forking out at about the same height. Leaving the canoes floating at the foot of the tree the men climbed up the trunk and carefully cut straight boughs and wedged them into the forks of the trees to form the outline of a platform. Smaller boughs and strips of paper-bark completed the platform. No rope, no vine, was used in the building of this fragile stage high above the water: one careless step, one clumsy lunge of the body, and the hunter or half the platform fell into the swamp.

In the trees the evening meal was cooked. A pile of swamp grass, plastered with blue mud, was the hearth on the fragile platform; and on a small fire the plucked geese were roasted and the eggs were baked in the ashes. Night after night the geese and the eggs were the hunters' meal; the remainder was put aside, to be carried across to the shore at the end of the expedition. Often the party of hunters also built a stronger sleeping platform in another clump of trees across the water. Six or eight men might spend the night on that platform, waving their fans of goosewing-feathers across the face, huddled together in the smoke of a slow-burning fire, exhausted by their day's work but unable to sleep long because of the bites from mosquitoes and leeches. To a naked body the smoke of the fire did not offer sufficient protection. Moreover the dry wood was scarce in the swamp, and during the middle of a night—when the fire was low—one of the men had to shin down the trunk and push his canoe to another tree in search of a dead branch which, torn from the trunk, could

be ferried back in the darkness. The aromatic smell of the fire, the greasy touch of the cooked goose, the whine of mosquitoes, the heaviness of the hot air, the faint noises of the swamp or the night-they were mainly forgotten by the time Donald Thomson sat down to record his two expeditions into the Arafura Swamp. But, rare amongst anthropologists, he retained the sense of wonder he felt at sunrise and evening in the presence of these tree-dwellers:

> It was an unforgettable experience to sit looking across the park-like expanse of the swamp and see from one's sleeping platform the sun rise or set over the water, or watch the long file of canoes converge at dusk on the prearranged camping place, bringing in their spoils. Unforgettable too the scene at night; the glimmer of camp fires high up in the trees, or reflected in the dark waters of the swamp below, and the talk of the natives as they plucked and cooked the geese. They recounted and lived over again the day's adventures recalling critical moments in the stalking of the quarry they had killed or lost.

And in the morning they set out again, poling their canoes, alert for the honking of geese or the sights which to sharp eyes could indicate a nearby nest. When finally they returned to shore, their bark canoes laden with eggs and half-cooked geese, they craved for vegetables and other food as much as the women on shore craved for a taste of cooked goose.

After a spell on land and a long sleep in the smoke-filled hut they often built another canoe before venturing into the

swamp again. The hunting season could last almost two months, and by then the last of the unhatched goslings were big in the eggs: those eggs tasted sweet and were valued more than the fresh-laid eggs. Thomson noted the cry of *cheep, cheep* that preceded the hatching, and on 2 May he jotted in his notebook that he had seen the first baby goose of the season.

He wrote the comment in his notebook, which is still unpublished, in 1937. Observing a hunt that might have been enacted in many swamps almost annually for several thousand years, he had happened to voyage in those strangely-elegant canoes in the year that the jet engine was invented in England. His aboriginals were sitting in their tree platforms, sweltering, in the year that the Russians established a scientific observatory on an ice floe near the North Pole. In 1937, when that refinement of clothing—the nylon stocking—was first manufactured on the other side of the world, the goose-hunters went naked day and night. These contrasts, however, were certainly not all in favour of European society, because 1937 was also the year of George Orwell's book *The Road to Wigan Pier*, and Orwell's average coalminer in Lancashire could not afford to buy in a month as many pounds of cooked poultry and as many eggs as these primitive hunters were eating in a day.

GEOFFREY BLAINEY (1930–), Australia

How Owls Catch Hares

HUNTERS HAVE TOLD ME that eagle owls and other owl species catch hares at night in the following way: they lie in wait on tracks followed by hares and seize the hare with one foot while clinging with the other to the branch of a bush or tree. The owl holds the hare like this until the hare's strength is exhausted, and then plunges the other claw into it to finish it off. My informants add that the hare sometimes manages to tear off the claw in which it is held, while the owl is still cling-ing with the other to a branch, and that some hunters have taken hares that had an owl-claw hanging from their flesh, torn off, and already dried up. I confess that I thought this most unlikely, but the hunter and expert A. S. Khomiakov, to whom I have previously referred, assured me that this was exactly so. Another hunter, Iu. Samarin, confirms it.

SERGEI TIMOFEEVICH AKSAKOV (1791–1859), Russia

ABOVE: *The Vision of St. Eustace* (detail), Pisanello (c.1394-1455), Italy
OVERLEAF: *Lioness* (study for *Daniel in the Lions' Den*), Peter Paul Rubens (1577–1640), Belgium

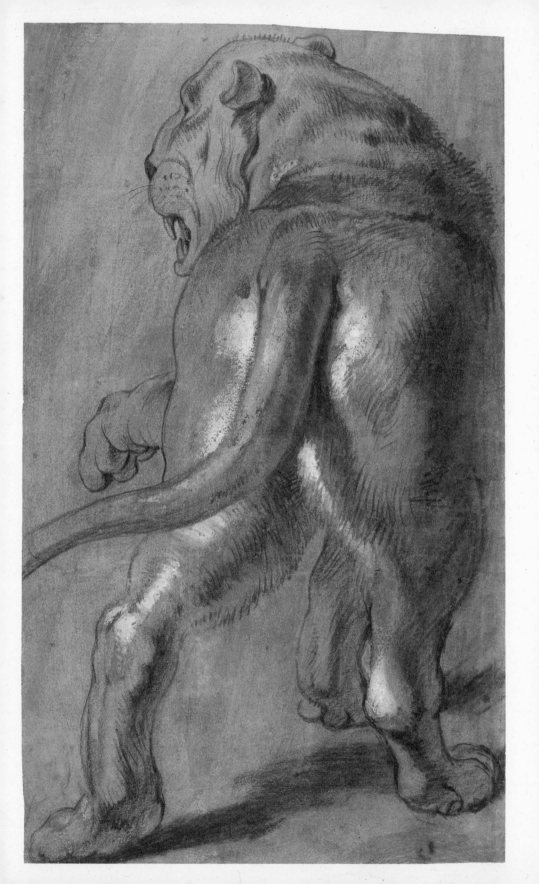

DEATH OF A GOAT

HAVING TIED THE GOAT to a peg driven into the ground at the bend in the track, about ten yards below the scrub jungle, we went down the hill for 150 yards, to where there were some big rocks behind which we concealed ourselves. The goat was one of the best callers I have ever heard, and while his shrill and piercing bleat continued, there was no necessity for us to watch him, for he had been very securely tied, and there was no possibility of the leopard's carrying him away.

The sun—a fiery red ball—was a hand's breadth from the snow mountains above Kedarnath when we took up our position behind the rocks, and half an hour later, when we had been in shadow for few minutes, the goat suddenly stopped calling. Creeping to the side of the rock and looking through a screen of grass, I saw the goat with ears cocked,

Brindled Gnoo, C. Hamilton-Smith (1826), England

looking up towards the bushes; as I watched, he shook his head and backed to the full length of the rope.

The leopard had undoubtedly come, attracted by the calling of the goat. That he had not pounced on it before the goat became aware of his presence was proof that he was suspicious. As Ibbotson's aim would be more accurate than mine, for his rifle was fitted with a telescopic sight, moving aside I made room for him, and as he lay down and raised his rifle I whispered to him to examine the bushes carefully in the direction in which the goat was looking. I felt sure that if the goat could see the leopard—and all indications were that he could—Ibbotson should also be able to see it through his powerful telescope. For minutes Ibbotson kept his eye to the telescope and then shook his head, and laying down the rifle made room for me.

The goat was standing in exactly the same position in which I had last seen it, and taking direction from it I fixed the telescope on the same bush at which it was looking. The flicker of an eyelid, or the very least movement of ear or even whiskers, would have been visible through the telescope, but though I also watched for minutes I, too, could see nothing.

When I took my eye away from the telescope I noted that the light was rapidly fading, and that the goat now showed as a red and white blur on the hillside. We had a long way to go, and waiting longer would be both useless and dangerous, so getting to my feet, I told Ibbotson it was time for us to make a move.

Going up to the goat—who from the time he had stopped bleating had not made a sound—we freed it from the peg, and

Leopard figure (detail), electrolyte copy by Elkington and Co., silver and gilt; artist unknown (9th century), England

with the man leading it we set off for the village. The goat quite evidently had never had a rope round its neck before and objected violently to being led. I told the man to take the rope off—my experience being that when a goat is freed after having been tied up in the jungle, through fear, or for want of companionship, it follows at heel like a dog. This goat, however, had ideas of its own, and no sooner had the man removed the rope from its neck, than it turned and ran up the track.

It was too good a calling goat to abandon—it had attracted the leopard once, and might do so again. Furthermore, we had only a few hours previously paid good money for it, so we in turn ran up the track in hot pursuit. At the bend, the goat turned to the left and we lost sight of it. Keeping to the track, as the goat had done, we went to the shoulder of the hill, where a considerable extent of the hill, clothed in short grass, was visible. As the goat was nowhere in sight we decided it had taken a short cut back to the village,

279

and started to retrace our steps. I was leading, and as we got halfway along the hundred yards of track, bordered on the upper side by scattered bushes and on the steep lower side by short grass, I saw something white on the track in front of me. The light had nearly gone, and on cautiously approaching the white object, I found it was the goat laid head and tail on the narrow track, in the only position in which it could have been laid to prevent it from rolling down the steep hillside. Blood was oozing from its throat, and when I placed my hand on it the muscles were still twitching.

It was as though the man-eater—for no other leopard would have killed the goat and laid it on the track—had said, "Here, if you want your goat so badly, take it, and as it is now dark and you have a long way to go, we will see which of you lives to reach the village." I do not think all three of us would have reached the village alive if I had not, very fortunately, had a fun box of matches with me (Ibbotson at that time was a non-smoker). Striking a match and casting an anxious look all round and taking a few hurried steps, and then again striking another match, we stumbled down the rough track until we got to within calling distance of the village. At our urgent summons, men with lanterns and pine torches came up to meet us.

We had left the goat lying where the leopard had placed it, and when I returned at daybreak next morning, I found the pug marks of the man-eater where he had followed us down to the village. The goat, untouched, was lying just as we had left it.

JIM CORBETT (1875–1955), India

Hailing the Elusory Mountain Lion

Mountain lions spirit themselves away in saw-toothed canyons and on escarpments instead, and when conversing with their mates they coo like pigeons, sob like women, emit a flat slight shriek, a popping bubbling growl, or mew, or yowl. They growl and suddenly caterwaul into falsetto—the famous scarifying, metallic scream functioning as a kind of hunting cry close up, to terrorize and start the game. They ramble as much as twenty-five miles in a night, maintaining a large loop of territory which they cover every week or two. It's a solitary, busy life, involving a survey of several valleys, many deer herds. Like tigers and leopards, mountain lions are not sociably inclined and don't converse at length with the whole waiting world, but they are even less noisy; they seem to speak most eloquently with their feet. Where a tiger would roar, a mountain lion screams like a castrato. Where a mountain lion hisses, a leopard would snarl like a truck stuck in snow. . . .

It's a risky business for the mountain lion, staking the strength and impact of his neck against the strength of the prey animal's neck. Necessarily, he is concentrated and fierce; yet legends exist that mountain lions have irritably defended men and women lost in the wilderness against marauding

jaguars, who are no friends of theirs, and (with a good deal more supporting evidence) that they are susceptible to an odd kind of fascination with human beings. Sometimes they will tentatively seek an association, hanging about a campground or following a hiker out of curiosity, perhaps, circling around and bounding up on a ledge above to watch him pass. This mild modesty has helped preserve them from extinction. If they have been unable to make any adjustments to the advent of man, they haven't suicidally opposed him either, as the buffalo wolves and grizzlies did. In fact, at close quarters they seem bewildered. When treed, they don't breathe a hundred-proof ferocity but puzzle over what to do. They're too light-bodied to bear down on the hunter and kill him easily, even if they should attack—a course they seem to have no inclination for. In this century in the United States only one person, a child of thirteen, has been killed by a mountain lion; that was in 1924. And they're informal animals. Lolling in an informal sprawl on a high limb, they can't seem to summon any Enobarbus-like front of resistance for long. Daring men occasionally climb up and toss lassos about a cat and haul him down, strangling him by pulling from two directions, while the lion, mortified, appalled, never does muster his fighting aplomb. Although he could fight off a pack of wolves, he hasn't worked out a posture to assume toward man and his dogs. Impotently, he stiffens, as the dinosaurs must have when the atmosphere grew cold.

EDWARD HOAGLAND (1932–), United States

Cougar, Ron Solonas (1952–), Canada

282

'Cougar' Ron Solonas 03©

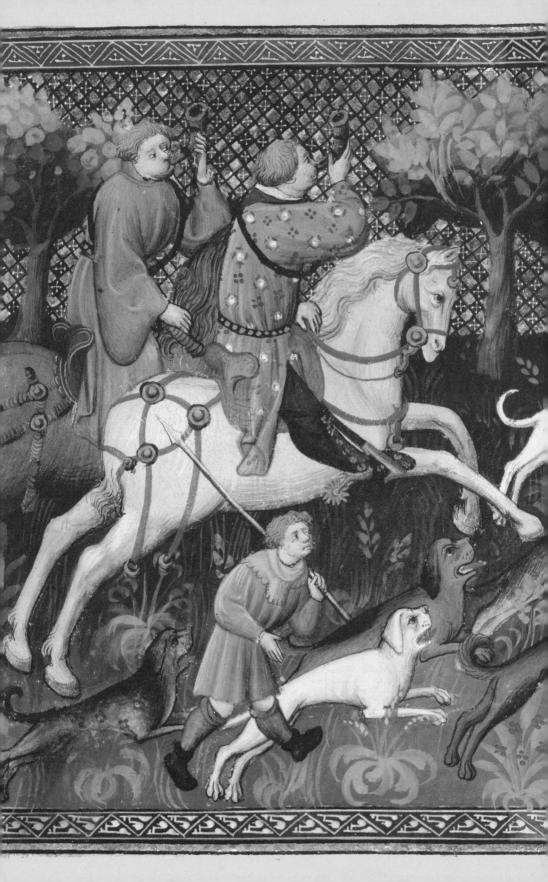

FROM SIR GAWAIN AND THE GREEN KNIGHT

1150 As the cry went up the wild creatures quaked.
The deer in the dale, quivering with dread,
hurtled to high ground, but were headed off
by the ring of beaters who bawled and roared.
The stags of the herd with their high-branched heads
and the broad-horned bucks were allowed to pass by,
for the lord of the land had laid down a law
that man should not maim the male in close season.
But the hinds were halted with hollers and whoops
and the din drove the does to sprint for the dells.
1160 Then the eye can see that the air is all arrows:
all across the forest they flashed and flickered,
biting through hides with their broad heads.
What! They bleat as they bleed and they die
 on the banks,
and always the hounds are hard on their heels,
and the hunters on horseback come hammering
 behind
with stone-splitting cries, as if cliffs had collapsed.
And those animals which escaped the aim
of the archers

Deer Hunt (detail), Gaston Phébus (1331–1391), France

were steered from the slopes down to rivers
 and streams
and set upon and seized at the stations below.
1170 So perfect and practised were the men at their posts
and so great were the greyhounds which grappled
 with the deer
that prey was pounced on and dispatched with speed
 and force.
 The lord's heart leaps with life.
 Now on, now off his horse
 all day he hacks and drives.
 And dusk comes in due course.

 . . .

And the lord of the land still led the hunt,
1320 driving hinds to their death through holts and heaths,
and by the setting of the sun had slaughtered
 so many
of the does and other deer that it beggared belief.
Then finally the folk came flocking to one spot
and quickly they collected and counted the kill.
Then the leading lords and their left-hand men
chose the finest deer—those fullest with fat—
and ordered them cut open by those skilled
 in the art.
They assessed and sized every slain creature
and even on the feeblest found two fingers' worth
 of fat.

 Trans. SIMON ARMITAGE (1963–), England

THE GREAT PROVIDER

WHEN THE FIRST JESUITS ARRIVED ... the Indians refused
to let them protect their flocks and herds from attacks by the
great cats.

The priests could not understand this until they learned
that for centuries ... people had obtained a very substantial
part of the meat in their scanty diet by following the hunting
cat and scavenging its kills after the rightful owner had eaten
his fill. The condors and vultures led them to the kill, and the
cat was their great provider.

BRUCE STANLEY WRIGHT (1912–1975), Canada

Mountain Lions at the Deer Cache, Frederick Remington (1861–1909), United States

Of the *Mouse* called the *Shrew*, or the *Erd shrew*.

THE MOST TERRIBLE PREDATOR OF ALL

IN RELATION TO ITS SIZE, the water-shrew is perhaps the most terrible predator of all vertebrate animals, and it can even vie with the invertebrates, including the murderous Dytiscus larva described in the third chapter of this book. It has been reported by A. E. Brehm that water-shrews have killed fish more than sixty times heavier than themselves by biting out their eyes and brain. This happened only when the fish were confined in containers with no room for escape. The same story has been told to me by fishermen on Lake Neusiedel, who could not possibly have heard Brehm's report. I once offered to my shrews a large edible frog. I never did it again, nor could I bear to see out to its end the cruel scene that ensued. One of the shrews encountered the frog in the basin and instantly gave chase, repeatedly seizing hold of the creature's legs; although it was kicked off again it did not cease in its attack and finally, the frog, in desperation, jumped out of the water and on to one of the tables, where several shrews raced to the pursuer's assistance and buried their teeth in the legs and hindquarters of the wretched frog. And now,

Of the Mouse Called the Shrew, Edward Topsell (c.1572–1625), England

288

horribly, they began to eat the frog alive, beginning just where each one of them happened to have hold of it; the poor frog croaked heartrendingly, as the jaws of the shrews munched audibly in chorus. I need hardly be blamed for bringing this experiment to an abrupt and agitated end and putting the lacerated frog out of its misery. I never offered the shrews large prey again but only such as would be killed at the first bite or two. Nature can be very cruel indeed; it is not out of pity that most of the larger predatory animals kill their prey quickly. The lion has to finish off a big antelope or a buffalo very quickly indeed in order not to get hurt itself, for a beast of prey which has to hunt daily cannot afford to receive even a harmless scratch in effecting a kill; such scratches would soon add up to such an extent as to put the killer out of action. The same reason has forced the python and other large snakes to evolve a quick and really humane method of killing the well-armed mammals that are their natural prey. But where there is no danger of the victim doing damage to the killer, the latter shows no pity whatsoever. The hedgehog which, by virtue of its armour, is quite immune to the bite of a snake, regularly proceeds to eat it, beginning at the tailor in the middle of its body, and in the same way the water-shrew treats its innocuous prey. But man should abstain from judging his innocently-cruel fellow creatures, for even if nature sometimes "shrieks against his creed", what pain does he himself not inflict upon the living creatures that he hunts for pleasure and not for food?

KONRAD LORENZ (1903–1989), Austria

OVERLEAF: *Le Crocodile*, artist unknown (c.1860)

A Voracious Monster

AN ADULT ANT-LION is very like a dragonfly, and looks fairly innocent. But in its childhood, as it were, it is a voracious monster that has evolved an extremely cunning way of trapping its prey, most of which consists of ants. The larva is round-bodied, with a large head armed with great pincer-like jaws. Picking a spot where the soil is loose and sandy, it buries itself in the earth and makes a circular depression like the cone of a volcano. At the bottom of this, concealed by sand, the larva waits for its prey. Sooner or later an ant comes hurrying along in that preoccupied way so typical of ants, and blunders over the edge of the ant-lion's cone.

It immediately realizes its mistake and tries to climb out again, but it finds this difficult, for the sand is soft and gives way under its weight. As it struggles futilely at the rim of this volcano it dislodges grains of sand which trickle down inside the cone and awake the deadly occupant that lurks there.

Immediately the ant-lion springs into action. Using its great head and jaws like a steam-shovel, it shoots a rapid spray of sand grains at the ant, still struggling desperately to climb over the lip of the volcano. The earth sliding away from under

Ant-lion, Gregory the Great (6th–7th century CE), Rome

its claws, knocked off its balance by this stream of sand and unable to regain it, the ant rolls down to the bottom of the cone where the sand parts like a curtain and it is enfolded lovingly in the great curved jaws of the ant-lion. Slowly, kicking and struggling, it disappears, as though it were being sucked down by quicksand, and within a few seconds the cone is empty, while below the innocent-looking sand the ant-lion is sucking the vital juices out of its victim.

GERALD DURRELL (1925–1995), England

FROM HOW TO STAY ALIVE IN THE WOODS

ANIMALS SHOULD NOT BE BLED any more than can be helped if food is scarce. Whether they should be so handled in other times is a matter largely of circumstances and of personal opinion.

Blood, which is not far removed from milk, is unusually rich in easily absorbed minerals and vitamins. Our bodies, for illustration, need iron. It would require the assimilation of ten ordinary eggs, we are told, to supply one man's normal daily requirement. Four tablespoons of blood are capable of doing the same job.

Fresh blood can be secured and carried, in the absence of handier means, in a bag improvised from one or other parts of the entrails. One way to use it is in broths and soups, enlivened perhaps by a wild vegetable or two.

BRADFORD ANGIER (1910–1997), United States

Panorama of Nature, artist unknown

The Mantis: Her Love-making

IT IS NEAR THE END OF AUGUST. The male, that slender swain, thinks the moment propitious. He makes eyes at his strapping companion; he turns his head in her direction; he bends his neck and throws out his chest. His little pointed face wears an almost impassioned expression. Motionless, in this posture, for a long time he contemplates the object of his desire. She does not stir, is as though indifferent. The lover, however, has caught a sign of acquiescence, a sign of which I do not know the secret. He goes nearer; suddenly he spreads his wings, which quiver with a convulsive tremor. That is his declaration. He rushes, small as he is, upon the back of his corpulent companion, clings on as best he can, steadies his hold. As a rule, the preliminaries last a long time. At last, coupling takes place and is also long drawn out, lasting

Praying Mantis (Camel Cricket), W. Daniell (1769–1837), England

sometimes for five or six hours. Nothing worthy of attention happens between the two motionless partners. They end by separating, but only to unite again in a more intimate fashion. If the poor fellow is loved by his lady as the vivifier of her ovaries, he is also loved as a piece of highly-flavoured game. And, that same day, or at latest on the morrow, he is seized by his spouse, who first gnaws his neck, in accordance with precedent, and then eats him deliberately, by little mouthfuls, leaving only the wings. Here we have no longer a case of jealousy in the harem, but simply a depraved appetite. I was curious to know what sort of reception a second male might expect from a recently fertilized female. The result of my enquiry was shocking. The Mantis, in many cases, is never sated with conjugal raptures and banquets. After a rest that varies in length, whether the eggs be laid or not, a second male is accepted and then devoured like the first. A third succeeds him, performs his function in life, is eaten and disappears. A fourth undergoes a like fate. In the course of two weeks I thus see one and the same Mantis use up seven males. She takes them all to her bosom and makes them all pay for the nuptial ecstasy with their lives.

Orgies such as this are frequent, in varying degrees, though there are exceptions. On very hot days, highly charged with electricity, they are almost the general rule. At such times the Mantes are in a very irritable mood. In the cages containing a large colony, the females devour one another more than ever; in the cages containing separate pairs, the males, after coupling, are more than ever treated as an ordinary prey.

I should like to be able to say, in mitigation of these conjugal atrocities, that the Mantis does not behave like this in a state of liberty; that the male, after doing his duty, has time

to get out of the way, to make off, to escape from his terrible mistress, for in my cages he is given a respite, lasting sometimes until next day. What really occurs in the thickets I do not know, chance, a poor resource, having never instructed me concerning the love-affairs of the Mantis when at large. I can only go by what happens in the cages, where the captives, enjoying plenty of sunshine and food and spacious quarters, do not seem to suffer from homesickness in any way. What they do here they must also do under normal conditions.

Well what happens there utterly refutes the idea that the males are given time to escape. I find, by themselves, a horrible couple engaged as follows. The male, absorbed in the performance of his vital functions, holds the female in a tight embrace. But the wretch has no head; he has no neck; he has hardly a body. The other, with her muzzle turned over her shoulder, continues very placidly to gnaw what remains of the gentle swain. And, all the time, that masculine stump, holding on firmly, goes on with the business!

Love is stronger than death, men say. Taken literally, the aphorism has never received a more brilliant confirmation. A headless creature, an insect amputated down to the middle of the chest, a very corpse persists in endeavouring to give life. It will not let go until the abdomen, the seat of the procreative organs, is attacked.

JEAN-HENRI FABRE (1823–1915), France

THE MOST DESTRUCTIVE ANIMALS
IN THIS COUNTRY

AS A PROOF OF THEIR amazing strength, there was one at Churchill some years since, that overset the greatest part of a large pile of wood, (containing a whole Winter's firing, that measured upwards of seventy yards round,) to get at some provisions that had been hid there by the Company's servants, when going to the Factory to spend the Christmas holidays. The fact was, this animal had been lurking about in the neighbourhood of their tent (which was about eight miles from the Factory) for some weeks, and had committed many depredations on the game caught in their traps and snares, as well as eaten many foxes that were killed by guns set for that purpose: but the Wolverene was too cunning to take either trap or gun himself. The people, knowing the mischievous disposition of those animals, took (as they thought) the most effectual method to secure the remains of their provisions, which they did not choose to carry home, and accordingly

Wolverine, J.J. Audubon
(1785–1851),
Haiti/United States

tied it up in bundles and placed it on the top of the woodpile, (about two miles from their tent,) little thinking the Wolverene would find it out; but to their great surprise, when they returned to their tent after the holidays, they found the pile of wood in the state already mentioned, though some of the trees that composed it were as much as two men could carry. The only reason the people could give for the animal doing so much mischief was, that in his attempting to carry off the booty, some of the small parcels of provisions had fallen down into the heart of the pile, and sooner than lose half his prize, he pursued the above method till he had accomplished his ends. The bags of flour, oatmeal, and pease, though of no use to him, he tore all to pieces, and scattered the contents about on the snow; but every bit of animal food, consisting of beef, pork, bacon, venison, salt geese, partridges, & c. to a considerable amount, he carried away. These animals are great enemies to the Beaver, but the manner of life of the latter prevents them from falling into their clutches so frequently as many other animals; they commit vast depredations on the foxes during the Summer, while the young ones are small; their quick scent directs them to their dens, and if the entrance be too small, their strength enables them to widen it, and go in and kill the mother and all her cubs. In fact, they are the most destructive animals in this country.

SAMUEL HEARNE (1745–1795), England

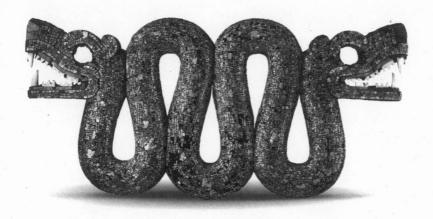

THE CRUEL FALCON

Contemplation would make a good life, keep it strict, only
The eyes of a desert skull drinking the sun,
Too intense for flesh, lonely
Exultations of white bone;
Pure action would make a good life, let it be sharp—
Set between the throat and the knife.
A man who knows death by heart
Is the man for that life.
In pleasant peace and security
How suddenly the soul in a man begins to die.
He shall look up above the stalled oxen
Envying the cruel falcon,
And dig under the straw for a stone
To bruise himself on.

ROBINSON JEFFERS (1885–1962), United States

Aztec or Mixtec Two-headed Serpent, artist unknown, Mexico

If I remember the sunflower forest it is because
from its hidden reaches man arose. The green world
is his sacred centre. In moments of sanity he must still see refuge there.
LOREN EISELEY

As too much light may blind the vision,
so too much intellect may hinder the understanding.
ROMAIN ROLLAND

8 —

CEREMONY OF INNOCENCE

The Heart's Solace and Delight

Haida figure, artist unknown (19th century), Canada

If only you were an Indian, instantly alert, and on a galloping horse, leaning into the rushing air, again and again trembling over the trembling ground, until you leave the spurs behind, for there were no spurs, until you throw away the reins, for there were no reins, and you scarcely saw the land lying before you like a smooth-mown heath, already without a horse's neck and a horse's head.

<div align="center">FRANZ KAFKA, Meditation</div>

ODDLY ENOUGH, describing conservationists as "tree-huggers" is intended to convey condescension, if not scorn. It mockingly pretends that those who hug trees are mere nostalgic folk, city people who view nature sentimentally or aesthetically; either that or they're part of some weird tofu-eating anti-development plot.

This attitude ignores—or is ignorant of—the fact that people have symbolically ·and physically embraced trees throughout recorded history. In India and Japan and Old Europe, sacred groves were revered as natural shrines, the homes of gods; in many places they still are—which shouldn't be surprising given our animal origins in the forest. Echoes of great trees in the soaring grace of a cathedral are not accidental.

Many of the most dramatic struggles to defend natural habitats have occurred in forests that are being assaulted by commerce. Old growth forests, which have the resonance of sacred groves,

attract the most passionate action. An impressive example was carried out by a group that established a makeshift but well-supplied camp in the upper branches of a threatened woods in Britain. The protesters were seasoned climbers who—because they had rigged the area with ropes, cables and platforms—moved from tree to tree with such ease that they could not easily be captured, and had to be waited out—as they were. However, the protest was an extremely effective and occasionally thrilling action. Imagining the young climbers swinging gracefully about beneath the canopy while heavy-footed authority watched from the ground, I thought of our distant arboreal relatives skipping about in the foliage while a leopard eyed them from the grass below.

WHEN I WAS EIGHT my mother fashioned me a deerskin loincloth on which she had sewn multicoloured beads in a design I later recognized in the North American Indian Gallery at the Royal Ontario Museum. With gull feathers stuck in my hair, and perhaps charcoal markings on my chest, I roamed the bush surrounding an isolated cottage my grandfather had built in 1893 beside a glacial lake. There was an extraordinary freedom out there, eluding the adults or creeping up on them, only to dart deeper into the woods when I feared they'd seen me. Exhilarated by the rich wild mystery in the voices of loons, and by the calls of owls in the dark, I imagined wolves and bears but encountered nothing larger than porcupines. I sometimes wonder if I was tuning in to the echoes of our species' unrecoverable life in the wild.

Five years later, when I was thirteen, I spent three months wandering the beaches and scrub bush around my uncle's house on Palm Beach in Queensland, Australia. All the other boys my age spent their weekdays in classrooms. My mother had taken us to visit her brothers after the war, and there wasn't an appropriate

school nearby, or that's what she said. I didn't question her.

I have retained memories of the adults and my cousins when they appeared, but beyond that there's a curious emptiness: what on earth was I doing with all that free time? The shark scare, of course, and a man's torn body at the tide-line; rocks to be climbed at Burleigh Heads; but mostly sand dunes like fossilized waves and spiky beach grasses in the shimmering heat; sometimes a whale in the distance; and the snakes, I remember them: a Death Adder, thick as my biceps, and a ponderous carpet snake longer than my aunt's living room that I found when following the wild irritable laughter of kookaburras.

On the surface it doesn't seem like much, not even to me: I certainly never felt that anything significant was happening as I idly poked about beneath the sky. And yet, sporadically thinking back to that largely unremembered period in my life, I've come to understand how profoundly important those few months were to me.

"Where have you been?" a mother asks her child.

"Out," he says.

"What were you doing?"

"Nothing," he says.

But it is a nothing filled with significance. For millions of years we humans and our biological ancestors lived in perfect balance with the vicissitudes of the natural world. That process made us who and what we are. Then, in the blink of an eye, we cut ourselves off from our origins.

There is nothing in our past that prepares us for life in swarming cities where 3, 6 or 18 million people are crammed together, as if in a polluted feedlot. For some, of course—those with money—it seems more like a stable for high-class polo ponies, or a Kobe beef operation where we're fed beer and massaged every day. But either way, we've lost our original world, and there's a growing body of

evidence to suggest that the resultant damage to us is grievous, and getting worse.

THE EVIDENCE IS ACCUMULATING. I first heard of "forest bathing"—walking in the woods—about five years ago from a writer and conservationist friend who is protecting a significant wooded area in the foothills of the Japanese Alps. While we were drinking good green tea in his forest-warden's shelter, he assured me that time spent in the woods significantly lowers stress and blood pressure; it reduces hyperactivity in children, and increases the ability of kids with ADHD to concentrate. Local authorities regularly bring disturbed kids to spend time wandering in his forest, and he told me that the changes in their behaviour begin almost immediately.

Formal Japanese research into the benefits of forest bathing has subsequently revealed that the human natural killer (NK) cells in our body, which fight cancer and strengthen the immune system, are increased by up to 50 percent after only three days spent in a forest, and the benefits can last for up to a month. Research in Europe and North America is confirming these findings. Richard Louv's *Last Child in the Woods* explores the evidence that our separation from nature has serious implications for our health and well-being. There's abundant evidence to support the notion that we, and especially our children, are suffering what might be called "nature deficit disorder." For example, patients recovering from surgery who can see landscapes from their beds heal significantly faster than those who don't; even paintings of a natural scene will help, which surely reveals how desperate we are. In a prison where some cells faced the prison yard and administrative buildings and others overlooked the countryside, it was discovered by chance that inmates with access to the natural scene had 24 percent fewer illnesses than their deprived peers.

A young friend recently described the peculiar agitation she felt when her family cottage in the woods was sold. She'd gone to it regularly for as long as she could remember; it had seemed a refuge, and now it was gone. Her response wasn't simply regret, but something deeper; she became obsessed with a need to get out of the city and into the forest, any forest. She and her partner began to make pilgrimages into the woods each weekend, whereupon her agitation vanished.

If your instinct is to walk in a park or ravine when you're melancholy or frustrated, you've most likely chosen an effective remedy: healing, wholesomeness, and wholeness are related, and to heal ourselves individually and collectively, we need to begin by rejoining ourselves with the wholeness of nature.

G.G.

Polar Bear and Ribbon Seal (detail), Louis Agassiz Fuertes (1874–1927), United States

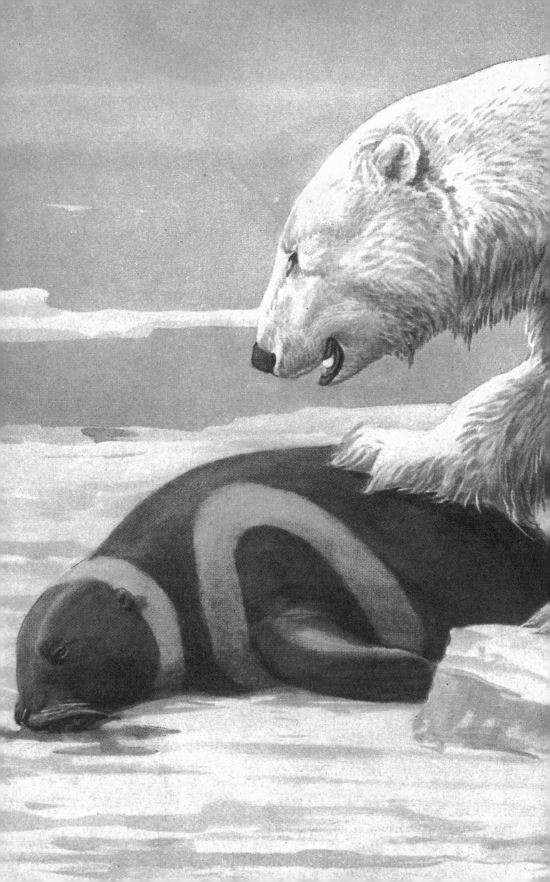

BEARS RESEMBLE PEOPLE
AND LIKE TO DANCE

The Northern Mewuk Say:

Bears are like people. They stand up, they have hands, and when the hide is off, their bodies look like the bodies of people. Bears know a great deal. They understand the Mewuk language, and their hearing is so sharp that they hear a person a long way off and know what he says.

Bears, like people, like to dance. Once an old Indian saw some bears dance in the forest. He saw *Oo-soo'-ma-te* the old she Grizzly Bear and a lot of little bears. The old she bear leaned up against a pine tree with her left hip and bent it down, and sang *moo'-oo, moo'-oo*. The little bears caught hold of the bent-over tree, hanging on with their hands over their heads, while they danced with their hind feet on the ground.

C. HART MERRIAM (1855–1942), United States

Of the Bear, Edward Topsell (c.1572–1625), England

Cantad, Amigos!

What could be more perfect in this setting than a wild chorus of coyotes? I switched on my flashlight for a few seconds, shone it in the direction of the disembodied voices, and counted eight pairs of eyes reflecting its beam. I shut it off, and began to bark and howl back at our visitors, an action which seemed to spur them on to even more exuberant polyphony. *"¡Cantad, amigos!"*, I called out, the directive to sing welling up from a subconscious memory. The coyotes continued their song for a few moments, then, almost as suddenly as it had started, the chorus stilled. In a couple of minutes I saw Hamlet relax, telling me that our callers had left.

What my subconscious had remembered, I recognized after a while, was a scene at the beginning of J. Frank Dobie's

Coyote mask, artist unknown, Mexico

classic, *The Voice of the Coyote*. The setting for that scene was "a small ranch down in the Brush Country of Texas." A steer had been butchered that afternoon. Some of the meat had been taken to the rancher's and ranch hands' households; some had been hung in the open for sun and wind to cure into jerky; the offal had been dragged out of the corral into the mesquites, where the coyotes would feast on it in the night. "Well, we'll have singing tonight," the rancher said after sundown, as he sat down with his family to a supper of fried steak, hot biscuits, and gravy. Dobie explains:

> The speaker was my father. The particular beef-killing day I am remembering was forty-odd years ago. Fresh meat and singing went together in the same place forty or fifty years before that; they still go together. After a group of vaqueros—as Mexican cowboys in the border country are called—fill up on fresh beef in the evening, they are going to sing, and if they have been freshly brought together for a cow hunt, they are going to sing more. When coyotes smell fresh meat after dark, they also are going to sing.
>
> "Well, we'll have singing tonight." We did not have long to wait. High-wailing and long-drawn-out, the notes of native versos came over the night air . . . [and] seemed to go up to the stars. And as they reached their highest pitch, a chorus of coyote voices joined them. When, at the end of the first ballad, the human voices dimmed into silence, the coyote voices grew higher; then all but one howler ceased. We heard a laugh, and one lusty vaquero yelled out, "*¡Cantad, amigos!*"—"Sing, friends!" The friends responded with renewed gusto.

"¡Cantad, amigos!" The words themselves seem to sing, not only because Spanish is a musical language, but also because these words bespeak a joyful attitude of harmony with the natural world, of camaraderie with fellow creatures. The rancher, the vaqueros, the coyotes had shared the flesh of the slaughtered steer, and now they shared their contentment in a burst of song that echoed back and forth in the starry Texas night. Dobie continues:

> For a time the antiphonies challenged and cheered each other, now converging, now alternately lapsing. The vaquero singing, on high notes especially, could hardly be distinguished from the coyote singing. Mexican vaqueros are Indian in blood, inheritance and instinct. Anybody who has listened long and intimately to the cries of coyotes seeming to express remembrance of something lost before time began must recognize those identical cries in the chants of Plains Indians and the homemade songs of Mexicans. English speakers living with the coyote seldom refer to his voicing as "singing"; to them it is "yelping," "howling," "barking"; but to the vaquero people it is nearly always *cantando*.

FRANÇOIS LEYDET (1927–1997), United States

THE SIAMANG.

London. Published by G & W. B. Whittaker. May. 1824.

A Magnificent Hairy Fellow

1910

How I hate the man who talks about the 'brute creation', with an ugly emphasis on *brute*. Only Christians are capable of it. As for me, I am proud of my close kinship with other animals. I take a jealous pride in my Simian ancestry. I like to think that I was once a magnificent hairy fellow living in the trees and that my frame has come down through geological times *via* sea jelly and worms and Amphioxus, Fish, Dinosaurs, and Apes. Who would exchange these for the pallid couple in the Garden of Eden?

W.N.P. Barbellion (1889–1919), England

Siamang, Sir Edwin Henry Landseer (1802–1873), England

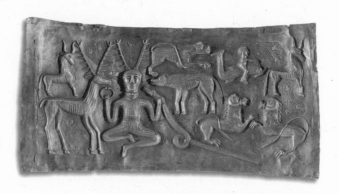

THE WILDWOOD

PEOPLE DANCED IN IMITATION of the animals which shared the land, perhaps to show affinity or reverence, perhaps mastery. At one of the earliest hunter-gatherer-fisher sites yet found in Britain, 20 sets of deer antlers have been discovered. Dating to about 9000 BC, immediately after the end of the Cold Snap, the antlers were found at Star Carr in North Yorkshire. What convinced archaeologists that these were masks and not trophies was something very obvious and practical: holes had been drilled through the skull-bone at the base of each set. This enabled a dancer or a shaman-priest to tie the horns on to his head. And because they were solid bone and heavy, the antlers had been shaved down to make them lighter.

. . . The men—and perhaps the women—who tied on the deer masks at Star Carr aimed to represent the deer they stalked in the woods and by the lakeside where they lived. There can be no doubt about that. But what were they doing when they imitated the movements of the animals, and why did they go to such lengths to do it?

Cernunnos panel of Gundestrup Cauldron, Celtic (c.1st century BC), Denmark

316

In Staffordshire, in the heart of England, at the village of Abbot's Bromley, the deer-men still dance. On the Monday following the first Sunday after 4 September, they are up at dawn to dance for a day around the farms surrounding the village. In what is called "the deer running" six men each carry a set of huge 12-pointer reindeer antlers fixed to a wooden mask. Carbon dating has shown that the antlers are at least a thousand years old and originated in Scandinavia. Three sets are painted white and three black. Accompanying the deer-runners are four other characters: the Fool, Maid Marion (also known as the "Man-Woman"), the Hobby Horse and the Bowman.

After the deer-men have danced to the music of a melodeon, with the Hobby Horse snapping his jaws and the Bowman twanging his bow-string to keep time, they separate into two groups. Black antlers face white and a ritual fight begins. Because the antlers are so heavy, the deer-men have to rest them on their shoulders before lowering their heads for a dignified, slow-motion charge. The oldest part of the ritual is thought to be the moment when the Bowman begins to stalk the herd of deer-runners, firing imaginary arrows at them. As the small tableau makes its way down the main street of Abbot's Bromley, the ghosts of a long past hover behind. Some touch the edges of recorded history. It cannot be a coincidence that the village lies in the heart of the territory of the Cornovii, an ancient Celtic tribe noted on Ptolemy's map of Britain. Cornovii means "The Horned People".

ALISTAIR MOFFAT (1950–), Scotland

FROM THE LOST WORLD

THERE WAS NOTHING which we could see upon the shore which seemed to me so wonderful as the great sheet of water before us. Our numbers and our noise had frightened all living creatures away, and save for a few pterodactyls, which soared round high above our heads while they waited for the carrion, all was still around the camp. But it was different out upon the rose-tinted waters of the central lake. It boiled and heaved with strange life. Great slate-coloured backs and high serrated dorsal fins shot up with a fringe of silver, and then rolled down into the depths again. The sand-banks far out were spotted with uncouth crawling forms, huge turtles, strange saurians, and one great flat creature like a writhing, palpitating mat of black greasy leather, which flopped its way slowly to the lake. Here and there high serpent heads projected out of the water, cutting swiftly through it with a little collar of foam in front, and a long swirling wake behind,

ABOVE: Macclesfield Psalter, detail (c.1330), England
PREVIOUS PAGES: *Scene from a Satirical Papyrus* (c.1100 BC), Egypt

320

rising and falling in graceful, swan-like undulations as they went. It was not until one of these creatures wriggled on to a sand-bank within a few hundred yards of us, and exposed a barrel-shaped body and huge flippers behind the long serpent neck, that Challenger, and Summerlee, who had joined us, broke out into their duet of wonder and admiration.

"Plesiosaurus! A fresh-water plesiosaurus!" cried Summerlee. "That I should have lived to see such a sight! We are blessed, my dear Challenger, above all zoologists since the world began!"

—

All this I shall some day write at fuller length, and amidst these more stirring days I would tenderly sketch in these lovely summer evenings, when with the deep blue sky above us we lay in good comradeship among the long grasses by the wood and marveled at the strange fowl that swept over us and the quaint new creatures which crept from their burrows to watch us, while above us the boughs of the bushes were heavy with luscious fruit, and below us strange and lovely flowers peeped at us from among the herbage; or those long moonlit nights when we lay out upon the shimmering surface of the great lake and watched with wonder and awe the huge circles rippling out from the sudden splash of some fantastic monster; or the greenish gleam, far down in the deep water, of some strange creature upon the confines of darkness. These are the scenes which my mind and my pen will dwell upon in every detail at some future day.

ARTHUR CONAN DOYLE (1859–1930), Scotland

The Three of Us Were Awestruck

The above letter mentions the visit of the engineer of the Electric Company and his lady. So prosaic in itself, it involved a mysterious incident. I have often puzzled over the incident, and it is not the only time that I have wondered whether the Maharajah might possess supernormal faculties. The couple were on their second visit to us, and incidentally mentioned an adventure that had happened to them after their first visit. They were motoring away from Dewas to Indore, and just as they crossed the Sipra some animal or other dashed out of the ravine and charged their car so that it swerved and nearly hit the parapet of the bridge.

His Highness sat up, keenly interested. "The animal came from the left?" he asked.

"Yes."

"It was a large animal? Larger than a pig but not as big as a buffalo?"

"Yes, but how did you know?"

"You couldn't be sure what animal it was?"

"No, we couldn't."

He leant back again and said, "It is most unfortunate. Years ago I ran over a man there. I was not at all to blame—he was drunk and ran onto the road and I was cleared at the

enquiry, and I gave money to his family. But ever since then he has been trying to kill me in the form you describe."

The three of us were awestruck. But he had told the story in an ordinary tone of voice and went on to ordinary things. On another occasion he told me of some witches that he had surprised at their work, on another of the tiny points of light that appear all over the Himalayas when the holy men light their fires.

On another occasion, when he was staying down at Bai Saheba's, he appeared to know what was occurring up in the New Palace before he had been informed. He was both shrewd and imaginative, and the combination explains much. But in the case of the Sipra animal there is an unexplained residuum.

E.M. FORSTER (1879–1970), England

Jaguar, artist unknown (19th century)

Angel riding on the back of a tiger, artist unknown, Roman

ANIMAL MASKS

THE INDIANS PLAY A CONSPICUOUS part in the amuse-
ments at St. John's eve, and at one or two other holidays
which happen about that time of the year—the end of June.
In some of the sports the Portuguese element is visible, in
others the Indian, but it must be recollected that masquerad-
ing, recitative singing, and so forth, are common originally to
both peoples. A large number of men and boys disguise them-
selves to represent different grotesque figures, animals, or
persons. Two or three dress themselves up as giants, with the
help of a tall framework. One enacts the part of the Caypor,
a kind of sylvan deity similar to the Curupira which I have
before mentioned. The belief in this being seems to be com-
mon to all the tribes of the Tupi stock. According to the fig-
ure they dressed up at Ega, he is a bulky, misshapen monster,
with red skin and long shaggy red hair hanging half way
down his back. They believe that he has subterranean campos
and hunting grounds in the forest, well stocked with pacas
and deer. He is not at all an object of worship nor of fear,
except to children, being considered merely as a kind of hob-
goblin. Most of the masquers make themselves up as ani-
mals—bulls, deer, magoary storks, jaguars, and so forth, with
the aid of light frameworks, covered with old cloth dyed or
painted and shaped according to the object represented. Some
of the imitations which I saw were capital. One ingenious fel-
low arranged an old piece of canvas in the form of a tapir,
placed himself under it, and crawled about on all fours. He

constructed an elastic nose to resemble that of the tapir, and made, before the doors of the principal residents, such a good imitation of the beast grazing, that peals of laughter greeted him wherever he went. Another man walked about solitarily, masked as a jabiru crane (a large animal standing about four feet high), and mimicked the gait and habits of the bird uncommonly well. One year an Indian lad imitated me, to the infinite amusement of the townsfolk. He came the previous day to borrow of me an old blouse and straw hat. I felt rather taken in when I saw him, on the night of the performance, rigged out as an entomologist, with an insect net, hunting bag, and pincushion. To make the imitation complete, he had borrowed the frame of an old pair of spectacles, and went about with it straddled over his nose. The jaguar now and then made a raid amongst the crowd of boys who were dressed as deer, goats, and so forth. The masquers kept generally together, moving from house to house, and the

performances were directed by an old musician, who sang the orders and explained to the spectators what was going forward in a kind of recitative, accompanying himself on a wire guitar. The mixture of Portuguese and Indian customs is partly owing to the European immigrants in these parts having been uneducated men, who, instead of introducing European civilisation, have descended almost to the level of the Indians, and adopted some of their practices. The performances take place in the evening, and occupy five or six hours; bonfires are lighted along the grassy streets, and the families of the better class are seated at their doors, enjoying the wild but good-humoured fun.

HENRY WALTER BATES (1825–1892), England

Sons of Horus (c.2613–2160 BC), Egypt

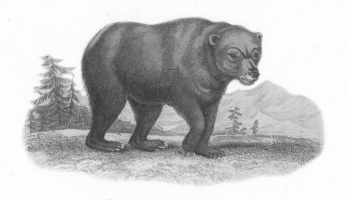

Lapland—The Old Bear

WE SHOULDERED OUR KNAPSACKS and set off again. As we descended the slope, the aspect of the landscape changed more and more. We wandered over immense tundras covered with carex grass and here and there patches of bright yellow clusters of cloud-berries which we picked and ate as we passed along. The solitary Dwarf-birches, the *betula nana* of the heights, grew into groves of silver birches, intermixed with aspen and ash and thickets of willow-elder, bird-cherry and wild currant. Soon we entered a dense forest of stately fir trees. A couple of hours later we were walking through a deep gorge walled in by steep, moss-covered rocks. The sky over our heads was still bright with evening sun but it was already almost dark in the ravine. Ristin glanced uneasily around her, it was evident that she was in a hurry to get out of the gorge before night-fall. Suddenly she stood still. I heard the crashing of a broken tree-branch and I saw something dark looming in front of me at a distance of less than fifty yards.

"Run," whispered Ristin, white in the face, her little hand grasping the axe in her belt.

Yellow Bear of Norway, William Home Lizars (1788–1859), England

I was quite willing to run had I been able to do so. As it was, I stood still, riveted to the spot by a violent cramp in the calf of my legs. I could now see him quite well. He was standing knee-deep in a thicket of bilberries, a twig full of his favourite berries was sticking out of his big mouth, we had evidently interrupted him in the midst of his supper. He was of uncommonly large size, by the shabby look of his coat evidently a very old bear, no doubt the same ear Turi had told me about.

"Run," I whispered in my turn to Ristin with the gallant intention of behaving like a man and covering her retreat. The moral value of this intention was however diminished by the fact that I was still completely unable to move. Ristin did not run. Instead of running away she made me witness an unforgettable scene, enough to repay a journey from Paris to Lapland. You are quite welcome to disbelieve what I am going to tell you, it matters little to me. Ristin, one hand on her axe, advanced a few steps towards the bear. With her other hand raising her tunic, she pointed out the wide leather breeches which are worn by the Lapp women. The bear dropped his bilberry twig, sniffed loudly a couple of times and shuffled off among the thick firs. "He likes bilberries better than me," said Ristin as we set off again as fast as we could.

Ristin told me that when her mother had brought her back from the Lapp school in the spring, they had come upon the old bear almost at the same place in the midst of the gorge and that he had scrambled away as soon as her mother had shown him she was a woman.

AXEL MUNTHE (1857–1949), Sweden

WHISKERS AS A LOVE CHARM

THE GREAT CARNIVORES have become the subject of leg-
end, folk-lore, and romance; and fear has made them objects
of propitiation and worship. Sacred red-painted stones are
placed to mark the spot where a tiger has slain a man. It is
believed that worship at these shrines will avert a similar fate.
It is a common belief that the spirit of a human being killed
by a man-eater accompanies its destroyer to warn it of any
approaching danger, while to certain forest tribes is given the
power to protect tigers by turning away the bullets of the
hunter. Many products derived from the tiger are held for
various reasons in high esteem. The fat is valued as an aphro-
disiac and as a remedy for rheumatism. The clavicles or 'lucky
bones', which are the rudimentary collar bones found loose
in the muscles of the lower neck near the shoulder joint, and
the claws are prized as charms and ornaments. The whiskers
may be used as a love charm or be pounded into a mechani-
cal poison to rid one of an enemy. The liver is eaten to impart
courage, and the milk of a tigress is applied to soothe ail-
ments of the eyes.

S.H. PRATER (1890–1960), India

Jaguar, J.J. Audubon (1785–1851), Haiti / United States

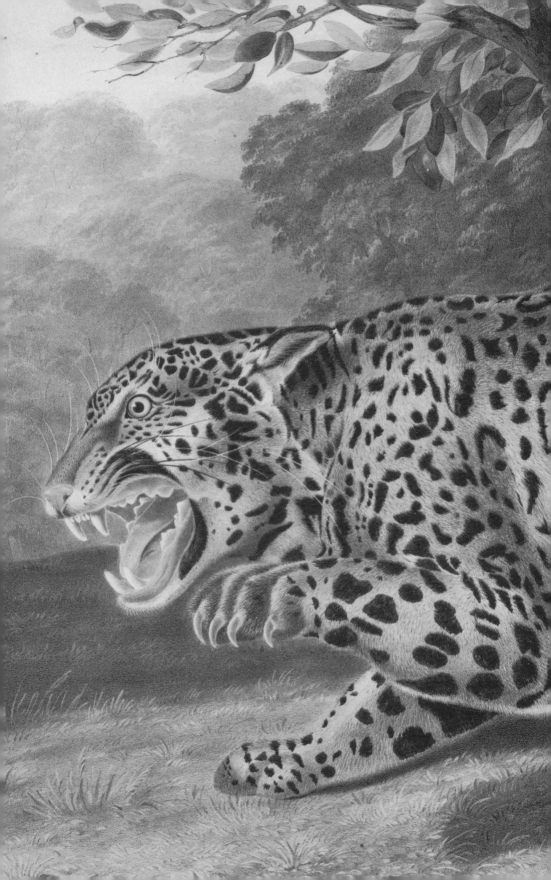

Gentiana. Vulpis.

ALL GOD'S CHILDREN CAN DANCE

ALL HE HAD EVER PRAYED FOR was an ability to catch outfield flies, in answer to which God had bestowed upon him a penis that was bigger than anybody else's. What kind of world came up with such idiotic bargains?

Yoshiya took off his glasses and slipped them into their case. Dancing, huh? Not a bad idea. Not bad at all. He closed his eyes and, feeling the white light of the moon on his skin, began to dance all by himself. He drew his breath deep into his lungs and exhaled just as deeply. Unable to think of a song to match his mood, he danced in time with the stirring of the grass and the flowing of the clouds. Before long, he, began to feel that someone, somewhere, was watching him. His whole body—his skin, his bones—told him with absolute certainty

(ABOVE) *Shaman Plans a Hunt*, Enookie Akulukjuk (1943–2006), Canada
(OPPOSITE) *Grey Fox*, Mark Catesby (1682–1749), England

333

that he was in someone's field of vision. So what? he thought. Let them look if they want to, whoever they are. All God's children can dance.

He trod the earth and whirled his arms, each graceful movement calling forth the next in smooth, unbroken links, his body tracing diagrammatic patterns and impromptu variations, with invisible rhythms behind and between rhythms. At each crucial point in his dance, he could survey the complex intertwining of these elements. Animals lurked in the forest like trompe l'oeil figures, some of them horrific beasts he had never seen before. He would eventually have to pass through the forest, but he felt no fear. Of course—the forest was inside him, he knew, and it made him who he was. The beasts were ones that he himself possessed.

How long he went on dancing, Yoshiya could not tell. But it was long enough for him to perspire under the arms. And then it struck him what lay buried far down under the earth on which his. feet were so firmly planted: the ominous rumbling of the deepest darkness, secret rivers that transported desire, slimy creatures writhing, the lair of earthquakes ready to transform whole cities into mounds of rubble. These, too, were helping to create the rhythm of the earth. He stopped dancing and, catching his breath, stared at the ground beneath his feet as though peering into a bottomless hole.

HARUKI MURIKAMI (1949–), Japan

WITH A SIGH OF REGRET

ONE EVENING FROM A HIDE near Kingfisher gorge, I was watching a troop of baboons through my glasses, as they worked over the ground on the opposite slope. While I watched, three wart-hogs emerged from some thick bush and started grubbing about, digging here and there for the roots they love and throwing up puffs of red soil with their tusks. As soon as the baboons saw them they moved over, and taking no notice of the pigs searched about in the torn ground for the insects and bits of root exposed by the industry of the hogs. On several occasions pig and baboon fed within a foot or two of each other quite unconcernedly.

On the rocks above some hyrax lay sunning themselves in the warmth of the setting sun and at the drift below, a herd of golden impala browsed on the bushes along the banks of the stream. The whole setting made a delightful picture of wildlife living undisturbed and in harmony. If I had shown myself all would have been spoilt.

It is a pity that man, through centuries of hunting and killing, is outlawed. Whenever he shows himself afoot he instills fear in the hearts of the dwellers of the bush. I had a very good example of this only yesterday.

I went out to see how a visiting scientist was faring at his camp in the game reserve. On arrival his boys told me that he was out, and had gone on foot. I went to look for him, and making for some high ground scanned the country below. It took about one minute to locate the area in which he would be found.

At a certain point game was moving about restlessly, other groups stood staring intently in a certain direction. Looking in the same direction, I saw some plover circling and swooping over a slight depression, and there, plodding slowly through the thin scrub, was a man. . . .

It was with a sigh of regret that I left my hide that evening as the blue haze of dusk closed in. A bushbuck barked hoarsely in the dark shadows of the valley, and further off, a lone hyaena was moaning to the night.

K. DE P. BEATON, details unknown

Death of a Unicorn (detail), Ashmole Bestiary (early 13th century), England

A Band of Rare Mammals

ON ONE OF MY LAST WINTER DAYS with the desert bighorns, they no longer kept me out of their world. With motions I had come to know as an exquisite union of liturgy and physics, they closed the distance between us and herded me toward a threshold, a place best described as a hairsbreadth.

Their slender legs rose like smoke from stone, curving into pale rumps. The rump carried all the muscle, the force that was capable of pushing their stocky bodies up a sheer cliff

Bighorn Ram, Sallie A. Zydek (contemporary), United States

with nothing beneath their hooves but air and a foothold barely larger than my lower lip. This is what you will find at the centre of the desert bighorn: dry, vertical space. On the flats, they seem as awkward as square wheels.

Their haunches held but small tensions now. The sheep stood about like mildly bored ballerinas. Black hooves found cusps of white snow. Breath condensed in milky wraiths. The wind did not matter to them. They moved serenely among themselves, brushing flanks warm with blood, weaving me toward that breach of transmutation.

Something in their amber eyes told me that I was about to change, to be given a language without tongues. I wanted to leap into that wild side—their side—then bring back their startling news from the other-than-human world. But I was weighted with a wobbly confusion about how to see, how to behave.

After so many days among the bighorns, in the end it seemed best to quiet the mind and act like a rock. I am simply here, I thought, here at the periphery of several hundred pounds of Ovis with lovely rumps and eyelashes as delicate as fish bones.

I then became the first rock in history to be overcome with feeling, a serene aching aimed at nothing in particular, only a cobalt sky with no edge but winter's cold and a river beside us that shook out its light in full dazzle, a river rimmed with ice and a band of rare mammals whose own biology and history could have lost them to the world.

ELLEN MELOY (1946–2004), United States

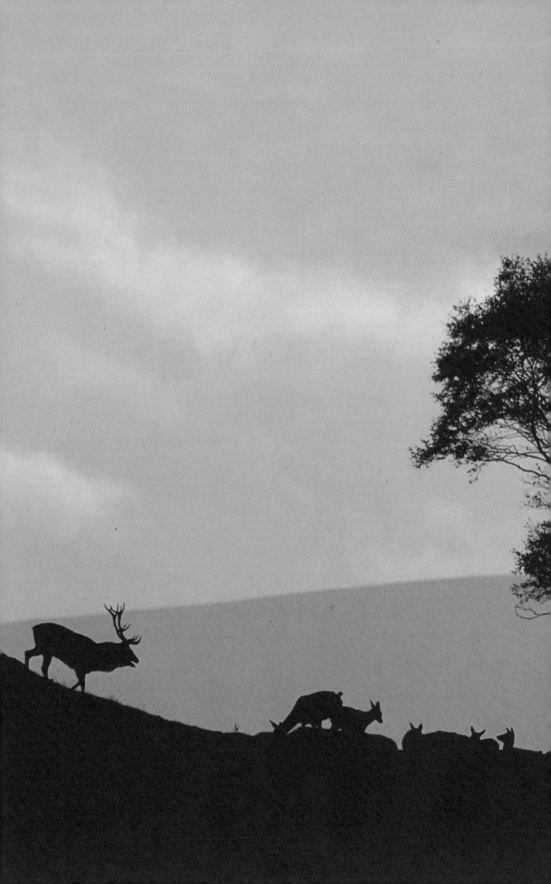

The Evening was Peaceful

The evening was beautiful. Jourdan whistled. He had just cast the last handful of seeds. Bobi still had three handfuls before the ground was completely covered. He cast two, then this was the last. He stopped and turned around. He answered the whistle. It was finished. The evening was as sweet as willow sap. The two men met under the whitebeam. On the horizon the form of the distant sower was still visible—perhaps it was Jacquou—the size of a fly. He had stopped. He must have finished, too. The evening was peaceful and made for repose.

They saw the stag and all his herd coming. It had been a long time since anyone had seen them.

Bobi was shaking out the sacks.

"There they are," said Jourdan.

And Bobi understood at once that he was speaking of the stag, the does, and the fawns. It was a wild herd and seemed to have been created for the heart's solace and delight.

The stag called toward the two men but did not come any nearer. He stopped on the other side of the field. He stretched his neck, opened his mouth, and called a long sort of phrase in which were repeated three kinds of syllables and clickings

Stag and deer, Laurie Campbell (1958–), England

of the tongue. That lasted a long time. With head lowered, he seemed to be explaining something. Behind him crowded the does and fawns. Only their trembling ears were visible.

The stag stopped speaking. He waited the reply. Bobi whistled.

"Wait," said Jourdan. "I'll whistle, too."

He wanted to. He whistled.

The stag listened to the voices of the two men. For a moment he stood motionless, his head lifted. Then he began to walk in a circular path around the whitebeam tree. He had a noble, precise step that shook his neck. His antlers were broader and larger than before. They sprang from his forehead, thick and black like the roots of an oak. Behind him, in single file, came the does with tiny, light, rapid step. They were obliged to stop from time to time, so as not to pass the male. Then came the fawns. There were five. They were as red as foxes.

Thus they encircled the whitebeam tree at a distance of forty or fifty steps; then, always at the same pace, the stag broke the circle and moved out on the plateau in the direction of the place where the distant sower was sometimes visible. Finally, the stag broke into a gallop. All his family followed. The fawns leaped in every direction, but they had good legs and did not allow themselves to be outdistanced. They were soon only a ball of dust, then nothing. The evening grew silent once more.

JEAN GIONO (1895–1970), France

Polar Bears Wrestling, Inuit (19th century), Alaska

An Elephant's Death

IN A CASE WHEN AN ANIMAL is mortally wounded and cannot rise, the other members of the herd . . . circle it disconsolately several times, and if it is still motionless they come to an uncertain halt. They then face outward, their trunks hanging limply to the ground. After a while they may prod

Elephants, Mary Frank (1933–), United States

and circle again, and then again stand, facing outward. Eventually, if the fallen animal is dead, they move aside and just hang around . . . for several hours, or until nightfall, when they may tear out branches and grass clumps from the surrounding vegetation and drop these on and around the carcass, the younger elephants also taking part in this behaviour. They also scrape soil towards the carcass and then stand by, weaving restlessly from side to side. Eventually they move away from the area.

SYLVIA SIKES (1925–), Kenya/England

Large, Fascinating Eyes

MAN DESTROYED THE ORDER of nature by his thought and labour. He craved a new discipline through a sequence of self-imposed prohibitions. He was ashamed of his face, a visible sign of difference. He often wore masks, animal masks, as if trying to appease his own treason. When he wanted to appear graceful and strong, he became a beast. He returned to his origins lovingly submerged in the warm womb of nature.

In the Aurignacian epoch the images of men have the forms of hybrids with the heads of birds, apes and deer: in the cave of Trois Frères a human figure is dressed in animal hide and antlers, presiding as "god of the cave" or "the wizard" with large, fascinating eyes. One of the most beautiful portrayals depicts a fabulous animal carnival. A crowd of horses, bucks, bison and a dancing man with a bison's head who plays a musical instrument.

ZBIGNIEW HERBERT (1924–1998), Poland

Black-maned Lion, William Home Lizars, (1788–1859), England

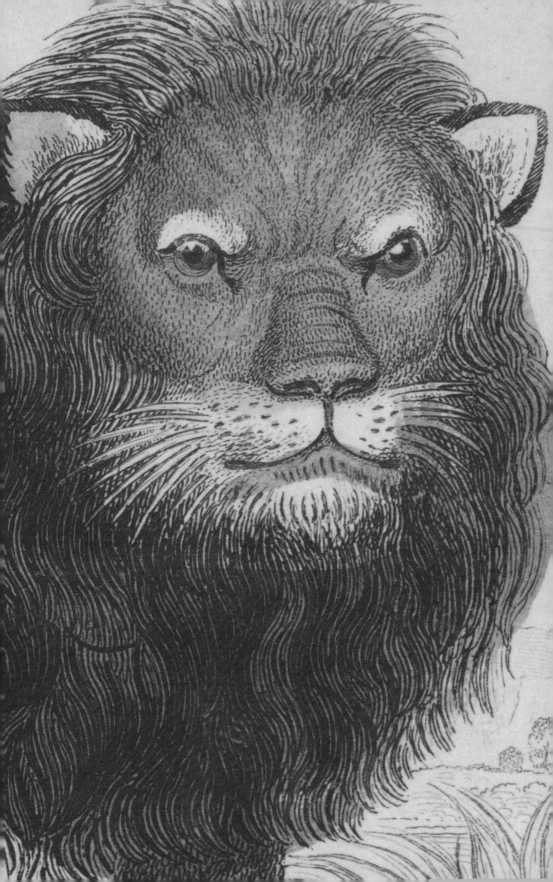

Aelian. *On the Characteristics of Animals: Vol. 1*, Loeb Classical Library™ Vol. 446. Trans. A.F. Scholfield.Reprinted by permission of the publishers and Trustees of the Loeb Classical Library™, Cambridge, Mass. Harvard University Press. Copyright © 1958 the President and Fellows of Harvard College. The Loeb Classical Library™ is a registered trademark of the President and Fellows of Harvard College.

Aksakov, Sergei Timofeevich. *Notes of a Provincial Wildfowler*. Trans. Kevin Windle. Northwestern University Press, Evanston, Illinois. Copyright © 1998 Northwestern University Press.

"An Ainu Story." Trans. Arthur Waley. Ed. Diana Spearman. *The Animal Anthology*. Hohn Baker, London.

Angier, Bradford. *How to Stay Alive in the Woods*. Collier Books, New York. Copyright © 1956 Bradford Angier. Reprinted by kind permission of Stackpole Books.

Armitage, Simon. Trans. *From Sir Gawain and the Green Knight: A New Verse Translation*. Copyright © 2007 by Simon Armitage. Used by permission of W. W. Norton & Company, Inc., New York, and Faber and Faber Ltd., London.

Atwood, Margaret. *The Door*. McClelland & Stewart Ltd., Toronto. Copyright © 2007 O. W. Toad. Published by kind permission of the author.

Barbellion, W. N. P. *The Journal of a Disappointed Man*. Penguin, London, 1948.

Bates, Henry Walter. *The Naturalist on the Rivers Amazon*. New York: The Humboldt Publishing Co. Available at www.gutenberg.org/etext/2440

Beaton, K. de P. *A Warden's Diary*. East African Standard Ltd., 1949.

Benjamin, Walter. Excerpt from *Reflections: Essays, Aphorisms, Autobiographical Writings*. Copyright © 1978 Houghton Mifflin Harcourt Publishing Company. Reprinted by permission of the publisher.

Bierhorst, John, Ed. "The Coyote Teodora" from *Latin American Folktales*. Copyright © 2002 John Bierhorst. Used by permission of Pantheon Books, a division of Random House Inc.

Birney, Earle. *The Poems of Earle Birney*. New Canadian Library Original #6 McClelland & Stewart Ltd. Copyright © 1969 Earle Birney. Reprinted by kind permission of Madam Justic Wailan Low.

Blainey, Geoffrey. *Triumph of the Nomads: A History of Ancient Australia*. Sun Books, South Melbourne, Victoria 3205, Australia. Copyright © Text & Maps Geoffrey Blainey. Reprinted by permission of the author.

Cahalane, Victor H., in *Discovery: Great Moments in the Lives of Outstanding Naturalists*. Ed. John K. Terres. Harper & Row; J. B. Lippincott, Philadelphia and New York.

Carter, Angela. "The Werewolf" from *The Bloody Chamber*. Copyright © 1980 Angela Carter. Reproduced by permission of the Angela Carter estate, c/o Rogers, Coleridge & White Ltd., London.

Chamberlain, B. H. Trans. Ishanashte "The Man who Married the Bear-Goddess." from Aino Folk-Tales. www.sacred-texts.com/shi/aft/index.htm

Champion, F. W. *The Jungle in Sunlight and Shadow*. Charles Scribner & Sons, New York, 1934.

Corbett, Jim. From *Man-Eaters of Kumaon*. Oxford University Press. New York, London 1946. Copyright © 1946 OUP New York. Reprinted by permission of Oxford University Press.

Corbett, Jim. "Death of a Goat" and "Goat Boy and the Leopard" in *The Man-Eating Leopard of Rudraprayag* by Jim Corbett. Geoffrey Cumberlege, Oxford University Press, 1951. Reprint by permission of Oxford University Press.

Darwin, Charles. *Notebooks on Transmutation*. www.darwin-online.org.uk

D'Aurevilly, Barbey. "The Famous Black Panther" *Les Diaboliques*. Trans. Ernest Boyd. Alfred A. Knopf, New York, 1925.

DeMontaigne, Michel. Quotation available online.

De Vigny, Alfred. From *The Death of the Wolf*. Trans. Rivers Scott, in *The Animal Anthology* Ed. Diana Spearman. John Baker, London 1966.

De Voragine, Jacobus. *The Golden Legend or Lives of the Saints*. Compiled by Jacobus de Voragine, Archbishop of Genoa, 1275. First Edition Published 1470. Englished by William Caxton, First Edition 1483, Edited by F.S. Ellis, Temple Classics, 1900 (reprinted 1922, 1931). www.fordham.edu/halsall/basis/goldenlegend/GoldenLegend-Volume3.htm#George

Dobie, Frank J. From *Coyote Wisdom*, Frank J. Dobie, Mody C. Boatright, and Harry H. Ransom eds. (Denton: University of North Texas Press and Texas Folklore Society, 1938, 2000). Copyright © 1983 the Texas Folklore Society. Reprinted by permission.

Doyle, Sir Arthur Conan. *The Lost World*. www.gutenberg. org/etext/139

Durrell, Gerald. *Encounters with Animals*. Penguin Books Ltd. Harmondsworth, Middlesex, England. Copyright © Gerald Durrell. Courtesy of Curtis Brown Literary Agency, London.

Eisely, Loren. *The Invisible Pyramid*. University of Nebraska Press. Copyright © 1970 Loren Eisely.

Engel, Marian. *Bear*. McClelland & Stewart Ltd., Toronto. Copyright © 1976 Marian Engel. Reprinted by permission of Charlotte and William Engel.

Evelyn, John. *Diary* qtd in *The Assassin's Cloak*. Ed. Irene & Alan Taylor. Canongate Books, Edinburgh.

Evelyn-White, H. G. Trans from H.G. Evelyn-White's Loeb Classical Library text, with reference to T.W. Allen, W.R. Halliday, and E.E. Sykes, eds. *The Homeric Hymns* (2nd ed., 1936).

Fabre, Jean-Henri. *The Life of the Grasshopper*. Trans. Alexander Teixera de Mattos. McClelland, Goodchild & Stewart Ltd., Toronto, 1917.

Flanagan, Robert. *Incisions*. House of Anansi Press Ltd. Copyright © Robert Flanagan. 1972. Reprinted by kind permission of Robert Flanagan.

Flaubert, Gustave. *The Legend of St. Julian the Hospitaller*. www.onlinebooks. lbrary.upenn.edu/webbin/gutbook/lookup?num=10458

Forster, E. M. Excerpt from *The Hill of Devi*. Copyright © 1953 by E. M. Forster and renewed 1981 by Donald Parry. Reprinted by permission of Houghton Mifflin Harcourt Publishing Company (Canada & U.S.A.). Reprinted by permission of The Provost and Scholars of King's College, Cambridge, and the Society of Authors as the Literary Representative of the Estate of E. M. Forster (U.K.)

Frazer, Sir James. *The Golden Bough*. Reprinted by permission of The Masters and Fellows of Trinity College Cambridge.

Giono, Jean. From *Joy of Man's Desiring* by Jean Giono. Copyright © 1980 Aline Giono. Reprinted by permission of North Point Press, a division of Farrar, Straus and Giroux, LLC and Editions Grasset & Fasquelle. From *Que ma joie demeure*. Trans. Katherine Allen Clarke. Editions Grasset & Fasquelle, Paris.

Godfrey, Dave. *Death Goes Better with Coca-Cola*. House of Anansi Press, Toronto. Copyright © 1967 Dave Godfrey. Reprinted by permission of David Godfrey.

Grady, Wayne. *Bringing Back the Dodo*. McClelland & Stewart Ltd., Toronto. Copyright © Wayne Grady. Reprinted by kind permission of Wayne Grady.

Grünbein, Durs. "To a Cheetah in the Moscow Zoo" from *Ashes for Breakfast: Selected Poems*. Trans. Michael Hofmann. Copyright © 2005 Durs Grünbein. Translation copyright © 2005 Michael Hoffman. Reprinted by permission of Farrar, Straus and Giroux, LLC., New York, and Faber and Faber Ltd., London.

Heaney, Seamus. Trans. From *Beowulf* by Seamus Heaney. Copyright © 1999 Seamus Heaney Used by permission of W. W. Norton & Co. Inc., New York, and Faber & Faber Ltd., London.

Hearne, Samuel. *A Journey from Prince of Wales Fort in Hudson's Bay, to The Northern Ocean*. London, T. Cadell Jun. and W. Davies (successors to Mr. Cadell, in the Strand).

Heming, Arthur. *The Drama of the Forest*. Copyright © 1947 McClelland & Stewart Ltd., Toronto.

Henry, Alexander. *Travels and Adventures in Canada and the Indian Territories, between the years 1760 and 1776*. M. G. Hurtig Ltd., Edmonton. 1969.

Herbert, Zbigniew. *Barbarian in the Garden*. Harcourt & Brace, New York and London, 1985. Reprinted by kind permission of Michael March.

Hesiod. From *The Theogeny of Hesiod*. Trans. Hugh G. Evelyn-White. www.sacred-texts.com/cla/hesiod/theogeny.htm

Hesse, Herman. From *Steppenwolf*. Random House, New York / Penguin, London, 1967 / Allen Lane, 1974. Trans. Basil Creighton.

Hoagland, Edward. From "A Form of Vandalism" and "Hailing the Elusory Mountain Lion" in *Walking the Dead Diamond River*. Published by The Lyons

Hornaday, William Temple. *The Extermination of the American Bison.* Smithsonian Institution Press, Washington and London. Foreword and Introduction copyright © 2002 Smithsonian Institution.

Hudson, W. H. *The Purple Land.* The Modern Library. 1927

Jameson, Anna. *Winter Studies and Summer Rambles in Canada.* Saunders & Otley, London, 1839.

Jeffers, Robinson. From *The Collected Poetry of Robinson Jeffers*, edited by Tim Hunt, Volume 2, 1928-1938. Copyright © 1938, renewed 1966 by Donnan Jeffers and Garth Jeffers. Used by permission of Stanford University Press. All rights reserved. Permission also granted by Carcanet Press Ltd., Manchester. Copyright © Random House, Inc. 1987.

Jennison, George. *Noah's Cargo.* A. & C. Black Ltd., London, 1928.

Kafka, Franz. *Meditation.* Trans. Siegrid Mortkowitz. Vitalis BIBLIOTHECA BOHEMICA. Copyright © Vitalis 2007.

Kinnell, Galway. "Everyone Was in Love" from *Strong Is Your Hold: Poems.* Copyright © 2006 Galway Kinnell. Reprinted by permission of Houghton Mifflin Harcourt Publishing Company and Bloodaxe Books, 2007. All rights reserved.

Kipling, Rudyard. *Rudyard Kipling's Verse: The Definitive Edition.* Hodder and Stoughton, London, 1942.

Lawrence, R. D. *Wildlife in Canada* (revised edition). Thomas Nelson & Sons (Canada) Ltd. Copyright © 1970 R. D. Lawrence.

Leopold, Aldo. "Thinking Like a Mountain" from *A Sand County Almanac.* (Oxford University Press, 1949). Ballantine Books, New York. Reprinted by permission of Oxford University Press.

Leydet, François. *The Coyote.* University of Oklahoma Press, Norman and London. Copyright © 1977 François Leydet. Reprinted by permission of the University of Oklahoma Press.

Livingston, John A. *The John A. Livingston Reader: Including the Fallacy of Wildlife Conservation AND One Cosmic Instant: A Natural History of Human Arrogance.* McClelland & Stewart Ltd., Toronto. Copyright © The Estate of John Livingston.

Livingstone, Dr. David. *Missionary Travels and Researches in South Africa.* www.gutenberg.org/etext/1039

Long, William J. *Mother Nature.* Harper & Brothers, New York & London. 1923.

Lopez, Barry. *Giving Birth to Thunder, Sleeping with his Daughter: Coyote Builds North America.* A Bard Book / Published by Avon Books. A Division of the Hearst Corporation, New York. Reprinted by permission of SLL/Sterling Lord Literistic, Inc. Copyright © Barry Holstun Lopez.

Lopez, Barry. *Of Wolves and Men*. Charles Scribner's Sons, New York. Reprinted by permission of SLL/Sterling Lord Literistic, Inc. Copyright © 1978 Barry Holstun Lopez.

Lorenz, Konrad Z. *King Solomon's Ring*. Trans. Marjorie Kerr Wilson, HarperTorchbooks, Harper & Row, New York. Copyright © 1952 Harper & Row Publishers. Reprinted by kind permission of Taylor & Francis Books.

Low, Tim. From *The Quirks and Quarks Question Book* by CBC, quoting Tim Low, freelance consultant and former Curator of Fishes at the Vancouver Aquarium © 2002. Published by McClelland & Stewart Ltd. Used by permission of the publisher.

Meeker, Joseph W. *The Comedy of Survival: Studies in Literary Ecology*. Charles Scribner & Sons, New York. Copyright © 1972, 1973, 1974 Joseph W. Meeker. Copyright © 1972 *Canadian Fiction* Magazine. Reprinted by kind permission of Joseph W. Meeker.

Meloy, Ellen. *Eating Stone*. Vintage Books 2006. Copyright © 2005 Mark Meloy. Reprinted by permission of SLL/Sterling Lord Literistic, Inc., and Pantheon Books, a division of Random House Inc.

Merriam, C. Hart, Ed. *Dawn of the World* by C. Hart Merriam. First © 1910, C. Hart Merriam and Lowell John Bean © 1993. *The Dawn of the World: Myths and Tales of the Miwok Indians of California*. University of Nebraska Press.

Miyazawa, Kenji. From "The Bears of Nametoko" in *Once and Forever: The Tales of Kenji Miyazawa*. Translated by John Bester. Copyright © 1993, 1997 Kodansha International Ltd. Reproduced by permission. All rights reserved.

Moffat, Alistair. From *Before Scotland: The Story of Scotland Before History*. Copyright © 2005 Alistair Moffat. Reproduced by kind permission of Thames & Hudson Ltd., London.

Montague, John. *Selected Poems*, Exile Editions. Copyright © 1982, 1991 John Montague. Reproduced by permission of the publisher.

Moodie, Susanna. *Roughing it in the Bush*. Published by Richard Bentley, London, 1852.

Munthe, Axel. *The Story of San Michele*. John Murray, London, 1930. Reproduced by permission of John Murray (Publishers) Ltd. and kind permission of Adam Munthe.

Murikami, Haruki. *After the Quake*. Trans. Jay Rubin, Vintage Books, London 2003. Copyright © 2001 Haruki Murakami. English translation copyright © 2002 Haruki Murakami. Reprinted by permission of International Creative Management, Inc.

Musil, Robert. *Posthumous Paper of a Living Author*. Trans. from the German by Peter Wortsman. English translation copyright © Peter Wortsman. Published by arrangement with Archipelago Books, New York; archipelagobooks.org.

Neruda, Pablo. *Arte De Pajaros – Art of Birds*. Trans. Jack Schmitt. Lynx Edicions Montseny, Barcelona. Copyright © Pablo Neruda. Reprinted by kind permission of Jack Schmitt.

Newlove, John. "The Yellow Bear" from *Black Night Window*, McClelland & Stewart Ltd., Toronto. Copyright © 1968 John Newlove. Reprinted by kind permission of Susan Newlove.

Newlove, John. "God Bless the Bear" from *A Long Continual Argument: the selected poems of John Newlove*. Chaudier Books, Ottawa. Reprinted by kind permission of the publisher.

Nonus. *Dionysiaca Book 6*. Trans. W. H. D. Rouse. Can be found at: www.theoi.com/Text/NonnusDionysiaca6.html

Nowlan, Alden. "Bull Moose" from *Between Tears and Laughter: Selected Poems*. Bloodaxe Books, 2004. Copyright © 1962 Alden Nowlan. Reprinted by permission of House of Anansi Press, Toronto.

Orwell, George. "Shooting an Elephant" from *Shooting An Elephant And Other Essays* by George Orwell. Copyright © 1946 George Orwell. Reprinted by permission of Bill Hamilton as the Literary Executor of the Estate of the Late Sonia Brownell Orwell and Secker & Warburg Ltd., London. Copyright © 1950 Sonia Brownell Orwell and renewed 1978 by Sonia Pitt-Rivers. Reprinted by permission of Houghton Mifflin Harcourt Publishing Company, New York.

Peterborough Bestiary. MS 53 (fols. 189-210v) The Parker Library Corpus Christi College, Cambridge, UK. Courtesy of the Master and Fellows of Corpus Christi College, Cambridge.

Pessoa, Fernando. *The Book of Disquiet*. Ed and Trans. Richard Zenith, Allen Lane. Reprinted by permission of SLL/Sterling Lord Literistic, Inc. Copyright © 2001 Richard Zenith.

Ponting, Clive. *A Green History of the World: The Environment and the Collapse of Great Civilizations*. Penguin Books. Copyright © 1991 Clive Ponting.

Prater, S. H. *The Book of Indian Animals*. Reproduced by kind permission of the Bombay Natural Historical Society, Bombay. Copyright © 1965 Bombay Natural History Society.

Rasmussen, Knud. *Intellectual Culture of the Iglulik Eskimos*. Report of the Fifth Thule Expedition 1921-24. The Danish Expedition to Arctic North America in Charge of Knud Rasmussen PH. D. Vol. VII. No 1, Gyldendalske Bochandel, Nordisk Forlag. Copenhagen, 1929.

Russell, Franklin. *The Hunting Animal*, Harper and Row, Publishers, New York. Copyright © 1983 Franklin Russell.

Safety in Grizzly and Black-bear Country. Northwest Territories Resources, Wildlife & Economic Development pamphlet 2nd Edition, October 1998.

Sankhala, Kailash. *Tiger! The Story of the Indian Tiger*. Collins, London, 1978 and Simon and Schuster, New York. Copyright © 1977 Kailash Sankhala.

Shepard, Paul. *Nature and Madness.* The University of Georgia Press. Athens & London. Copyright © 1982 Paul Shepard.

Shepard, Paul. *The Tender Carnivore & The Sacred Game.* The University of Georgia Press, Athens, Georgia. Copyright © 1973 Paul Shepard.

Sikes, Sylvia. *Natural History of the African Elephant.* Reprinted by permission of The Orion Publishing Group, London. Weidenfeld and Nicolson (an imprint of the Orion Publishing Group), London, 1971.

Snyder, Gary. "This Poem is for Bear (Hunting 6)" from *Myths and Texts,* Pantheon Books, New York. Copyright © 1978 Gary Snyder. Reprinted by permission of New Directions Publishing Corp., and kind permission of Gary Snyder.

Tate, Allen. "The Wolves" from *Collected Poems 1919–1976.* Copyright © 1977 Allen Tate. Reprinted by permission of Farrar, Strauss & Giroux, LLC.

Thomas, Elizabeth Marshall. *The Tribe of Tiger.* Copyright © 1994 Trustees of the Elizabeth Marshall Thomas 1993 Irrevocable Trust. Reprinted by permission of The Orion Publishing Group, London. Weidenfeld & Nicolson (an imprint of the Orion Publishing Group), London, and Simon & Schuster, Inc., New York.

Tolstoy, Leo. *The Bear Hunt.* Can be found at: www.onlineliterature.com

Tranströmer, Tomas. From "March 1979" by Tomas Tranströmer. Trans. Robin Robertson, appeared in *The Deleted World.* By permission of Enitharmon Press, 2006.

Trigger, Bruce G. Volume Editor. *Handbook of North American Indians,* Vol. 15. Smithsonian Institution, Washington, 1978.

Van der Post, Laurens. From "A walk with a White Bushman." Published by Chatto & Windus, London. Copyright © 1986 Laurens van der Post & Jean-Marc Pottiez. Reprinted by permission of The Random House Group Ltd.

Visser, Margaret. Excerpt from *The Rituals of Dinner.* Copyright © 1991 Margaret Visser. Published in Canada by HarperCollins Publishers Ltd., Toronto. All rights reserved. Published in the United States by Grove/Atlantic. Used by permission of Grove/Atlantic, New York.

Waldron, G.E. (preface) *The Tree Book,* Project Green Inc., Windsor, ON. Copyright © G. E. Waldron. Used by kind permission of G. E. Waldron.

Wallace, Alfred Russel. *The Malay Archipelago.* London: Macmillan and Co., 1890.

Walton, Izaac. *The Compleat Angler.* Can be found at: www.gutenberg.org

Wilson, Edmund. Excerpt from "The Little Water Ceremony" from *Apologies to the Iroquois.* Copyright © 1959, 1960 Edmund Wilson. Reprinted by permission of North Point Press, a division of Farrar Straus & Giroux, LLC.

Wright, Bruce Stanley. *The Eastern Panther: A Question of Survival.* Clarke Irwin & Co., Toronto. Copyright © 1972 Bruce S. Wright.

Zagajewski, Adam. "Circus," in *Without End: New and Selected Poems.* Trans. Clare Cavanaugh. Copyright © 2002 Adam Zagajewski. Translation copyright © 2002 Farrar, Straus and Giroux, LLC. Reprinted by permission of Farrar, Straus and Giroux, LLC, New York, and Faber and Faber Ltd., London.

ENDPAPERS: *The Bunyip*. J. Ford (1860–1840), England.

i. *Bears and cubs wrestling, climbing tree, grazing and suckling*. From *Livre de Chasse* (*Book of the Hunt*) by Gaston Phébus, Paris, France. C. 1410. MS.M.1044, fol. 18 v. Photo credit: The Pierpont Morgan Library/Art Resource NY. The Pierpont Morgan Library, New York.

ii-iii. *Native Sketch of Bison Hunting*. Artist unknown (c.1890–1910). Copyright © The Trustees of the British Museum.

iv-v. *Leopard*. Jean Baptiste Oudry, France. By kind permission of Staatliches Museum Schwerin. Particular thanks to Dr. Gero Seelig.

viii. *Una and the Lion*. William Bell Scott. By permission of the National Galleries of Scotland, Scottish National Gallery of Modern Art.

x. *An Allegory of Prudence*. Titian (Tiziano Vecellio), Italy. c. 1565–70. (Workshop of) Presented by Betty and David Koetser, 1966 (NG 6376) © National Gallery, London, Great Britain/Art Resource, NY.

xiv. *Tiger*. Calligraphy print (c.19th century), North India. Victoria and Albert Museum. V & A Images.

ECHOES OF A WORKING EDEN

xvi. *Panel of Lions*, Chauvet Cave, Chauvet, France. Photo copyright © Jean Clottes. By kind permission of the French Ministry of Culture and Communication, Regional Direction for Cultural Affairs—Rhône–Alpes Region—Regional Department of Archaeology.

5. Gundestrup Cauldron Celtic (1st century BC), Denmark. Photograph John Lee, the National Museum of Denmark. Image by kind permission of NationalMuseet/The National Museum of Denmark.

8. *Swift Fox* J. J. Audubon, Haiti/United States. Toronto Reference Library.

10. *White Tailed Deer Through Birches*. Robert Bateman, Canada. Reproduced by kind permission of Robert Bateman.

13. *Painted wooden mask in the form of a wolf*. Artist unknown (before 1867 AD), Alaska (Northwest coast of America). Tlingit Wolf Mask. Copyright © The Trustees of the British Museum.

14-15. *Felix Nigra*. From *The Natural History of the Felinae*. William Home Lizars, England. Courtesy of the Royal Ontario Museum. Copyright © ROM.

17. *Tiger*. Edward Topsell, England. Reproduced courtesy of the Thomas Fisher rare Book Library, University of Toronto.

18. *Wolf pack and Bull Moose*. Robert Bateman, Canada. Reproduced by kind permission of Robert Bateman.

24. *Leopardess*. Jean Baptiste Oudry, France. By kind permission of Staatliches Museum Schwerin. Particular thanks to Dr. Gero Seelig.

25. *Polar Bear*. Sir Edward Henry Landseer. Gibson collection.

27. *Lion of Senegal*. Karl Joseph Brodtmann, Switzerland.

28. *Unicorn Church ornament*. Ixworth Thorpe, Suffolk. Sir Ninian Comper.

30. *Lynx*. Artist unknown. (19th century) Gibson collection.

31. Hand stencil, Chauvet cave, Chauvet, France. By kind permission of the French Ministry of Culture and Communication, Regional Direction for Cultural Affairs—Rhône-Alpes Region—Regional Department of Archaeology.

32–33. Chinese horse, Lascaux, France. Reproduced courtesy of artres.com, French Ministry of Culture.

36. *Grey Fox*. J. J. Audubon, Haiti/United States. Toronto Reference Library.

37. *Rhinoceros*. Artist unknown.

39. *Lion*. William Home Lizars, England. Thomas Fisher Rare Book Library, University of Toronto.

41. *Alaska Brown Bear*. Louis Agassiz Fuertes, United States. Reproduced courtesy of *National Geographic*.

45. *Leopard*. Artist unknown. (19th. century) Gibson collection

DIET OF SOULS

46. *Calling the Animal Spirits*. Simon Tookoome, Canada. Thank you also to the Matchbox Gallery.

53. *Aigocerus Niger*. William Home Lizars, England.

54. *Owl and Goose Become Human*. Annie Kilabuk Jr., Nunavut, Canada. Reproduced by permission of Kilabuk's descendants and the Uqqurmuiut Inuit Artists Association, Uqqurmuiut.

55. *Grizzly Bear*. J. J. Audubon, Haiti/United States. Toronto Reference Library.

59. *Felis*. Artist Unknown. Gibson collection.

61. *Ocelot*. J. J. Audubon, Haiti/United States. Toronto Reference Library.

63. *Japanese Brown Bear*. Artist unknown.

65. *Pair of Leopards*. Artist unknown (mid–16th century), Benin. National Art Museum, Lagos

67. *Le Céraste*. Artist unknown (c.1860). Gibson collection.

68. *Royal Tiger*. Karl Joseph Brodtmann, Switzerland.

71. *Chippewas on Lake Superior*. Cornelius Kreighoff, Netherlands/Canada. 1860. Art Gallery of Ontario. Copyright © 2009 The Thomson Collection.

72. *The Spirit of 1943*. Lowes Dalbac Luard, England. London Underground Poster. Reprinted by kind permission of TfL (Transport for London).

74. *Sea-Satyr*. Conrad Gessner, Switzerland. Taken from Conrad Gessner's *Icones animalium quadrupedum viviparorum et oviparorum: quae in Historiae animalium*. Courtesy of the Australian Museum Research Library. Special thanks to Leone Lemmer.

75. *Screech Owl*. Thomas McIlwraith, Scotland/Canada.

77. *Hunting Lodge Fresco*. (15th century), Italy. A bear and two male figures. Copyright © DeA Picture Library/Art Resource NY. Villa Borromeo, Oreno di Vimercate, Italy.

80-81. *Black–tailed Deer*. Louis Aggasiz Fuertes, United States. Reproduced courtesy of *National Geographic*.

BEAUTY AND THE BEAST

84. *Little Red Riding Hood*. Gustave Doré, France. Illustration from *Les contes de Perrault*, engraved by Pannemaker, published by J. Hetzel, 1862 (etching) (b/w photo) by Gustave Doré. Courtesy Bibliothèque des Arts Décoratifs, Paris, France/Archives Charmet/The Bridgeman Art Library.

91. *Beauty and the Beast*. Henri Rousseau, France.

92. *Desert Cat*. Artist unknown (c.1896). Gibson collection.

95. *Polar Bear* (detail). J. J. Audubon, Haiti/United States. Toronto Reference Library.

97. *Gorilla Carrying Off a Woman*. Emmanuel Frémiet, France.

98-99. *Mule Deer*. Louis Agassiz Fuertes, United States. Reproduced courtesy of *National Geographic*.

101. *St. George and the Dragon*. Ralph Siferd, Canada. Reprinted by kind permission of Ralph Siferd.

104–105. *A Tiger Hunt at Jhajjar*. Shulam Ali Khan, (c.1820), Delhi, India. Courtesy of Victoria and Albert Museum. V & A Images.

107. *Anonymous creature*. Artist unknown.

109. *Ivory Sculpture of Polar Bear*, Inuit. Etuangat Aksayook, Canada. Courtesy of the Royal Ontario Museum. Copyright © ROM.

111. *Bear/Sloth* (or *Bear/Ape*). Edward Topsell, England. Thomas Fisher Rare Book Library, University of Toronto.

112. *Monkeys*. Peterborough Bestiary MS 53. England. Reproduced courtesy of the Master and Fellows of Corpus Christi College, Cambridge.

113. *Prairie Wolf*. J. J. Audubon, Haiti/United States. Toronto Reference Library.

116. *Funerary Figure*. Artist Unknown (5th century). artres.com/Landesmuseum Saarbrucken, Germany.

117. *A Bear Walking*. Leonardo da Vinci, Italy. Metalpoint on light buff prepared paper. The Metropolitan Museum of Art, Robert Lehman Collection, 1975 (1975.1.369) Image © The Metropolitan Museum of Art.

119. *Studies of a Werewolf*. Charles Le Brun, France.

122-123. *Reclining demimondaine*. (c.1900), France.

DEATH'S GOLDEN EYE

124. *Lioness and Kudu*. Martin Harvey, South Africa.

130-131. *Lioness and Cubs*. William Home Lizars, England. Thomas Fisher Rare Book Library, University of Toronto.

133. *Puma*. Artist unknown (19th century). Gibson collection

136. *Small or common jaguar*. Artist unknown. Gibson collection.

137. *Lioness Devours Boy/Ivory plaque of a lioness devouring a boy* (c.9th–8th century BC), Phoenicia. From the palace of Ashurnasirpal II, Nimrud, northern Iraq. Copyright © The Trustees of the British Museum.

140-141. *Lion and Bull*. From *Arabic Version of the Book of Kalilah and Dinana* by Abdú Illah ibu n'l—Mugaffa. Arabic (14th century). Parker Library, MS 578. Courtesy of the Master and Fellows of Corpus Christi College, Cambridge.

143. *Tiger*. Artist unknown. Gibson collection.

144. *Diana the Huntress*. School of Fontainebleau (c 16th century), France. Photo: Daniel Arnaudet. Photo credit: Réunion des Musées Nationaux/Art Resource NY/Louvre, Paris, France.

146. *Hyena* (early 14th century). Peterborough Bestiary. MS 53. Courtesy of the Master and Fellows of Corpus Christi College, Cambridge.

147. *Frog*. Artist unknown. Gibson collection.

148. *Wolf in a Trap*. Jean–Baptiste Oudry, France. Reproduced by kind permission of Staatliches Museum Schwerin. Particular thanks to Dr. Gero Seelig.

150. *Papa! Here Is My First Rifle Shot*. C. H. Barbant (mid-19th century), France. Gibson collection.

151. *Leopard*. Artist unknown. Gibson collection.

153. *Sambar Deer (Cervus Unicolor) in Forest, Sri Lanka*. Lawrence Worcester (photo 1999). Photo copyright © Lawrence Worcester, by permission of Lawrence Worcester.com. Courtesy L. Worcester.

156. *Moose Lunar*. Charles Pachter, Canada. Courtesy of the Artist.

159. *Medieval Women Hunting*. Artist unknown.

160-161. *Roping of the Bear* (oil on canvas). James Walker (1819–1889), United States. Santa Margarita Rancho of Juan Forster, c.1870. Reproduced courtesy of the California Historical Society/The Autry National Centre/Gift of Mr. and Mrs. Reginald F. Walker/The Bridgeman Art Library.

163. Cave bear, Chauvet, France. Photo copyright © Jean Clottes. By kind permission of the French Ministry of Culture and Communication, Regional Direction for Cultural Affairs—Rhône-Alpes Region—Regional Department of Archaeology.

166. *A Mughal Prince*. Artist unknown (1605), India. Courtesy the Victoria and Albert Museum. V & A Images.

MIGHTY AND TERRIBLE

170-171. *Man with Lion's head*. Artist unknown, (30,000–34,000 BP). Statuette carved of mammoth tusk, 296mm. Upper Paleolithic period (Aurignacian). Photo Thomas Stephan. Copyright © Ulmer Museum, by kind permission.

177. *Monster Tamer/Bull-Headed Lyre*. Object B17694, image #150107. Artist unknown (c. 5000 BP). Ur. Reproduced by permission of the University of

Pennsylvania Museum of Archaeology & Anthropology.

178. *Cross Fox*. J. J. Audubon, Haiti/United States. Toronto Reference Library.

181. *The Manticore*. Artist unknown, Holland.

182. *Magical Spirit, from Nineveh/Stone relief from the South-West Palace of Sennacherib* (Room 32) Artist unknown (Two guardian figures, Ninevah c.645 BC), Assyria. Copyright © The Trustees of the British Museum.

185. *Head of Dionysus*. Cameo (1st century AD); pendant (c.1730), Germany. Victoria and Albert Museum. V& A Images.

186-187. *Nebuchadnezzar*. William Blake, England. Copyright © Tate Museum, London 2009.

188. *Watson and the Shark*. John Singleton Copley, United States. The Detroit Institute of Arts, USA/Founders Society purchase, Dexter M. Jerry Jr. fund/The Bridgeman Art Library. National Gallery of Art, Washington DC. 1782.

191. *The Five–Faced Shiva*. Artist unknown (mid–18th century), India. Victoria and Albert Museum. V & A Images.

192. *Mask of Dzoonokwa*. Artist unknown Kwakwaka'wakw (c. 19th century AD), British Columbia, North America. Copyright © The Trustees of the British Museum.

195. *Altarpiece Dragon*. Sir Ninian Comper, Scotland. Photo by Mike Harding. Reproduced by kind permission of Mike Harding.

196. *Flight from the Mammoth*. Paul Joseph Jamin, France. Musée Nationale d'Histoire.

197. *A Description of the nature of four–footed beasts or Manticore*. 1678. Joannes Jonstonus, Poland.

199. *White Wolf*. J. J. Audubon, Haiti/United States. Toronto Reference Library.

201. *Of the Wolf*. Edward Topsell, England. Thomas Fisher Rare Book Library, University of Toronto.

202. *Dragon*. Peterborough Bestiary (early 14th century), England. Reproduced courtesy of Corpus Christi College Library, Cambridge.

203. *Le Devin*. Artist unknown (c.1860). Gibson collection.

206. *Griffin*. Peterborough Bestiary, (early 14th century), England. Courtesy of the Master and Fellows of Corpus Christi College, Cambridge.

207. *Frog*. Artist unknown. Gibson collection.

208. *Rao Umed Singh Hunting a Boar*. Artist unknown, (c.1790), Bundi, India. Victoria and Albert Museum. V & A Images.

KILLING WITHOUT EATING

210. From *A House of Cards*. Images from the Eisbergfreistadt Souvenir Deck of Cards by Kahn & Selesnick 1923/2008. Courtesy of the artists.

216. *Birds Hanging*. Eisbergfreistadt Souvenir Deck of Cards by Kahn & Selesnick 1923/2008. Courtesy of the artists.

218-219. *Evening Clouds*. Graeme Gibson (1934–), Canada.

220. *Polar hare*. J. J. Audubon, Haiti/United States. Toronto Reference Library.

224-225. *Common wild cat*. J. J. Audubon, Haiti/United States. Toronto Reference Library.

229. *The Hunters at the Edge of Night* (oil on canvas). René Magritte, Belgium. Private Collection/The Bridgeman Art Library. Copyright © Estate of René Magritte/SODRAC (2009).

230. *Stone relief from the North-West Palace of Ashurnasirpal II* (Room B, Panel 10) or *King Ashurnasirpal*. Neo–Assyrian frieze (883–859 BC), Nimrud (ancient Kalhu), northern Iraq. Copyright © The Trustees of the British Museum.

232. *The Hind in the Wood*. Walter Crane, England, 1900. Victoria and Albert Museum. V & A Images.

237. *Tacuinum Sanitatis*. (14th century). Artist unknown.

238. *Metis Running Buffalo*. Paul Kane, Canada. 1846. Art Gallery of Ontario. Copyright © 2009 The Thomson Collection.

241. *Lion and porcupine*. Villard de Honnecourt, France. Ms Fr 19093 fol.24v *Lion and Porcupine* (pen & ink on paper) (facsimile). Reproduced courtesy of Bridgeman Art Library/Bibliotheque Nationale, Paris, France/Giraudon.

242-243. *A Sandringham Banquet*. Artist unknown, England. Gibson collection.

245. *The Deer Hunt*. Pella Mosaic. (late 4th century BC), Macedonia. Copyright © The Print Collector/Heritage–Images/Imagestate.

247. *An Englishman on an Elephant*. Artist unknown (c.1830), India. Victoria and Albert Museum. V& A Images.

249. *Black Bears*. J. J. Audubon, Haiti/United States. Toronto Reference Library.

253. *Cave horses*. Chauvet, France. By kind permission of the French Ministry of Culture and Communication, Regional Direction for Cultural Affairs—Rhône-Alpes Region—Regional Department of Archaeology.

254-255. *Cheetah Siesta*. Robert Bateman, Canada. Reproduced courtesy of Robert Bateman. Gibson collection.

256. *Pistrix*. Giovanni Vendremin/Severo, Francesco Buzzacarini. Spencer Collection, The New York Public Library, Astor, Lenox and Tilden Foundations.

258-259. *Bears*. Peterborough Bestiary (early 14th century). The Parker Library MS53. Courtesy of the Master and Fellows of Corpus Christi College, Cambridge.

WHAT IMMORTAL HAND OR EYE

260. *Tiger*. John Dickson Batten, England. British Museum/ Bridgeman.

267. *Crocodilus*. Mark Catseby (1682–1749), England. Reproduced courtesy of the Thomas Fisher Rare Book Library, University of Toronto.

268. *Song of Innocence: The Tyger*. William Blake, England. (PML/945 plate 42). Photo credit: The Pierpont Morgan Library/Art Resource NY. The Pierpont Morgan Library, New York.

271. *Magpie Goose*. H. Goodchild. Details unknown.

275. *Orange Hare* (detail) from *The Vision of St. Eustace*. Pisanello, Antonio, Italy. c.1438–42. Egg tempura on wood bought 1895 (NG 1436). Copyright © National Gallery, London / Art Resource NY.

276. *Lioness, a drawing*. (Study for *Daniel in the Lions' Den*), Peter Paul Rubens, Belgium c.1613 / 15. Copyright © The Trustees of The British Museum.

277. *Brindled Gnoo*. C. Hamilton-Smith (1826), England. Gibson collection.

279. *Leopard figure* (detail). Electrolyte copy by Elkington and Co. silver and gilt. Artist unknown (19th century), England. Victoria and Albert Museum. V & A Images.

283. *Cougar*. Ron Solonas. "Ron Solonas is a member of the Carrier Sekani First Nation, in the Northern Interior of British Columbia." Gibson collection. Courtesy of the Artist.

284. *Stag Hunting* from the *Livre de la Chasse*. Gaston Phébus de Foix, France. Ms Fr 616 fol. 77 (vellum) by French School (15th century). Bibliothèque Nationale, Paris, France / The Bridgeman Art Library.

287. *Mountain Lions at the Deer Cache*. Frederick Remington, United States.

288. *Of the Mouse Called the Shrew....* Edward Topsell, England. Thomas Fisher Rare Book Library, University of Toronto.

290-91. *Le Crocodile*. Artist unknown (c.1860). Gibson collection.

293. *Ant–lion from the Queen Mary Psalter*. Gregory the Great (6th–7th century CE), Rome. Copyright © The British Library Board. Royal MS 2B.vii. All rights reserved, 2009.

294. *Panorama of Nature*. Artist unknown. Gibson collection.

296. *Praying Mantis (Camel cricket)*. W. Daniell, England.

299. *Wolverine*. J. J. Audubon, Haiti / United States. Toronto Reference Library.

300. *Mosaic of a double–headed serpent*. Aztec / Mixtec, 15th–16th century AD. Artist unknown, Mexico. Copyright © The Trustees of the British Museum.

CEREMONY OF INNOCENCE

302. *Haida Figure*. Artist Unknown (19th century) from the collection of Murray Frum. Courtesy of Murray Frum.

309. *Polar Bear and Ribbon Seal*. Louis Agassiz Fuertes, United States. Reproduced courtesy of *National Geographic*.

310. *Of the bear*. Edward Topsell, England. Thomas Fisher Rare Book Library, University of Toronto.

311. *Coyote mask*. Artist unknown. Mexico. F. Reichenbach Col. MAAOA, Marseilles.

314. *Siamang*. Sir Edwin Henry Landseer, England. Gibson collection.

316. *Cernunnos* panel of Gundestrup Cauldron. Celtic (c.first century BC), Denmark. National Museum of Denmark.

318-319. *Scene from a Satirical Papyrus* (c.1100 BC). Possibly from Thebes, Egypt Late New Kingdom. Copyright © The Trustees of the British Museum.

320. *Macclesfield Psalter.* (c.1330), England. Reproduced by permission of the Syndics of the Fitzwilliam Museum, Cambridge.

323. *Jaguar.* Artist unknown. (19th century), Gibson collection.

324. *Angel Riding on the Back of a Tiger.* Artist unknown. Roman. University of Pennsylvania Museum. 1244. Boy Akratos, daimon of unmixed wine and follower of Dionysus (Bacchus), riding on a lion. House of the Faun Pompeii. Penn Museum object 1244, image #166277. Permission of the University of Pennsylvania Museum of Archaeology & Anthropology

326-327. *Sons of Horus*: Faience amulets. (c.2613–2160), Egypt. Copyright © The Trustees of the British Museum.

328. *Yellow bear of Norway.* William Home Lizars, England. Thomas Fisher Rare Book Library, University of Toronto.

331. *Jaguar.* J. J. Audubon, Haiti/United States. Toronto Reference Library.

332. *Grey Fox.* Catesby, England. Thomas Fisher Rare Book Library, University of Toronto.

333. *Shaman Plans a Hunt.* Enookie Akulukjuk, Inuit, Canada. Reproduced by permission of Akulukjuk's descendents.

337. *Death of a Unicorn.* Ashmole Bestiary (early 13th century), England. By permission of The Bodleian Library, University of Oxford. MS Ashmole 1511, fol. 14v.

338. *Bighorn Ram.* Scratchboard, 1995. Sallie A. Zydek, wildlife artist, (contemporary), United States. Courtesy of the Artist. www.natureartists.com

340. *Stag and Deer.* Laurie Campbell, England. Image provided Courtesy of the Artist. Available at www.lauriecampbell.com

343. *Polar Bears Embracing/Wrestling.* Western Eskimo, (19th century CE), Ivory, h. 8cm. Photo: Wener Forman/Art Resource NY/Alaska Gallery of Eskimo Art, Alaska.

344-345. *Elephants.* Mary Frank, United States. Photograph by Ralph Gabriner. Reproduced by kind permission of the artist.

347. *Black–maned lion.* William Home Lizars, England. Thomas Fisher Rare Book Library, University of Toronto.

Every effort has been made to contact the copyright holder. In case of inadvertent errors or omissions please contact the publisher.

Author's Acknowledgements

To all who helped with this book, either in conversation or by leading me to an effective text or image, my warmest thanks. Notable among many are Margaret Atwood, Mark Cocker, Murray Frum, Wayne Grady, John Houston, Lewis Hyde, Peter Jenny, the late John Livingston, Alberto Manguel, Peter Matthiessen, Ralph Siferd, Philip Slayton, and Marylee Stephenson.

Once again I'm grateful for the generous professionalism of librarians at the Parker Library (Christ the King College in Cambridge), the Royal Ontario Museum, the Thomas Fisher Rare Book Library (University of Toronto), and the Toronto Reference Library. Dealing with all of them has been a pleasure.

Felicity Blunt, Rosemarie Ceminaro, Nikki Cloker, and Victoria Fox were all understanding and helpful when both virtues were needed.

Particular thanks to Gayna Theophilus whose contribution has been essential, and to Laura Stenberg. Also to the estimable Susan Burns, to Phoebe Larmore, and to Vivienne Schuster at Curtis Brown. And then my publishers—Brad Martin and Maya Mavjee (Doubleday Canada); Nan Talese (Nan A. Talese/Doubleday); and Bill Swainson (Bloomsbury).

Finally, once again, my thanks to Scott Richardson for his marvellous presentation of the material.

INDEX OF CONTRIBUTIONS